Photo Icons
1928—1991

Hans-Michael Koetzle

Photo Icons
The Story Behind the Pictures
1928–1991

TASCHEN

HONGKONG KÖLN LONDON LOS ANGELES MADRID PARIS TOKYO

To stay informed about upcoming TASCHEN titles,
please request our magazine at www.taschen.com/magazine
or write to TASCHEN America, 6671 Sunset Boulevard, Suite 1508,
USA–Los Angeles, CA 90028, contact-us@taschen.com,
Fax: +1-323-463 4442. We will be happy to send you a free copy of
our magazine which is filled with information about all of our books.

© 2002 TASCHEN GmbH
Hohenzollernring 53, D–50672 Köln
www.taschen.com

Project management: Ute Kieseyer, Cologne
Editorial coordination: Daniela Kumor, Cologne

Translation: Sally Schreiber, Cologne
Editing: Frances Wharton, London
Malcolm Green, Heidelberg

Design: Claudia Frey, Cologne
Production: Thomas Grell, Cologne

Printed in Italy
ISBN–13: 978–3–8228–1831–2
ISBN–10: 3–8228–1831–3

Contents

Reading pictures
Hans-Michael Koetzle

The photographic era was heralded in 1827 by a camera picture produced by an exposure lasting over several hours, using a simple asphalt-coated plate. Meanwhile, official statistics tell us that over five billion photographs are printed each year in the big laboratories in Germany. There can be no doubt about it: we are living in an age of technically produced images. Photographs, pictures from films, television, video and digital media all fight to catch our attention. They try to seduce us, to manipulate, eroticise and even at times to inform us. People talk of how we are being deluged by images, which sounds threatening, but at heart this points above all to a phenomenological problem: how do we deal with all of these images? How do we select between them? What in fact do we manage to take in? And what, on the other hand, still has a chance of entering our collective memory?

We find ourselves at the moment in a paradoxical situation. While traditional analogue photography is losing its influence in its traditional territories, such as photojournalism or amateur photography and snapshots, the conventional camera photograph is becoming increasingly the object of a public discourse. Photographic images are now an accepted fact in art galleries and museums, at art fairs and auctions. The question as to whether photographs are actually art appears to have answered itself. Six-figure dollar cheques for key works from the history of photography, or for works by contemporary photo-artists, have long since ceased to be a rarity. A young generation has discovered in photography the same thing that previously investors found in antiques. Photography is starting to reach a ripe old age, and yet is more relevant now than ever before. As a medium of the more contemplative kind, it has found – in unison with mostly flickering images – a new, forward-looking role.

The media scientist Norbert Bolz has spoken in this connection of the "large, quiet image" that grants something like a secure foothold in the current torrent of data. Where television, video or Internet at best produce a visual "surge", the conventional photographic picture – as the

"victory of abstraction" – is alone in having the power to take root in our memory and engender something akin to a memory. The doyen of advertising, Michael Schirner, put this to the test in the mid-Eighties in his exhibition "Bilder im Kopf" [Pictures in Mind]. The show simply presented black squares with captions added in negative lettering: "Willy Brandt Kneeling at the Monument to the Heroes of the Warsaw Ghetto", for instance. Or "The Footprint of the First Man on the Moon". Or "Albert Einstein Sticking out His Tongue". Photography, as the Dusseldorf photographer Horst Wackerbarth puts it succinctly, is "the only genre that can achieve a popular effect on the immediate, visible level, and an elitist one after its initial impact on a deeper, more subtle level."

Each of the two volumes *Photo Icons I* and *Photo Icons II* presents 20 photographs from some 170 years, all arranged in chronological order. And every one of them is a key image from the history of the medium: images that have pushed photography forward in terms of either its technology, aesthetics or social relevance. There is a tradition to viewing "icons" such as these by themselves, each on their own. Best known in this context is John Szarkowski's classic book *Looking at Photographs*, first published in 1973. But going beyond Szarkowski's associative, journalese style, the present volumes also provide in-depth analyses of the contents. With the history of the picture's reception, we arrive at the question of when and in what way the motif became exactly what it is: a visual parameter for central categories of the human experience. Almost every technical approach and every major field of application (from portraiture to landscapes, from the nude to the instantaneous shot) has been included here, making the two volumes simultaneously a "potted history of photography". This prompts us to read pictures critically, to look at them more attentively and with greater awareness. As early as the 1920s, Moholy-Nagy pointed to the dangers of visual analphabetism. That applied to the era of silver salts in the photographic lab. Yet it applies more than ever to the age of satellite TV, video and Internet.

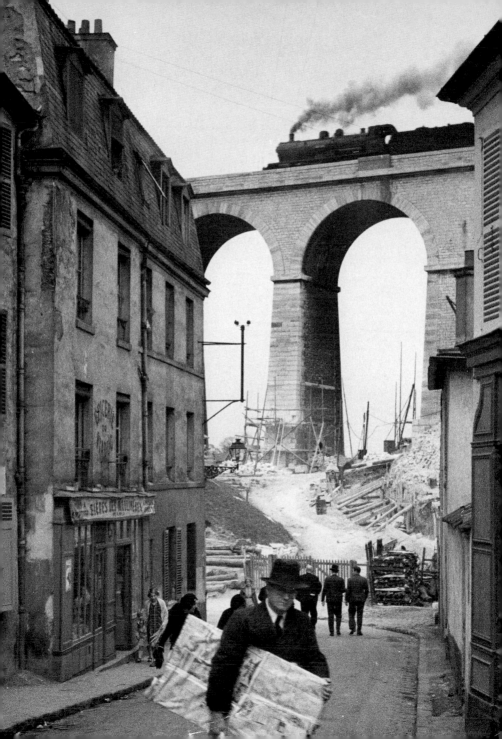

1928 André Kertész
Meudon

**He always saw himself as a realist and documentary
photographer. But during his time in Paris, the Hun-
garian-born André Kertész had in fact matured into
artistic greatness. Just how strongly he was also influ-
enced by the Cubist and Surrealist developments of
his age is clear in *Meudon*, taken in 1928.**

At least in titling his photographs, the great poet among twentieth-
century photographers was fairly prosaic: the names of what are today
probably his best known works – *Chez Mondrian, Danseuse satirique*, and
Fourchette – merely designate what is to be seen in the photograph. And
also in christening this photograph *Meudon*, Kertész was referring to an
actual place, a suburb to the southwest of Paris, approximately halfway to
Versailles. Just when in 1928 the picture was taken we do not know, but
from the leafless tree in the background, it must have been either at the
beginning or end of the year, even though the photograph wasn't pub-
lished until 1945, a good decade and a half after Kertész took it.
The New York publishing house of J. J. Augustin brought out *Day of Paris*,
edited by George Davis and designed by Alexey Brodovitch, in a $9^{1}/_{2}$ x 7-
inch format, with 148 pages containing 102 illustrations – in what was a
halfway decently printed volume, even though it was quite modest by
today's standards. Nevertheless, for André Kertész, the publication was
an important event, not so much because the design of the book had
been taken over by the man who was probably the most important art
director of the day, but because Kertész's collection of Paris shots taken
between 1925 and 1936 formed a reminiscence of what he always referred
to later as artistically the most fruitful and most beautiful period of his
life. Moreover, the publication constituted a piece of publicity during a
phase that otherwise must undoubtedly be regarded as the low point of
his career.

The greater part of his pictorial archive in his bags

André Kertész emigrated from Paris to New York in 1936, lured by an offer of the Keystone Agency – although it is possible that the photographer, scion of a Jewish Hungarian family, was also motivated by political developments in Europe. In his baggage, Kertész had carried along the greater part of his pictorial archive – a fact which suggests that he had determined to spend a longer time in the USA. This material was to form the basis of *Day of Paris* more than a decade later. The rest of the story is well-known – an almost immediate fall-out with Keystone; the artist's more-or-less unsuccessful attempts at finding work with all the various publishers and presses; his classification as an unfriendly foreigner in 1941, resulting in a ban on publication of his work; his jobbing after the war in magazine photography. Looking back, Kertész always designated his move to the USA as a mistake, and his work for magazines such as *House and Garden* and *Vogue* as a waste of time. Why he therefore remained in the USA remains a riddle; what is certain is that the artist, who had been active on numerous projects between the wars in Europe, could not gain recognition in the USA for his work, steeped as it was in the formal language of Surrealism. In an often-told story of his failure to acquire a foothold in *Life*, which had been founded in the year of his arrival in America, it is said that the editors told him that his pictures told too much: a highly telling comment when it comes to our picture.

Contradictions that create both the visual interest and the oddity of the image

The publication of the monograph in 1945, the year that the war ended, must therefore have seemed to Kertész to be a priceless recompense, all the more so because it also made amends for an even earlier blow. The title of the book, *Day of Paris*, may have seemed to many like a counterpart to Brassaï's warmly received *Paris de Nuit* of 1933, but in fact the publisher had originally offered the theme to Kertész. In view of the meager stipend, however, Kertész refused the commission, thus opening the door for his somewhat younger Hungarian colleague. No less a figure than Paul Morand had composed the foreword to Brassaï's first published work. *Day of Paris*, by contrast, was served with extended captions, supposedly written by the editor George Davis. *Meudon* appears as a full-page plate on page 83. "The sharp unreality of stage-sets. Like a toy an

André Kertész

Born **1894** in Budapest under the name of Kertész Andor. Works initially as a book-keeper at the Budapest stock exchange. **1914** military service. **1917** publication of first picture. **1925** moves to Paris. **1929** participates in "Film und Foto". **1929** first *Distortions* in mirrors. **1936** moves to New York. Publications in *Harper's Bazaar, Vogue, Coronet.* **1944** American citizenship. **1945** publication of his book *Day of Paris.* **1946** exclusive contract with *House and Garden.* Dies **1985** in New York. Estate (100,000 negatives) donated **1986** to the French state (Patrimoine Photographique)

Meudon 11

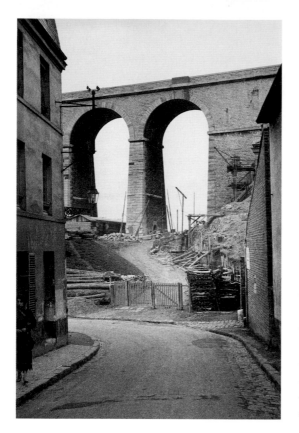

André Kertész:
Meudon, 1928

A total of three neg-
atives (the published
shots and two vari-
ants) have survived in
André Kertész' estate.

engine crosses the viaduct in a suburb," reads the caption – which indicates that the image had already irritated and alienated its contemporaries.

A train, coming from the right, is crossing a viaduct. In the foreground, as if accidentally, a man in a dark coat wearing a hat is crossing the street, while further behind, nine figures, two of them children, are heading off in various directions. Nothing in the picture is unusual in itself: there is no 'event' here, no 'transgression' of borders in the sense of the artistic theory promulgated by Structuralism. And yet the effect of the vertical black-and-white photograph is somehow disturbing. Does this feeling originate in a simultaneity of dissimilar things, that captures the observer's gaze, surprises them, leaves questions unanswered? Normally, photography presents connections, reveals causalities, reveals insights. But this picture explains nothing; it seems to be torn from some kind of unknown context. And on top of this, it is loaded with an entire series of clearly obvious contradictions that constitute the visual interest, but also the oddity, of the image. There is, for example, the massive viaduct and equally imposing steam locomotive that appear as if in miniature in the photograph, as if taken over from a model train set. And then there is the well-groomed gentleman, whose dark coat together with his tie and Homburg don't quite fit into the otherwise rather shabby surroundings. What is a man like him, whom we would rather expect to find strolling on one of the boulevards in the center of the city, doing out here in the suburb of Meudon – and furthermore, 'caught' with a newspaper-wrapped

object which the 'suspect' seems to be transporting like booty from left to right through the picture. Even though it depicts a scene clearly drawn from everyday life in Paris, something surreal clings to the photograph, something reminiscent of the paintings of de Chirico, or the inventions of a Balthus or René Magritte, or of certain scenes in the films of Luis Buñuel. More than anything else, the photograph resembles a still taken from a film; the architecture, diminishing in size as the receding street curves away to the left, and the viaduct in the deep background, lend the picture a tangibly stage-like quality.

Friends with the Avant-garde circles of Montparnasse

At the time he made the picture, the Hungarian-born Kertész, age thirty-four, was a well-known and successful photographic artist in Paris. No less a figure than Julien Levy would soon designate him as a "prolific leader in the new documentary school of photography." Strictly speaking, Kertész was a member of the large Hungarian-Jewish Diaspora whose innovative work was making a major contribution to the development of a new look to photography around 1930. In this context one can name Robert Capa, Stefan Lorant, Martin Munkácsi, as well as Brassaï, born Gyula Halász, who had moved to Paris in 1924. Kertész's first photographs date from 1914, and his journalistic publications had already gained him a certain degree of fame in Hungary of the early 1920s. Why he moved to Paris in 1925 we do not know; after all, the majority of his photographic compatriots were drifting to Berlin, at that time the uncontested center of a dynamically growing

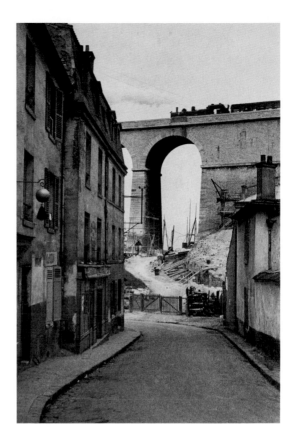

Opened for use in September 1840, the 476 feet long and 105 feet tall railway viaduct at Meudon was considered the greatest feat of engineering in its day. Nevertheless, it seems unlikely that André Kertész travelled solely on its account to the outskirts of Paris.

photographic press. What is certain is that in Paris he soon found his way into the artistic Avant-garde circles of Montparnasse. Although he seems to have had only a loose connection with the reserved Man Ray, he was in regular contact with more-or-less well-known Hungarian artists such as Lajos Tihanyi, Josef Csáky, István Beöthy, and even Brassaï. Kertész regularly met his colleagues in the Café du Dôme, which, located on the corner of the boulevards Montparnasse and Raspail, soon became the center for the informal group of artists.

In addition to achieving a respectable measure of success in these years as a photojournalist, especially for German and French papers, Kertész still had enough time and energy to pursue freelance projects directed toward developing his personal photographic style – one which is moreover not to be defined with any of the traditional vocabulary. According to Jean-Claude Lemagny, his pictures "have something restrained, dampened, soft, about them." Kertész was perfectly aware of the artistic tendencies of his age, especially Cubism and Surrealism, "but neither dominate his work; both remain subservient to the actual photographic task at hand... Kertész is surrealistic only to the extent that reality itself is. With every step in the real world, an abyss of poetry can open up."

The ideal tool for the artist

Meudon came into being at an important moment in Kertész's life, for this was the year in which he purchased his first Leica. The small-format camera, which had been available on the market since 1925, proved to be the ideal tool for the artist. The 35-mm camera, at once handy and discrete, made Kertész's particular approach as a strolling photographer considerably easier. In addition, the 36-exposure rolls allowed pictures to be taken in sequence, thus allowing a visually more experimental approach to a valid pictorial formula – an advantage which, as we shall see, played an important role also in the conception of *Meudon*.

Portraits of his artist friends; including Mondrian, Foujita, and Chagall; interiors, as well as everyday objects and street scenes, were among Kertész's more common themes in those early years in Paris. Nonetheless from the beginning, Kertész's visual exploration of the metropolis on the Seine occupied the center of his artistic interest. In these years, according to Sandra S. Phillips, he often strolled through areas like Montmartre and Meudon. Gaining familiarity with the traditional artist-quarter

of Montmartre was, of course, a part of the required task of every new-comer to the Paris scene. Meudon, in contrast, was not a place that a strolling photographer would visit as a matter of course: one must inten-tionally board a streetcar to get there. But what might have drawn Kertész to Meudon in 1928?

At this point, the survival of a total of three small-format negatives, dis-tributed on two nitrate films, becomes significant. One image is without people or train, and lacks both date and frame number on the roll. Two more images, including the published version, were taken one directly after the other. Which was the first exposure? Presumably the scene with-out people or train, for it seems unlikely that the visually experienced Kertész would have followed the dramatic composition of our picture with a comparatively boring variation without human figures. In any case, the photographer made two visits to Meudon. The diminishing wood pile and the alterations in the scaffolding of a building indicate that a good deal of time must have elapsed between the first shot and the two suc-ceeding ones. If Kertész had traveled out to Meudon for the sake of the viaduct, however imposing it might be, he would undoubtedly have been satisfied with his first picture, in which the bridge is clearly evident – or he would have immediately attempted another shot. Consequently, there must have been another motive that drew Kertész to Meudon, where the critical picture was made almost in passing, as it were.

Kertész's exhibition at the gallery Sacre du Printemps in 1927 undoubtedly marked an important station in the artist's professional career. Not only was the show one of the first exhibitions emphasizing the art of photo-graphy in general, but it also constituted the first large summary of his work in progress, with which he hoped to establish connections to better known photographers, in particular Man Ray. A group photograph also dating from 1927 reveals just how much a part of the international art circle in Paris Kertész had already become. On the picture titled *After the soirée* we see Piet Mondrian, Michel Seuphor, Adolf Loos, Ida Thal, and in the background the German artist Willi Baumeister who, in his own words, had met with "recognition and very great interest on the part of the French artists" and even toyed for a time with the idea of moving to France. At least on one other occasion Kertész did a portrait of Baumeis-ter: in 1926 in Mondrian's studio together with Gertrud Stemmler, Julius Herburger, Piet Mondrian, Michel Seuphor, and Margit Baumeister. In

 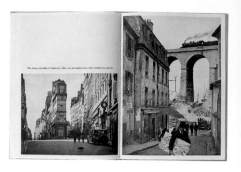

André Kertész: Day of Paris: The book, designed by Alexey Brodovitch, was published 1945 by the publishers J. J. Augustin of New York, and was Kertész's first book offering in the USA.

other words, Kertész and Baumeister had met at the latest by 1926. Taking a closer look at the group portrait of 1926, there is an astounding similarity between Baumeister and the gentleman in a dark coat, whose shadowed face nonetheless emerges as powerful and broad – and who likewise seems to be wearing glasses.

Never rearranged a subject

We know that Willi Baumeister visited Paris in 1926, 1927, and 1929, even if there is no direct evidence for 1928. In a letter to Oskar Schlemmer dated 2 November 1928, now privately owned, the German artist speaks of a certain "Miss whom I met in Paris" – a statement that certainly does not constitute proof of a visit to the city during the year in question, but which makes it nonetheless more probable. If we assume that Willi Baumeister in fact was in the French capital during the course of the year, what might have led him to Meudon? A visit to his friend and fellow-painter Hans Arp, whose studio was in fact located in Meudon at this time? Clearly, there is at least some evidence to support the hypothesis that the photograph presents us with the figure of the constructivist Willi Baumeister – whom Kertész had accompanied to Meudon and captured on film as he crossed the street. The flat, newspaper-wrapped package also suggests the possibility of a painter. But if the figure is in fact that of his friend Baumeister, why then did Kertész not identify him in the caption beneath the picture? The explanation is simple: "The difference between Kertész and Bourke-White, as well as many others who did photographs on assignment to satisfy editorial needs, is that she would sometimes rearrange a subject; Kertész never would," declared Weston

Naef. But the idea of staging a scene would certainly have occurred to Kertész's 'teammate' Willi Baumeister, who appears, moreover, as a complete figure in the uncropped photograph. The possibility of staging is all the more realistic since Kertész was demonstrably working toward an ultimate composition for his picture – as evidenced by the three 'stations' through which the photograph passed. Moreover, a reference to Baumeister in the photograph would have led to an inevitable hierarchizing of the elements in the picture. The balance among viaduct, train, and man-with-hat would shift in the direction of the human figure, and we would therefore understand the picture solely as a portrait of Willi Baumeister – and a none too good one at that. Only insofar as the photograph keeps its secret does it also retain its visual power and surrealistically inspired poetry.

Day of Paris: *double-page spreads, showing pages 82–83: (left)* Quartier Saint Denis *and (right)* Meudon; *pages 114–115:* Tuileries Gardens; *pages 136–137: (left)* Kiki of Montmatre *(sic!) and (right)* Montparnasse, Studio

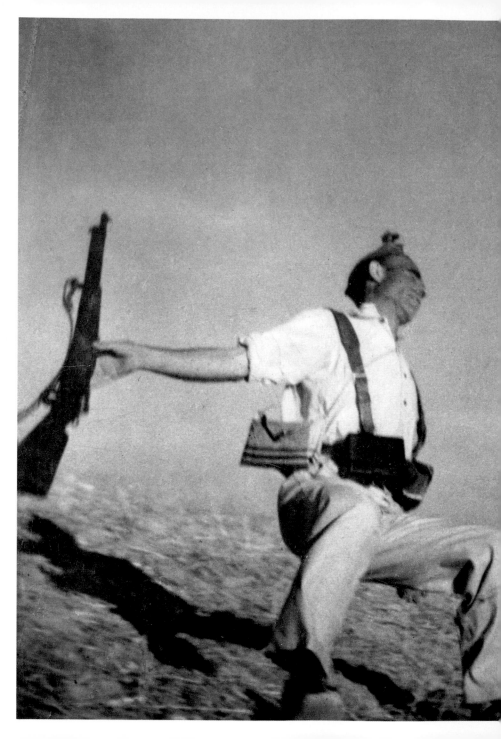

1936 Robert Capa
Spanish Loyalist

Córdoba Before the Fall

Robert Capa was more than a war photographer, even if it was his war scenes that made him famous. In the end, his estate comprised more that 70,000 negatives – but that of his most famous picture is accounted lost.

Finally, he has acquired a name. For decades, he was merely an unknown soldier, a nameless victim of war. He, or rather his picture, stood symbolically for the millions of deaths lost to war and violence. The caption affixed to the image was as brief as it was general: *Loyalist Soldier* was the most usual title. Or *Falling Soldier*, or even *Loyalist Militia* – but this reference to the Anarcho-Syndicalists who fought on the Republican side of the war attempted a more exact identification than the picture really allowed. For as many critics have rightly noted, this photograph drew, and still draws, its power precisely from its generalization of death. Only insofar as the photograph stands for a reality that passes beyond time can it function as an icon of dying in a higher sense. As late as 1984, the writer Peter Härtling, in his lectures on poetics given in Frankfurt-am-Main, addressed the issue of the "absence of data on the Soldier" and asked whether it was proper to create something like an identity for him. According to Härtling, "He cannot have been a soldier after the model of a Malraux or Hemingway, but rather one of those who were buried – nameless among thousands of nameless – in the Cemeteries of the Moon, as Georges Bernanos described them in helpless protest." Härtling answered his own question: "No, I would not give him a name." But now we know the facts: the name of the soldier is Federico Borrell García. He was twenty-four years young, came from Alcoy in southern Spain, and died on 5 September 1936 on the Córdoba front near Cerro Muriano.

The most exciting shot of battle action

The soldier's death is documented in the files of the military archives of Salamanca, to which we will return later. The photographer Robert Capa,

then aged twenty-two, captured the instant of the soldier's death – and at the same time created what is probably his most famous photo. There is no information about the picture; not even Magnum, the agency co-founded by Capa and which still holds the rights to the picture under entry number CAR 36004 W000X1/ICP 154, has data about its circulation and reception. Nonetheless, historians and biographers agree on the unique status of this picture. To cite just a few voices: the Capa scholar Richard Whelan·speaks of "the most exciting and immediate shot of battle action" ever taken; Russell Miller in his recent book on Magnum declares it to be "the greatest war photograph ever taken"; the German illustrated *Stern* (41/1996) termed the photograph "a symbol of the Spanish Civil War and later the ultimate image for the anti-war movement"; and finally, Rainer Fabian, in his article on more than 130 years of war photography, speaks of "the most legendary and most-published war picture in history." According to Fabian, "War photography is the use that one makes of it"; that is, a war picture defines itself primarily through the way it is used. Robert Capa's photograph of the Spanish Loyalist was not the first picture to emerge from a war, but is stands as "the first compelling action shot taken during wartime" (Carol Squiers). One tends to treat such superlatives with skepticism; after all, many photographs and films also emerged from the First World War, at a time when Capa's preferred working camera, the Leica, was not yet on the market. In those days, photojournalists had comparatively large and clumsy cameras, weak lenses, and glass negatives that debarred quick reactions or sequences. Notwithstanding, one cannot exclude the possibility that among the many thousands of photographs taken, there might be a picture of a death that is at least the equal of Capa's. What had certainly changed since the end of the First World War, however, was the situation of the media. War pictures were now treated differently, as photographs found a forum in the newly created illustrated press. As a result, there was now a demand and, in many lands, a largely uncensored public sphere. In short, a change in paradigms had taken place.

Robert Capa

Born Endre Ernö Friedmann **1913** in Pest/Hungary. **1931** moves to Berlin. Studies at the liberal German College for Politics. **1932–33** lab assistant at the photo agency Dephot. **1932** first photos are published. **1933** moves to Paris. Acquainted among others with Gisèle Freund and Henri Cartier-Bresson. From **1936** photojournalism on the Spanish Civil War for *Vu* and *Regards*. **1938** war correspondent in China. Moves **1939** to the USA. Works for *Collier's* and *Life*. Highly acclaimed reportages on the European theatres of war. **1947** founder member of Magnum. **1954** in Indochina for *Life*. Killed that same year by a mine

The blossoming new genre of illustrated magazines
The specific character of the Spanish Civil War must also be kept in mind. For most Europeans, it was a distant civil war which one nonetheless regarded with curiosity because here – quasi symbolically for the rest of

the world – the struggle between the Left and the Right, between Communism and Fascism, was being fought out. In other words, in this age before television there was a strong and international interest in pictures that the new genre of illustrated magazines, which had blossomed into being since the 1920s, knew how to satisfy. Advances in printing techniques, new forms of distribution, and revolutionary layout techniques allowed the improved reproduction of images more quickly and attractively than had been possible earlier, and supplied them to the readers. In addition, a new generation of photographers had appeared: equipped with faster cameras and a new understanding of their role. The field now included photojournalists, adventurers, and parvenus who personally stood – or were supposed to stand – for the originality, seriousness, and authenticity of a story. It is not by chance that reports became more and more personalized. When the English illustrated *Picture Post* devoted all of eleven pages to Robert Capa's civil war photographs in December 1938, the cover clearly proclaimed him to be the greatest war photographer in the world. This was not the first publication of pictures from Spain, but it was the start of a myth that is still effective today.

He was young and obviously ambitious, a photographer with leftist sympathies, a charmer, a ladies' man, gambler, and adventurer all in one – thus we can imagine Capa in those years. In addition, he was undoubtedly a "concerned photographer," who above all believed in himself, his talent, skill, and courage to achieve good pictures. His real name was Endre Ernö Friedman, and he had been born in Budapest in 1913, the second of a tailor's three children. Even as a boy, he was alert and knew how to take his life in hand. In 1931 he moved to Berlin, studied at the Academy for Politics, and earned a bit of money at the legendary Dephot agency, where he carried coal, handled the laboratory work, and at some point was also permitted to take a camera into his own hands. Photographs of the camera-shy Leo Trotsky are said to be the beginning of his career as a photographer. Even here, Capa already succeeded instinctively and with a good deal of chutzpah in a brilliant report. "If your pictures are no good," he is reported to have said, "you didn't get close enough."

The first to recognize the visual power of the photograph

Hitler's takeover hindered the further development of Capa's career, at least in Nazi Germany. Like so many of the photographic guild – Stefan

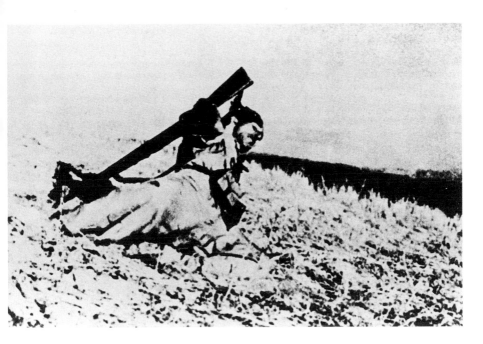

Lorant, Martin Munkácsi, Simon Guttmann, to name only Capa's fellow Hungarians — Capa, who was Jewish, felt forced to emigrate. Only after he moved to Paris did the talented novice with a sense for themes change his name to Robert Capa — a man whose work was in fact not at all limited to war photography, even if it was primarily his war reports that carried him to fame.

These were restless times politically. Spain was caught up in civil war since July 1936. An alliance of right-wing generals, large landowners, nobles, and the Catholic Church had risen up against the elected popular-front government. Political upheaval was also threatening France, with workers on strike since May to force the leftist government under Léon Blum to undertake social reform. Precisely where Capa stood politically is unknown, but a picture published in the left-oriented illustrated *Vu* from 3 June 1936 testifies to his interest in the workers' strike. Similarly, during the Spanish Civil War we can identify at least a modicum of sympathy for the Left in Capa, who had been inspired by Karl Korsch and his ideals of a people's front in Berlin. What in any case is certain is that in early August, Capa and his long-term companion Gerda Taro set out for Spain to docu-

Comment sont-ils tombés. under this title, VU magazine (23 September 1936) for the first time published Capa's Loyalist Soldier together with this lesser known photograph of a falling soldier.

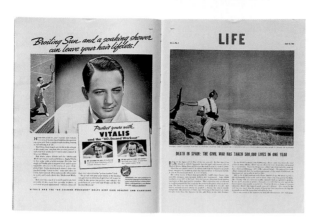

ment the two-week-old conflict from the perspective of the Anarcho-Syndicalists. Capa photographed in Barcelona and on the Aragón front, then went on to the Huesca front, until he finally arrived at Córdoba, where he took the picture that would be his most famous. The *Spanish Loyalist* initially appeared in *Vu*, No. 447, on 23 September 1936. The pic-

Double-page spread from Life: *advertising and editorial in absurd, almost cynical competition with each other*

ture occupies the upper left half of a double-page spread entitled "La Guerre Civile en Espagne." Responsible for the layout was Alex Liberman, later art director of the American *Vogue*, who thus was the first to recognize the visual power of the photograph. Under the picture, Liberman also placed a variant, thus conveying the rhythm of a film to the sequence of images – although close observation indicates that there are really two protagonists depicted here. There is no reference to place, time, or even the names of the dead. The caption remains general in content, speaking in pathos-filled tones about the whistle of a bullet and blood being drunk by the native soil. The next to publish the picture was *Life*, in its issue from 12 July 1937. Under the heading "Death in Spain," the magazine marked the first anniversary of the beginning of the war and spoke of the victims – *Life* reported half a million lives had been lost. The article opened with Capa's photograph in large format, although slightly cropped on the right. Two days later, the Communist magazine *Regards*, which had already published several of Capa's reports, also published the photograph. Capa himself gave it a prominent position on the cover of his book *Death in the Making* (New York, 1938), along with other photographs he and Gerda Taro had taken in Spain. He still, however, absolved himself of the duty to provide data on the location, time, or circumstances of the picture.

Soon the photograph began to provoke questions; doubt as to its authenticity began to make the rounds. *Life* commented on the moment in which the solder is struck by a bullet in the head. But even a close exam-

ination of the picture fails to reveal a bullet wound anywhere on the body. One also might ask oneself how a man hit by a bullet while he is storming down an incline can fall backwards. Speculation also arose over the blossom-white uniform, hardly appropriate for the battle field. Furthermore, it is strange that Capa photographed the soldier from the front: wouldn't

Double-page spread from La Revue du Médecin, 30 September 1936: the first issue of the magazine for doctors and pharmacists published Capa's pictures (including the variant from p. 21) in an exceptionally avant-garde layout.

this necessarily imply that he had rushed ahead of the militiaman? On the other hand, there is just as much that argues against the thesis that Capa staged the photograph, including his very professionalism as a photographer. It hardly would have been necessary for him to have staged such a picture. And that one of the members of the Confederación National del Trabajo (CNT) should have stooped to act out his own death appears equally implausible. Nonetheless, in the course of several interviews, the British journalist O'Dowd Gallagher re-ignited the discussion over the credibility of the photograph in the 1970s when he declared that he had shared a hotel room with Capa near the French border at the time the photo was made, and that later, Loyalist soldiers staged useful photos for the press. Elsewhere, however, Gallagher speaks of Franco's troops in Loyalist uniforms who carried out the deception. But, as Richard Whelan points out, aside from the journalist's self-contradictory testimony, Capa as a Jew and a self-declared anti-fascist would have found it difficult to work together on a project with the Falangists.

The key picture of a longer sequence

Neither can the original negatives offer further information, for they have disappeared. Capa himself spoke about the picture only once, in an interview on 1 September 1937. According to a paraphrase by a journalist for the New York *World Telegram*, Capa and the militiaman had both been left behind by the troops: "Capa with his precious camera and the soldier with his rifle. The soldier was impatient. He wanted to get back to the

Loyalist lines. Time and time again he climbed up and peered over the sandbags. Each time he would drop back at the warning rattle of machine-gun fire. Finally the soldier muttered something to the effect that he was going to take the long chance. He climbed out of the trench with Capa behind him. The machine-guns rattled, and Capa automatically snapped his camera, falling back beside the body of his companion. Two hours later, when it was dark and the guns were still, the photographer crept across the broken ground to safety. Later he discovered that he had taken one of the finest action shots of the Spanish war."

Was Capa really alone with the militiaman? His biographer Richard Whelan expresses doubts on this point. After all, the key picture is one of a larger sequence in which several pictures clearly depict both of the soldiers who were later killed – one in the midst of a momentarily care-free group of CNT militiamen, and another in a leap over a trench. Furthermore, in the battle our protagonist is clearly recognizable. But there is something else that is suspicious: the two photographs of a wounded and a falling soldier published in the *Vu* issue of 1936 must have been taken at approximately the same time, judging by the unchanged cloud formations. The perspective is also identical. Finally, the argument for the existence of two militiamen is supported by a more exact look at their clothing. One of the soldiers is wearing a white shirt and trousers; the other, a kind of worker's overall. On one soldier, the leather suspenders follow a straight line down to the trousers; the other soldier wears them crossed. "If one then looks closely at the ground in the *Falling Soldier* photograph and in the variant image," argues Richard Whelan in his biography of Capa, "and compares the configuration of prominently upstanding stalks, it becomes obvious that the two men are shown falling on almost precisely the same spot. (The *Falling Soldier* is about one foot closer to the photographer than is the man in the other picture.) We may well then ask why it is that although the two men fell within a short time of each other...in neither picture do we see the body of the other man on the ground."

The truth is the best picture

Neither Whelan nor Capa's younger brother Cornell, who administered the estate left by Capa after he was killed by a mine in 1954 in Indochina, have ever allowed a doubt to be raised about their belief in the truth of

the documentary photograph. Furthermore, according to Whelan, it's "a great and powerful image... To insist upon knowing whether the photograph actually shows a man at the moment he has been hit by a bullet is both morbid and trivializing, for the picture's greatness ultimately lies in its symbolic implications, not in its literal accuracy as a report on the death of a particular man." Whelan's biography of Capa was published in the USA in 1985. Exactly ten years later, a certain Mario Brotóns Jordá edited and published his memoirs on the Spanish Civil War under the title *Retazos de una época de inquietudes*. Brotóns had himself fought on the Córdoba front. In Capa's famous photograph he recognized the leather bullet pouches that were made in exactly that fashion only in Alcoy, and that only the militiamen from Alcoy carried. Based on various indications in Capa's photograph, Whelan had dated it to 5 September and deduced that the location was somewhere around Cerro Muriano. And in fact, as Brotóns was able to find out in the State Archive in Salamanca, there was only a single militiaman from the Alcoy region who was killed on 5 September 1936 on the Cordoba front near Cerro Muriano: Federico Borrell García. When Brotóns then showed Capa's photograph to a surviving brother of the deceased soldier, he identified the victim as Federico. Thus, according to Richard Whelan, the story had come full circle. Capa's "Loyalist," according to the *Stern* "really did fall in battle." And thus the overall credibility of the photographer was rehabilitated. As Capa expressed it at the time in an interview with the *World Telegram*: "No tricks are necessary to take pictures in Spain. You don't have to pose your camera [i.e., pose your subjects]. The pictures are there, and you just take them. The truth is the best picture..."

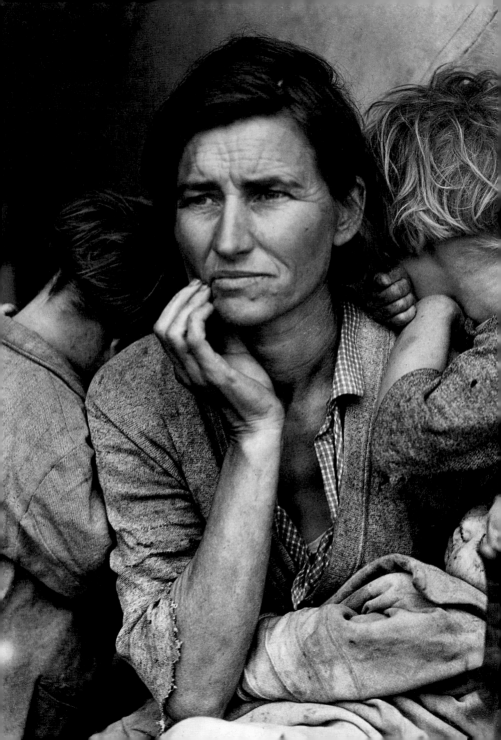

Dorothea Lange
Migrant Mother, Nipomo, California

1936

Stock market crash, economic crisis, and catastrophic drought in the southern states: with good reason the decade following 1929 came to be known in the USA as 'the bitter years'. It was during this period that Dorothea Lange made a portrait of a female migrant worker and her children, thereby creating an image that has established itself as a timeless metaphor for human suffering.

Madonna for a Bitter Age

Her name is Florence Thompson; she is 32 years old, married, with no permanent address and seven children to feed. What would constitute no mean feat even in times of economic prosperity now threatens to bring the family to the brink of disaster during the Great Depression in the USA. Florence Thompson is one of the many migrant workers, as they came to be called during these dark times, who traversed the land seeking any work they could find. But it turns out that now, in March 1936, the pea harvest is once again poor, and that means no work – and therefore no income – for the pickers. Florence Thompson has found lodgings for the time being, in a camp for pea pickers in Nipomo, California. "Of the 2,500 people in this camp," noted Dorothea Lange; "most of them were destitute."

One of the most-cited pictorial images of our times

We know surprisingly much about the woman in the photograph, in part thanks to the comparatively precise information that the photographer provided on the back of at least the early prints. From another source we also know that one of the daughters (left in the picture) later made a futile attempt in court to stop the publication of the photograph. Furthermore, in 1983 there was a public appeal for contributions for Florence Thompson, ill with cancer. The 'bitter years', as they have been made real

to us particularly in the works of John Steinbeck and John Dos Passos, now lie well over a half a century in the past, and few persons can recall the Great Depression from first-hand experience. The portrait of the young Florence Thompson, however – thin-lipped, care-worn, gazing emptily into the distance – is familiar to almost everyone. Since its appearance in "The Family of Man" exhibit (1955), conceived by Edward Steichen and viewed by more that nine million people around the world, the photograph has become a part of the collective memory. Originally designated in 1955 simply as "U.S.A: Dorothea Lange Farm Security Adm.," the photograph is now known as Migrant Mother, a much more gripping title that raises the concrete historical circumstances to a level of timeless contemplation. The picture, intended as a documentary, has understandably become one of the most-cited pictorial images of our century.

Through the years, there have been numerous attempts to subject Migrant Mother to art-historical analysis. Comparison has often been made to images, common since the Renaissance, of the Mother of God with the Christ Child. Other interpretations explain the success of the picture through its balanced composition, or refer to the: "dignity and essential decency of the woman facing poverty" (Denise Bethel), or to the picture's "simplicity of means, its restrained pathos, and its mute autonomy of language" (Robert Sobieszek). Whatever the reasons may be, what remains certain is that Dorothea Lange largely ignored all such theoretical motives when she took the photograph. As she herself once described her approach to her work: "Whatever I photograph, I do not molest or tamper with or arrange... I try to [make a] picture as part of its surroundings, as having roots... Third - a sense of time... I try to show [it] as having its position in the past or in the present..." Ironically, the framing actually chosen by Lange here is so narrow that the tent in the background is not even recognizable. Furthermore, the image is fairly indefinite temporally: only with difficulty can one conclude – based on the children's haircuts – that the picture

Close-up from Migrant Mother: the thumb is clearly visible on this print (right edge of the picture). It seems to have bothered the photographer, and later she removed it from the negative.

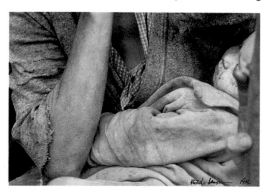

stems from the 1930s. As far as setting up a 'scene' is concerned – or rather, the attempt to avoid doing this – we know that Lange approached the family slowly, taking pictures all the while, thus giving the family members the chance to pose themselves. In fact, in the initial photographs, the children are looking into the camera; only in the final photo of the sequence do they turn away, thus demonstrating their condition as social outsiders that Lange had first documented in 1933 with her photograph *The White Angel Breadline*.

Making human suffering into an aesthetic object

A further modest but important detail is often overlooked in the discussion of Dorothea Lange's *Migrant Mother*: namely, the thumb that appears in the lower right of the picture and that remains vaguely recognizable even in the retouched version. Dorothy Lange retrieved the picture from the archives of the Farm Security Administration approximately two years after it had been shot, which is to say in 1938. In an action that remains controversial to this day – and one which elicited furious protest especially from Roy Stryker, Lange's immediate superior at the FSA – Lange eliminated the image of the thumb, whose owner remains only a matter for speculation, although it may belong to Florence Thompson herself. Whatever the case may have been, the incident illustrates Lange's ambivalent understanding of 'documentary', which for her implied not merely demonstrating, but also convincing; that is, in addition to the simple registration of reality, her concept also includes moving the observers – in a double sense, for Florence Thompson is supposed to have in fact thanked her survival to the published picture.

In other words, Dorothea Lange was seeking visual evidence, but also quite consciously a suggestive image. In making human suffering into an aesthetic object, the photographer discovered a way of stimulating attention, interest, and sympathy in world saturated with optical images. As once formulated by John R. Lane, she carried "the concept of documentary photography far beyond the purely pragmatic domain of record-making." Lange's *Migrant Mother* exemplifies precisely this understanding, and probably for this reason it became the single best-known motif of the FSA campaign. The visible thumb, however, would have spoilt the overall composition, and invested the photograph with an unintentional humor – the reason why Lange broke with her own principles to remove it.

Dorothea Lange

Born **1895** in Hoboken/New Jersey. **1913** drops out from high school and turns to photography. **1917** courses under Clarence H. White. **1919** opens a portrait studio in San Francisco. After **1930** turns to social topics. **1935** marries the social scientist Paul Schuster Taylor, who puts her in contact with the Resettlement Administration (from **1937** FSA). Works for the organisation till **1939**. **1939** publication of *An American Exodus*. **1943–45** works for Office of War Information. **1955** participates in "The Family of Man". Dies **1965** in San Francisco of cancer

Dorothea Lange: Migrant Mother, Nipomo, California

Here the situation as a whole. According to her statements, the photographer took a total of five exposures.

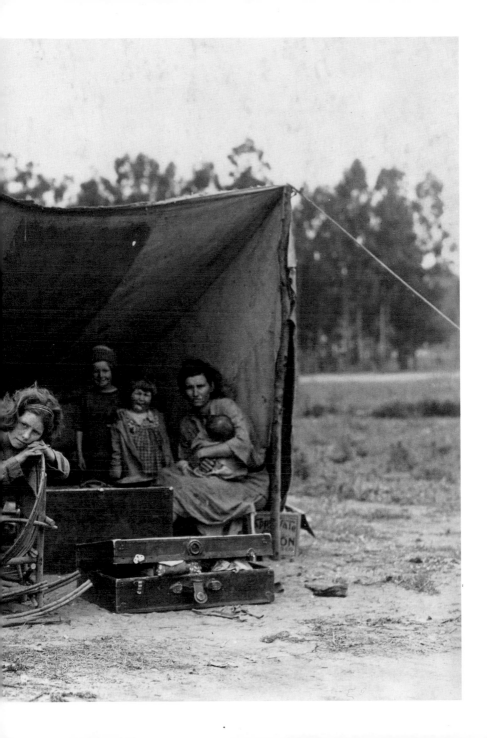

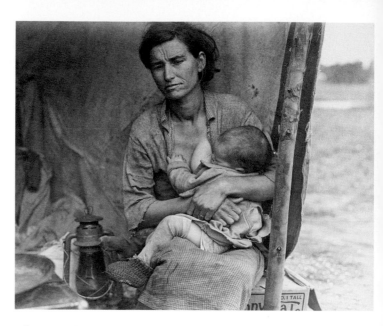

When Dorothea Lange took the picture in 1936, she was forty years old, a committed photographer, and herself the mother of two children. Divorced from her first husband, the painter Maynard Dixon, she had now been married for a year to the sociologist Paul Schuster Taylor. Born in Hoboken, New Jersey, Lange had quit school at age eighteen more or less on the spur of the moment, in order to devote herself to photography. She studied first under Arnold Genthe and afterward with the no-less-renowned Clarence H. White. In the years following 1900, pictorialism was still at its zenith – a school of art photography which pursued the model provided by painting, and of which Clarence White (described by Lange as extremely helpful and inspiring) was one of its leading representatives. Lange's early photographs, insofar as any have survived, still reveal overtones of the pictorial approach, although, as stressed by Sandra S. Phillips Lange encompassed a social interest that reached beyond the formal principles of the pictorial approach. At age seven, Lange suffered from polio, which resulted in a deformity of her right leg, and five years later, her father abandoned the family. Thus, concludes Phillips, "[Lange's] great ability to identify with the outsider was shaped by these two emotionally shattering events, disability and desertion."

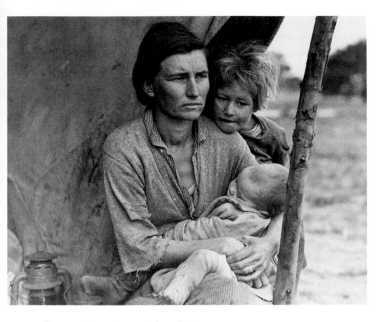

A further variant. It is clear just how Lange resolutely approached the family with her camera.

An eye focussed on the social realities

Intending to widen her horizon, Lange set off on a world tour in 1918, but she and her friend got no further than San Francisco before being robbed of their savings. So Lange took a job in the photographic department of a drugstore to supply the funds necessary for survival. The following year, Lange established herself in the city with her own photographic studio, which she maintained until 1934. The collapse of the New York stock market in 1929 and the ensuing economic crisis caused a professional break in a double sense for Lange, who by then had long been a successful portraitist. On the one hand, there were now fewer customers who could afford a studio portrait, and on the other hand, especially in the agricultural American South, the unemployed, the homeless, and the migrant workers increasingly became a part of the street scene. This was the phenomenon that Lange captured with her camera: her view of the down-and-out and needy waiting in front of a soup kitchen set up by a wealthy woman, known under the title of *The White Angel Breadline*, stands as the turning point in her photographic œuvre. From that time on, it was the social realities in an increasingly industrial America that dominated her artistic work.

The Crash of 1929 had hit agriculture in the American South perhaps even harder than industry. The prices for farm products had been declining since the early 1920s, and increasing mechanization had brought unemployment to thousands of farm laborers. On top of this came the droughts that transformed once-rich farmland into deserts. According to one official estimate, in 1936 approximately six hundred and fifty thousand farmers were attempting to wring a living from almost two hundred and fifty million acres of parched and leached-out land. *A Record of Human Erosion*, the subtitle of Dorothea Lange's most important book (1939) thus bears a double meaning.

The end of a long, hard winter

Franklin D. Roosevelt's New Deal aimed at consolidating the economy, industry, and agriculture. A great variety of state measures – which admittedly first had to be pushed through Congress – finally resulted in an unparalleled state-controlled relief program. The Historical Section of the Resettlement Administration (RA; known as the Farm Security Administration after 1937) was created to propagandize the new initiative, as it were. Headed by Roy Stryker, the chief task of the Section was to document the disastrous situation in rural America. Photographers such as Ben Shan, Walker Evans, Carl Mydans, Arthur Rothstein, Russell Lee, and Jack Delano were hired for this purpose. Dorothea Lange joined the group in 1935, but left four years later after disagreements with Roy Stryker. In total the FSA bequeathed around 170,000 negatives and 70,000 original prints to posterity.

Even before starting her work for the FSA, Dorothea Lange was already actively photographing in southern California. Her husband, Paul Taylor, had been assigned by the State Emergency Administration (SERA) to investigate the situation of needy migrants in California, and his wife accompanied him to the pea harvest in Nipomo. In other words, the photographer was already familiar with the camp in which a year later, in March 1936, she would take her most famous photograph. In was the end of a long, hard, winter, she recalled – and simultaneously the conclusion of several weeks of working with the camera. She was on her way back home in the car. It was raining. A sign on the side of the road announced the camp of the pea harvesters. But, according to Lange: "I didn't want to remember that I had seen it." She drove past, but could

not put it out of her mind. Suddenly, approximately twenty miles later, she turned the car around: "I was following instinct, not reason." She drove back to the rain-soaked camp, parked her car, and got out. Already from the distance she saw the woman, a "hungry and desperate mother," an apparition that drew her like a magnet. "I do not remember," said Lange later in a conversation with Roy Stryker, "how I explained my presence or my camera to her, but I do remember she asked no questions. I took five shots, coming ever closer. I did not ask her name or history. She told me her age, that she was 32. She said that they had been living on frozen vegetables from the surrounding fields, and birds that the children killed. She had just sold the tires from her car to buy food. There she sat in that lean-to tent with her children huddled around her, and seemed to know that my pictures might help her, and so she helped me."

As early as 6 March 1936, two versions from the series appeared in the *San Francisco News* — and in response the federal government immediately ordered food to be sent to the affected region. The key image itself was first published in *Survey Magazine* in September 1936, and was included in an exhibit of outstanding photographic achievement organized by the magazine *U.S. Camera* in the same year. Dorothea Lange therefore understood full well the suggestive power of this modern Madonna. That the picture some day would be treated as an art object, however, was hardly foreseeable: the most spectacular, if not the first, auction of an early (unretouched) print of *Migrant Mother* took place in 1998 at Sotheby's in New York, where the Paul Getty Museum in Malibu, California, bid $244,500 for this 13^1/$_2$ x 10^1/$_2$-inch vintage print .

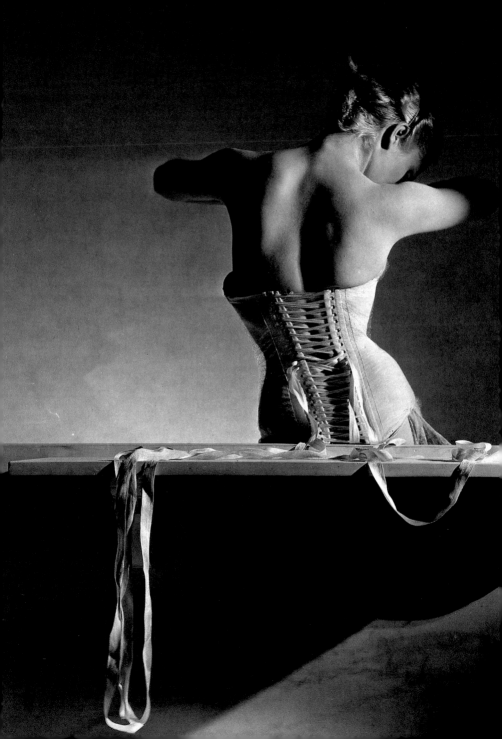

Horst P. Horst
Mainbocher Corset

1939

In August 1939, on the eve of the Second World War, Horst P. Horst took his famous photograph of the *Mainbocher Corset* in the Paris *Vogue* studios on the Champs-Elysées. The picture, which marked the end of his work for some time, later became his most cited fashion photograph.

Eros
Reined In

There's no question: it's a "great silent picture," to borrow the expression of the media scholar Norbert Bolz – a picture that literally lends form and, by means of photography, permanence to the beautiful phantasm of fashion. Many consider the photograph to be Horst P. Horst's best work – an opinion that the photographer himself would probably agree with, for otherwise, how is one to explain that he chose the motif almost as a matter of course for the cover of his autobiography *Horst. His Work and His World*? Timeless beauty, balance, an interplay of modesty and charm, eros and humility, provocation and subtle elegance are simultaneously at play in the photograph, not to mention the flattering light and dramatic shadows. After all, wasn't the photographer called a master of dramatic lighting?

Horst P. Horst photographed his *Mainbocher Corset* in the studios of the Paris *Vogue* in 1939. Only a few years earlier, Martin Munkácsi had let a model in light summer clothing and bathing shoes run along the dunes of a beach – freedom, adventure, summertime, sun, air, movement, sporty femininity – all caught by a photographic technique schooled in photojournalism. Munkácsi's picture, first published in the December 1935 issue of *Harper's Bazaar*, caused a sensation. Its carefree dynamism marks, as it were, the opposite pole to the aesthetics of a Horst – who was, after all, a man of the studio – and of well thought-out staging, in which light was more than a mere necessity to call an object forth from darkness. With Horst, there were always settings, constructions, parts of

an architecture built for the moment. Munkácsi photographed with a Leica, and the photographer moved to keep up with the moving object. Horst in contrast favored the large camera mounted on a stand and a focusing screen that allowed him to calculate his photograph down to the last detail. In other words, Horst sought to produce elegance as the outgrowth of intuition and hard work. How long did he pull at the bands, turn and twirl them, until they arrived at the right balance on an imaginary scale between insignificance and the determining factor in the picture! Roland Barthes, the great French philosopher, structuralist, and prognosticator of photography, might well have discovered his 'punctum' precisely here, that is, the apparently insignificant detail of a photograph that gives the picture its fascination and charm, and ultimately what awakens our interest. Horst P. Horst would probably have described the effect differently. Occasionally he spoke of "a little mess" that he carefully incorporated into his pictures. In later years, when he photographed the interiors of rich and prominent Americans for *House and Garden*, this 'point' might be a not-quite-fresh bouquet of flowers, or pillows on the sofa that suggested that someone had already been comfortably seated there. Or, as rumor once had it, a full ashtray – but one searches his pictures futilely for anything of the sort: even the planned accident had its limits in the productions of a Horst.

Representative of both the old and the new age

Horst P. Horst – his real name was Horst Paul Albert Bohrmann – had initially come to Paris in 1930 to work voluntarily for Le Corbusier. In fact Horst developed into the super-aesthete among the fashion photographers of the age. He seized the artistic tendencies of those years, amalgamated them into a new aesthetic rooted in traditional ideals, and thereby provided an orientation in taste for an age that was flagrantly questioning tradition across international borders. Born in 1906 in Weissenfels on the Saale River in Germany, Horst studied briefly in Hamburg at the School of Commercial Arts before migrating to the Seine, where the young, blond, handsome photographer soon felt himself at home. Significantly, it was not the impoverished bohemia of exiled Hungarians, Russians, or Avant-gardists such as Man Ray, that appealed to Horst; instead, he sought his friends

Horst. His Work and His World: *This large monograph, edited by Valentine Lawford and published 1984, gave pride of place to the* Mainbocher Corset *on the title page.*

among the exalted bourgeoisie with an interest in art, or among precisely those commercial artists who were especially successful in fashion and fashion publicity. The Baltic Baron von Hoyningen-Huene, already one of the great fashion photographers of his time, became a particularly important and influential friend to Horst. The younger photographer, well built but somewhat short, often stood as model for Hoyningen-Huene, and thus gradually established a foothold in fashion photography for himself. Unmistakable in Horst's early pictures are the influences of Hoyningen-Huene's typically polished approach to photography, oriented on geometric Art Deco principles. In addition, Horst was also clearly influenced by the photography of the Bauhaus, whose principles he often consciously adopted – without attempting to explore the limits of the medium, however, as did an artist like Moholy-Nagy, for example. Horst furthermore admired Greece and the classical world, an interest that he shared in turn with Herbert List, and was also was open to the Surrealists, without really becoming one. He always photographed 'straight', thus placing himself in the ranks of those who had overcome 'applied' pictorialism, such as was cultivated by Baron de Meyer or the early Stieglitz. Paradoxically, Horst was a representative of both the old and the new age.

Horst's work was first published at the beginning of the 1930s in the French *Vogue*. Later he devoted a book to the decade, which one can justly call his most creative period: *Salute to the Thirties*. Published in 1971 with photographs of both Horst and Hoyningen-Huene, the book oddly does not include the *Mainbocher Corset*. On the other hand, the volume includes a sensitive foreword by Janet Flanner, in which the legendary Paris correspondent of the *New Yorker* described once more the atmosphere that came to an end with the Second World War. Horst had photographed his famous study on the very eve of the coming catastrophe. "It was the last photograph I took in Paris before the war", he later recalled, "I left the studio at 4:00 a.m., went back to the house, picked up my bags and caught the 7.00 a.m. train to Le Havre to board the Normandie. We all felt that war was coming. Too much armament, too much talk. And you knew that whatever happened, life would be completely different after. I had found a family in Paris, and a way of life. The clothes, the books, the apartment, everything left behind. I had left Germany, Heune had left Russia, and now we experienced the same kind of loss all over again. This photograph is peculiar – for me, it is the essence

Horst P. Horst

Born **1906** in Weissenfels/Saale as Horst Paul Albert Bohrmann. Studies at the Hamburg School of Commercial Arts. **1930** moves to Paris. Internship under Le Corbusier. Makes the acquaintance of Hoyningen-Huene. **1931** first shots for French, **1932** American *Vogue*. **1939** moves to the USA. **1943** American citizenship. **1951** closure of the *Vogue* studios, followed by opening of own studio. Intensive work for *House and Garden*. **1961** photo series on the lifestyle of international High Society. Dies **1999** on Long Island

of that moment. While I was taking it, I was thinking of all that I was leaving behind."

Highlights and deep shadows

Horst remained the classicist among photographers. Women, he once said, he photographed like goddesses: "almost unattainable, slightly statuesque, and in Olympian peace." Stage-like settings along with all kinds of props and accessories emphasize his affinity to the classic world – although under Horst's direction, plaster might mutate into marble and pinchbeck into gold. In his best pictures, he limited himself to a few details. In our present case, a balustrade suggesting marble skillfully turns the rear view of the semi-nude into a torso. In addition, it is the light – the direction from which it falls, forming highlights and deep shadows – that gives the photograph the desired drama. "Lighting," Horst once admitted, "is more complex than one thinks. There appears to be only one source of light. But there were actually reflectors and other spotlights. I really don't know how I did it. I would not be able to repeat it." The rear view of the nude clearly looks back to the great French achievements in art – we need only think of Ingres or, later, Degas, or the nineteenth-century photographic nudes of Moulin, Braquehais, or Vallou de Villeneuve, not to mention the ancient models. Horst, however, ironically comments on the ideal of the well-formed female body in a choice pose by means of a decidedly erotic accessory, namely the corset. The suggestiveness of the pose is increased by the loosened bands that almost invite the virtual observer to enter the game of concealing and revealing. After all, there are always two involved with a corset: the woman wearing it and someone who laces it. And in terms of the effect of the photograph on a female observer, the equally elegant and relaxed staging suggests that the proverbial torture of wearing a corset cannot really be as great as it is made out to be. Few viewers notice that the wasp waist was achieved with the help of a bit of light retouching.

So here it was again: the corset. Enlightened doctors had warned against it; Coco Chanel had combated it. In the eyes of the reform movement of the 1920s, the corset was nothing less than a relict of feudal times and the expression of a highly unhealthy way of life. But now, suddenly, on the eve of the Second World War, it had reappeared. More precisely: it appeared in the fashion shows of 1939. Dresses, coats, jackets once again

Vogue *(Paris): cover of the December 1939 issue*

C'ÉTAIT HIER

showed a waist, thus making a corset a necessary item for all those for whom, as *Vogue* formulated it, things were not quite comme il faut. At first glance, it may seem absurd to attempt to locate in the corset a reference to the political situation around 1940. But fashion has always been the expression of its time, and is it not worth noting that the corset reappeared precisely at the moment when half of Europe had fallen under totalitarian rule (and the other half maintained at least sympathy for the right wing). Whatever the answer may be, the French edition of *Vogue* had the job of 'selling' its readers the idea of the corset. "Oh," said a commentary in the September issue of 1939, "stop complaining that the corset is uncomfortable. In the first place, the modern stays are well designed: one can sigh and even breathe properly. And secondly, comfort is not really the issue, but rather acquiring the bodily proportions of a siren. Or those of Tutankhamun in his golden coffin."

Making themselves useful at least through work
In the spring of 1939, Horst had traveled with Hoyningen-Huene through Greece. Upon his return to Paris, he met with Jean Cocteau and Thornton

Double-page spread from Vogue, December 1939: due to the War, neither the October nor the November issue appeared. Consequently, the unpublished pages (including the one with Horst's Mainbocher Corset) were offered in reduced format in the last issue of the year.

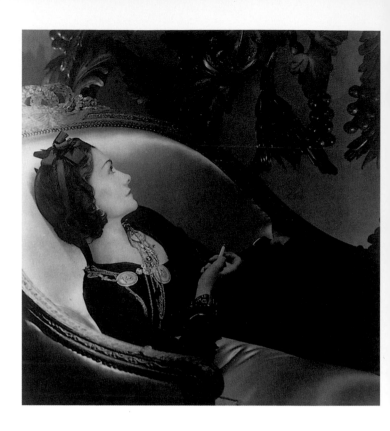

Wilder. In August he photographed the corset creation of Mainbocher. A
few days later, on 1 September, Hitler attacked Poland and the Second
World War began. Horst's photograph had actually been intended for a
Vogue special in October 1939. The pictures were ready, and the layouts
were finished. But in the present situation, did anyone still have an inter-
est in fashion? England and France had already declared war on Germany,
and *Vogue* did not appear in October. The November issue of the French
Vogue also failed to appear. Not until December was the magazine again
delivered to the kiosks. Business as usual? Not entirely. *Vogue*, too, could
not escape the shadow of war. "Must it be, you will perhaps ask, that in
these dark hours, frivolity has come in again?" asks an editorial, and then
continues: "Whoever makes this argument is forgetting that the French
clothing industry is the second most important sector next to metal-

working..." This real issue is therefore jobs and the question of proper behavior during a state of "total War." This meant "that the entire nation finds itself at war and must fight back on all fields and in all areas. Those who are not called to the dubious glory of fighting with weapons can at least make themselves useful through work..." Furthermore, the article continues, one might ask oneself whether it is not outmoded to speak now about the fashion shows from the previous August. Rarely, according to the anonymous editorial, were the fashion creations more ephemeral than in that year. "Like mayflies they lived hardly more than a single morning." To convey the readers an impression of the fashions, the editors decided to copy the already laid-out, but unprinted and undelivered, pages of the October issue. Thus Horst's *Mainbocher Corset* appears – reduced to the size of a postage stamp – on page 35 of the December issue of the French *Vogue*. By this time, the photographer was already long in the USA, and in the following year, he would apply for American citizenship. Similarly, Mainbocher, who had still managed to make an impression through "a memorable Collection" in 1939, closed its Paris house in 1940 and also moved to America. Thus Horst's magnificent rear nude unwillingly became the apotheosis of an age and of a profession. "The Thirties," as Janet Flanner later laconically observed, "were over."

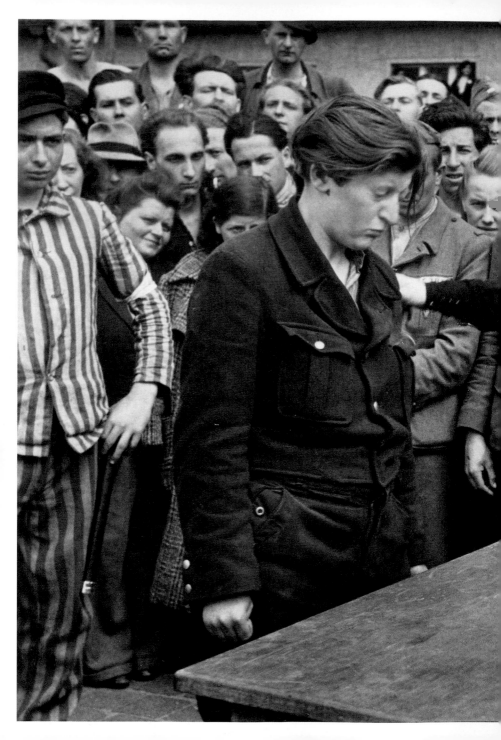

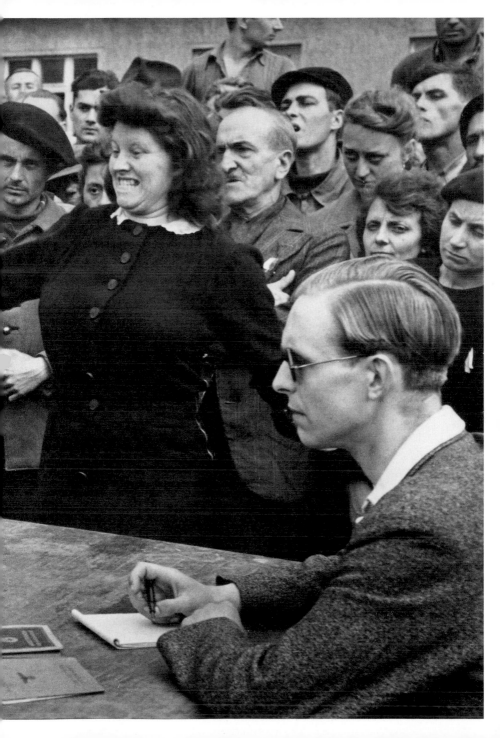

1945 Henri Cartier-Bresson
Germany, 1945

Dessau, Germany, shortly after the end of the Second World War. In a camp for so-called displaced persons, a Nazi victim suddenly recognizes a former Gestapo informant. The young Henri Cartier-Bresson was on the spot and took a photograph that became an icon of liberation and a symbol for the end of the Nazi terror.

In the end, he allowed himself to be persuaded. He knew that he was not especially good at writing, nor was he by any means a theoretician. His background was rather in drawing, painting. Throughout his life he insisted that he was a painter, that he had learned from painting, and that he saw with the eyes of a painter. He felt a strong connection to Surrealism – but only as a visually oriented person, not as a formulator of theorems and programs. In the end, however, succumbing to the pressure of his Greek publisher Tériade, he sat himself at his desk and "in five or six days" wrote it all down. "I had it already in my head from the beginning, says Henri-Cartier-Bresson, whose first great book, which also functioned as a photographic summary of decades of work, was titled thematically *Images à la Sauvette*, (literally: pictures in passing). The comparatively large volume of approximately 12^1/$_2$ x 11^1/$_2$ inches, bearing a drawing by Henri Matisse on the cover, appeared in 1952 in the Editions Verve of the legendary publisher Tériade. It would be no exaggeration to claim that it became one of the most significant and influential photographic works of the twentieth century – even if it had to wait for the English edition to unify Cartier-Bresson's work conceptually under an appropriated title: *The Decisive Moment*. The formula stood as a perfectly tailored banner over Cartier-Bresson's introduction that, as stressed by Wolfgang Kemp, "like no other text became the basis of an engaged photojournalism." It should be noted, however, that the title was originally drawn from a quotation by Cardinal von Retz; the American publisher Dick Simon adopted

the slogan for the English edition, and thus introduced the phrase into photographic theory and camera practice.

Brilliant slices extracted from the stream of time

Henri Cartier-Bresson – this "giant in the history of photography" (Klaus Honnef); "God the Father, Son, and Holy Ghost" (Roger Therond); the "greatest photographer of modernity" (Pieyre de Mandiargues); and "model for all later Leica photographers" (Peter Galassi) – was a master at intuiting critical moments. After the publication of *Images à la Sauvette*, or *The Decisive Moment*, critics have repeatedly described his work as brilliant slices extracted from the stream of time. Typically, Cartier-Bresson's photographs epitomize an event or happening just before it disintegrates or dissolves back into the flow of everyday life in a matter of seconds or split seconds. As a result, his work acquires something of a visionary, even prophetic, character. Yves Bonnefoy, for example, terms Cartier's photograph *Place de l'Europe in the Rain* (1932) nothing less than a miracle: "How was he able to recognize the analogy between the man running across the plaza and the poster in the background so quickly, how could he compose a scene out of so many fleeting elements – a scene that is as perfect in detail as it is mysterious in its totality?" He just has the feelers for it – thus Henri Cartier-Bresson explains the astounding results of his photographic activity in his typical laconic manner, adding: "I love painting. As far as photography is concerned, I understand nothing."

More a matter of style

Images à la Sauvette presents a total of 132 black-and-white photographs, with the introductory text mentioned above prefacing the plates. Although this statement was not the author's sole verbal commentary on his work, it nonetheless was, or became, his most important: in it, he presents a combination of programmatic discourse, reflection, and technical manual all in one. It is, in fact, a prescription for a 'photography in passing', and as such was adopted as a bible by legions of ambitious photographers directly after the publication of the book in the 1950s – and is still followed by photographers of today. Henri Cartier-Bresson, born in 1908 into a prosperous textile-manufacturing family in Chanteloup, France, studied with André Lhote. The purchase of his first Leica trans-

Henri Cartier-Bresson

Born the son of a wealthy family **1908** in Chanteloup/France. **1927–28** trains under André Lhote. Discovers the works of Munkácsi, resulting in a turn to photography. **1935** trains in film technique in New York under Paul Strand. **1936–39** collaborates with Jean Renoir. **1940–43** POW in Germany. **1946** first one-man exhibition at the Museum of Modern Art, New York. **1947** founder member of Magnum. **1952** publication of his book *Images à la Sauvette*. **1954** Soviet Union. **1958–59** China. **1960** Cuba, Mexico, Canada. **1965** India and Japan. **1967** culture Prize of the DGPh. **1970** marriage to Martine Franck. Dies **2004** in Céreste/France.

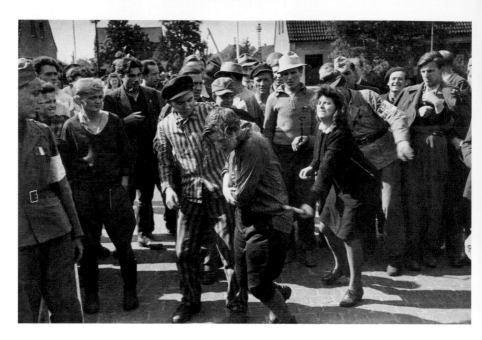

The Decisive
Moment: *The English
title of his book from
1952 was program-
matic for Henri Car-
tier-Bresson's œuvre.
Despite this, he also
frequently produced
sequences with a cer-
tain cinematic quality
when closing in on an
event.*

formed him into an indefatigable chronicler of his times, and he is justly
seen as one of the most influential and productive photographers of the
twentieth century. Each of his published photographs appears to be an
apparently effortless proof of his credo: "I like my pictures to be clear, or
better, climactic... This is more a matter of style than technique." To con-
jure an event at its culmination point onto celluloid – this is the magic
that his name still epitomizes today. Although Henri Cartier-Bresson did
journalistic reports, published essays, and produced photographic
sequences, he is above all the master of the single picture, in which a
theater of the world presents itself in microcosm.

Germany, 1945 – Our picture's official short title, more or less authorized
by Magnum – appears on pages 33–34 of *Images à la Sauvette*. The pic-
ture is therefore a double-spread, running across the gutter. Lincoln
Kirstein and Beaumont Newhall had taken note of this work as early as
1947, including it both in the first large post-war exhibition of the photo-
grapher's works at the Museum of Modern Art and also it in the slim
catalogue (on page 40) accompanying the show. The photograph has
also appeared in almost all subsequent retrospective monographs, the

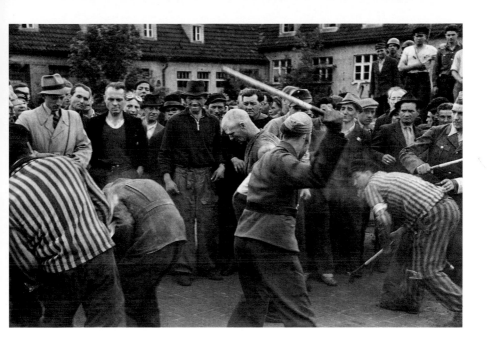

most prominent probably being Cartier-Bresson's large interim collection of photographs published in 1979 by Delpire under the simple title *Henri Cartier-Bresson photographe*. Here the famous work was of course included, along with many other classics such as *Rue Mouffetard, On the Marne*, and *Sevilla*. The ubiquity of the photograph has doubtless contributed to turning it into one of his best-known works. Moreover, the picture numbers among those deemed worthy of fuller commentary by the photographer. Thus, on the reverse of the key picture bearing the archive number HCB45003 W00115/25C, one finds the word: "Dessau. Border between American and Soviet zone. Transit camp for former prisoners held in eastern German area: political prisoners, prisoners of war, slave labor, displaced persons. A young Belgian woman and former Gestapo informer is recognized before she can hide herself in the crowd."
Dessau, a middle-size city north of Leipzig in today's Saxon-Anhalt, which had made an international name for itself before the war as the home of the Bauhaus school. We do not know precisely when Cartier took the picture – the photographer himself never spoke willingly about his work – but the date must have been between 21 April and 2 July 1945 – that is,

A further (scarcely known) motif from the Dessau-Kochstedt series dating from April through July 1945

between the American occupation of the city and the arrival of their Russian replacements. The location is the former anti-aircraft barrack in Dessau-Kochstedt, which functioned as a transit camp during the occupation. The building, partially visible in the background, had been dedicated under the Nazis in 1937 and would later be used by the Soviets as a barrack until the unification in 1989; today the area is a housing development. On this spring day in 1945 the sky is cloudy, the light, diffuse. The sun breaks through only occasionally, casting long shadows that might indicate afternoon; more probably, however, it is morning. Cartier-Bresson in any case was carrying his Leica, fitted with a 50-mm lens. By deduction, this means he was standing about ten feet away from the protagonists – close enough to capture the event, but also far enough to do obeisance to his preferred policy of not interfering. "One must creep up to the subject on tip toes," he once said, "even when it involves a still life. One must put on velvet gloves and have Argus eyes. No pushing or crowding: an angler doesn't stir up the waters beforehand."

Henri Cartier-Bresson: Images à la Sauvette. *The French first edition of his classic book appeared 1952, produced by legendary publishers Tériade with a dust jacket from Henri Matisse.*

At the time of the photograph, Cartier-Bresson was thirty-six years old with an international reputation as a photographer, though he certainly had not yet approached the cult status that he definitively achieved with the publication of *Images à la Sauvette*. Meanwhile, in the USA Kirstein and Newhall were preparing a "posthumous retrospective" for the photographer, presuming him to have been killed in the war – an assumption not at all far-fetched, when one recalls that Cartier-Bresson had been an active resistance fighter. Captured and interned by the Germans in 1940, he had escaped only on his third attempt three years later. At this point, in 1945, however, he was in fact working with the Americans on a film for the Information Service about the home-coming of French prisoners of war. "It was a film by prisoners about prisoners," as Cartier-Bresson recalled. "The scene played itself out before my eyes as my cameraman was filming it. I had my photography camera in my hand and released the shutter. The scene was not staged. Oddly, this picture doesn't turn up in the film."

The setting for a scene that became famous
This was not the first time that Cartier-Bresson conducted filming work and photographic work in parallel. One needs only to recall his famous

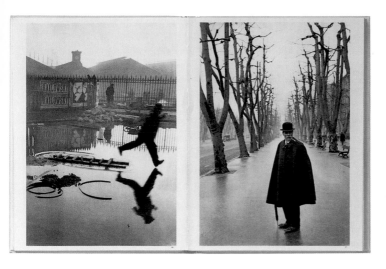

Double-page spread from Images à la Sauvette: Place de l'Europe in the Rain, Paris, *1932, and* Allée du Prado, Marseille, *1932*

picnic *On the Marne*, created while he was an assistant director to Jean Renoir (*La vie est à nous, Une partie de campagne*). But whereas *On the Marne* has nothing to do directly with the filming, in Dessau the photographer and his cameraman are shooting one and the same scene simultaneously, even if the film does not contain the 'most decisive' moment captured by Cartier-Bresson. *Le Retour*, as has been mentioned, was being made at the behest of the Office of War Information and the French Ministère des Prisonniers. The black-and-white film runs 32 minutes and 37 seconds, with a commentary in French spoken by Claude Roy in the original version includes. *Le Retour* opens with footage taken in Dachau in late April 1945 by the American troops who had liberated the concentration camp. Following these scenes are shots of freed prisoners, straggling soldiers, refugees wandering about in a daze – all of whom, according to the narrator, were causing chaos on the roads and hindering the sweep of an Allied victory. As a result, camps to contain these people were set up in occupied barracks, factories, and private houses. Cut. The film camera now does a long shot of a large interior courtyard that is about to become a stage of the scene made famous by Cartier-Bresson's photograph. We are looking at a crowd of several hundred people. In the center, a circular area has been cleared. In the background is the high gable roof of the former barrack, some of whose windows can also be

made out in Cartier's photograph. To the lower right in the picture is the table to which – cut and medium close-up – a young woman wearing dark breeches, light-colored wool socks almost up to the knee, and flat shoes is led. She walks with a stoop. With a serious expression and hanging head, she steps up to the table at which the accusation against her – whatever it is – is about to be processed. The young man on the left with sunglasses and parted hair raises his finger and seems to give a warning. His name is Wilhelm Henry van der Velden, a twenty-two-year-old Netherlander, who had been studying medicine until he, like his brother Karel, was interned in February 1943 in the Dutch concentration camp Westerbork. Now, at the behest of the Americans, he has been appointed commandant of the camp at Dessau, through which thousands of people are making their way daily, from West to East or vice versa. Above all, explains the commentary accompanying the film, it is necessary to be keep a careful watch out "for that handful of vile beings who were attempting to disappear amid the flood of deportees – to return home to 'business as usual'." The woman in the high-buttoned dark dress, who assumes a central position in a double sense of the word in Cartier's picture. is still standing several yards away on the right edge of the picture. But – cut and quarter close-up – now she, a Frenchwoman, moves up to the table, her arms still folded across her chest, a light colored purse dangling down. The commentary speaks of denunciators, Gestapo stooges, torturers, who will surely be turned over by those whom they had earlier betrayed. Again cut. The camera has now closed in on the two women. The one on the right addresses the other, screams at her: Yes! You helped the Gestapo, you are an agent. She lifts her arm and strikes, hitting the other woman in the face so that the accused is literally thrown out of the picture. Seconds later she re-enters, arranges her hair, looks briefly and confusedly at her 'torturer', bleeding at the nose. The sequence lasts exactly three seconds in the film; Henry Cartier-Bresson's exposure may have lasted 1/60 of a second.

The decisive moment of revelation
Cartier-Bresson remembered the film correctly when he said that the scene he caught with his camera does not appear. Speculation as to whether his picture was therefore staged are quickly laid to rest, however, when one takes a closer look at the crowd of observers in the back-

ground. Consider for example the young man wearing his beret at a slant: in the film, his belt buckle is enclosed within his left hand – exactly in the same position that can be seen between the two women in Cartier-Bresson's photograph. A peripheral detail such as this would hardly find its way into a scene set up later. Why then did the film camera not capture the precise moment of identification? Chronologically, Cartier's photograph lies between the third and fourth scenes of the film. That is, the woman has not yet been identified as an agent, and the blow has not yet been struck, or she would be visibly bleeding from the nose in the photograph. Perhaps the critical moment fell victim to cutting and editing or, more likely, the cameraman – who must have been standing almost elbow-to-elbow with Cartier-Bresson – was changing the lens to capture what followed close-up. In any case, the cameraman caught the subsequent activity on film; Cartier-Bresson, however, got the more truly 'decisive moment': that of revelation, of identification, of the instant in which past, present, and future – the memory of sorrow, and painful recognition, and furious response – come together. The distorted face of the former victim, now become a perpetrator, mirrors the tension of the tense situation.

For a long time afterward, Henri Cartier-Bresson reported, he received questions and letters containing a cut-out of the photograph, with a cross over one or another of the persons in the background together with the plea: "That is my brother, that is my father – please tell us where he is now! How can we find him?" Let us look at the facts: at least ten million foreign prisoners, foreign workers, and deportees were wandering through Germany as 'displaced persons' in the years following 1945. Thus the photograph also assumed a thoroughly pragmatic function in the decades following 1945. Artistically, the picture has survived because of its "emblematic value," as Jean-Pierre Montier has expressed it. In the face of historical fact – after all, there was no concentration camp in Dessau itself – Cartier-Bresson's photograph came to function as a symbol of the liberation: in our collective pictorial memory it has come to stand for the opening of the concentration camps and liberation from terror.

56 **Richard Peter sen.** View from the Dresden City Hall Tower

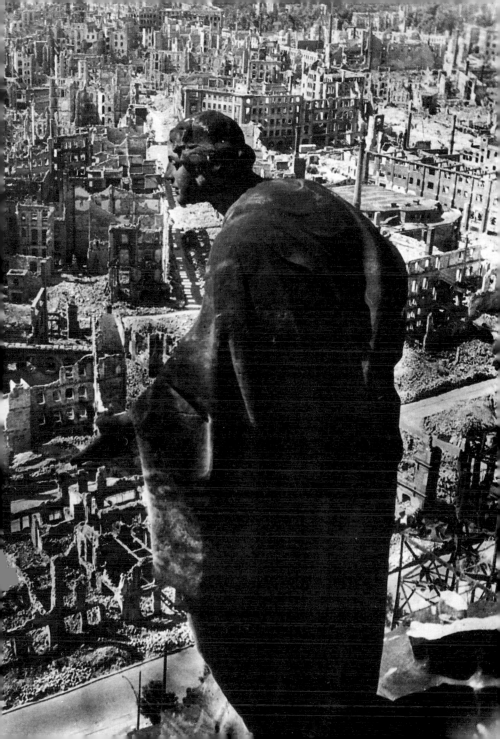

1945

Richard Peter sen.
View from the Dresden City Hall Tower Toward the South

Angel
Above the
City

Immediately after the end of the war, the Dresden photographer Richard Peter sen. started an ambitious cycle on the demolished city that had once been known as the "Florence on the Elbe." By the end of the 1940s, he had completed approximately a thousand photographs, including this famed view from the City Hall Tower looking toward the south.

Almost miraculously, the tower of the New City Hall, dating from the mid-eighteenth century, survived the firestorm of 13–14 February 1945. Not that it had totally escaped being damaged in the inferno, of course, but compared to the Zwinger palace or the Frauenkirche, whose former glory now lay buried under the ruins, the City Hall, located between the Ringstrasse, the City Hall Square, and Kreuzstrasse, was at least reparable. The east wing of the building had been particularly heavily damaged by fire bombs and blockbusters, but the tower, visible from a great distance, still remained standing, its hands stopped at 2:30 a.m. At a height of more than 325 feet, the tower was the tallest building in the city, but had lost its cupola. All that remained of it was a filigree-like skeleton, crowned by Dresden's recently adopted municipal emblem – a sculpted male figure in gilded bronze by Richard Guhr, which now seemed to be balancing as if on a tightrope. The famous double staircase had also survived the force of the demolition and firebombs. Richard Peter sen. climbed these steps for the first time in the middle of September 1945.

Nearly six square miles completely devastated
The photographer, well known in Dresden, was not the only one to make his way to the top of the City Hall Tower after the war had ended, how-

ever. The collection of the German Fotothek Dresden contains numerous views of the city taken from the tower – or rather, views of what remained of the "princely Saxon residence" (Götz Bergander), "famed throughout the world as a treasure chamber of art" (Fritz Löffler), the city that had once been the Florence on the Elbe. In all these photographs, the view was always shot over the shoulder of one of the figures sculpted by Peter Pöppelmann or August Schreitmüller, looking down onto the landscape of ruins. It is just this opposition – between personified virtue and death, light and darkness, proximity and distance, height and depth – that lends the photographs by Ernst Schmidt, W. Hahn, Wunderlich, Döring, Willi Rossner, and Hilmar Pabel their excitement, their suggestive power, and their memorial value.

Although some of these photographs may differ in their manner of presenting the subject, we may rest assured that it was Richard Peter's square photograph that inspired the others to find their way up the tower of the City Hall located in the south-east of the old city. In any case, Richard Peter's photograph was indisputably the first of an entire series of similar motifs – an image that bequeathed the world a valid pictorial formula for the horror of the bombing in general and of the destruction of the Baroque city of Dresden in particular.

The fire-bombing of Dresden is often compared with the dropping of the atom bombs on Hiroshima and Nagasaki. In the totality of the destruction and the number of victims – as well as in the sense of being a 'fitting' symbol for the times – all three catastrophes have much in common. On 13 and 14 February 1945, 'merely' three attacks, each by several hundred Lancaster bombers, Mosquitoes, Liberators, and Halifax planes of the Royal Air Force, sufficed to extinguish the strategically unimportant but historically unique center of the historic city of Dresden. The number of the victims is still disputed today, but estimates begin at more than 30,000; the exact figure will never be known, because many victims were instantly cremated. Furthermore, as pointed out by Adelbert Weinstein, the "already buried dead could in any case no longer be excavated from the cellars in this landscape of ruins. Because of the danger of epidemics, the rescue troops were even forced to wall up the make-shift bunkers or to burn them out with flame throwers." The damage to the buildings, on the other hand, can be statistically compiled. A surface area of nearly six square miles was completely devastated. Seven thousand public build-

Richard
Peter sen.

Born **1895** in Silesia. **1912** examination to become a journeyman smith. **1916–18** called up for WW I. From **1920** politically active in the German Communist Party. **1924** first camera reports for *Roter Stern* (later A.I.Z.). **1933** prohibited from practicing his profession. **1939** conscription. **1945** returns to Dresden. Archive is lost during the bombing. Involved in rebuilding the East German press. Founder editor of the glossy *Zeit im Bild*. **1946–49** photographic chronicles of destroyed Dresden and its reconstruction. From **1955** turns to calendar and book illustration and trade fair photography. Dies **1977** in Dresden

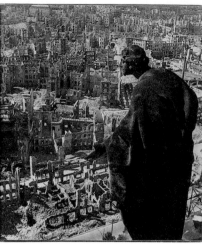

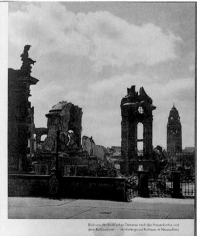

Blick von der Brühl'schen Terrasse nach der Frauenkirche und
dem Rathausturm — im Hintergrund Rathaus im Neuaufbau

Double-page spreads from Peter's Dresden book.
The book appeared in an astonishingly large edition for the time – 50,000.
Today it is regarded as one of the classic photo books on the war ruins.

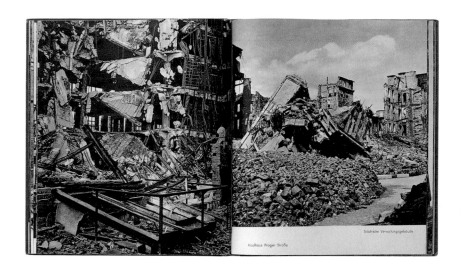

Kaulhaus Prager Straße

Städtische Verwaltungsgebäude

DER TOD ÜBER DRESDEN

Die Tragödie der geöffneten Keller darf der Menschheit
bei der Gewissensfrage – Krieg oder Frieden? – nicht vorenthalten bleiben.

ings – museums, churches, palaces, castles, schools, hospitals – lay in ruin and ashes. Of the city apartments, 24,866 of 28,410 fell victim to the bombing attack. More than thirteen million cubic yards of rubble had to be cleared away before reconstruction – still continuing to this day – could begin.

In the years following war, Richard Peter sen., born in Silesia in 1895, was one of the many photographers who sought a pictorial response to the apocalypse that had ended in Europe in May 1945. Parallel to the often-discussed *Trümmerliteratur* (literature of ruins), one may also speak of a regular 'photography of ruins' – the scenes of destruction offered by every larger German city to its own pictorial chroniclers: Friedrich Seiden-stücker and Fritz Eschen in Berlin, Herbert List in Munich, Wolf Strache in Stuttgart, August Sander in Cologne, Karl Heinz Mai in Leipzig. Photo-graphically important after 1945 were especially the cycles by Hermann Claasen and Richard Peter sen., whose books *Gesang im Feuerofen* (1947; Song in the Furnace) and *Dresden – eine Kamera klagt an* (1949; Dres-den: A Camera Accuses) were among the most-discussed publications of the post-war period.

Richard Peter: Dresden – eine Kamera klagt an (Dresden: A Camera Accuses). *Cover of the original German edition of 1949*

A feeling of emptiness and stillness

Not until seven months after the inferno – that is, only on 17 September 1945 – did Richard Peter sen. return to Dresden, his adopted city of resi-dence. Not only did he find the city in which he had lived since the 1920s, and where he had worked as a photojournalist with the legendary *A.I.Z.*, completely devastated, but also his own pictorial archive containing thou-sands of plates, negatives, prints, the sum of thirty years of photographic work, had been destroyed beyond repair. With a Leica that someone gave him as a gift, he set out once more to photograph: ruins, urban 'canyons', car wrecks, and finally the corpses in the air raid shelters, which began to be opened in 1946. This work occupied him for more than four years. Among the thousands of pictures he created was his *View from the City Hall Tower*, on which Peter worked for a full week, according to his own report.

"Rubble, ruins, burnt-out debris as far as the eye can see. To comprise the totality of this barbaric destruction in a single picture," as Peter himself described the creation of the photograph, "seemed at most a vague possibility. It could be done only from a bird's eye view. But the stairs to

almost all the towers were burned out or blocked. In spite of the ubiquitous signs warning 'Danger of Collapse,' I nonetheless ascended most of them – and finally, one afternoon, the City Hall Tower itself. But on that day, the light was from absolutely the wrong direction, thus making it impossible to take a photograph. The next day I climbed up again, and while inspecting the tower platform, discovered an approximately ten-foot-high stone figure – which could not in any way be drawn into the picture, however. The only window which might have offered the possibility for this was located around 13 feet above the platform, reachable only from inside the tower. Two stories down, I found a 16-foot stepladder that someone may have carried up after the fire to assess the extent of the damage. The iron stairway was still in good repair. How I managed to get that murderous ladder up the two stories remains a riddle to this day. But now I was standing high enough over the figure [to photograph] and the width of the window also allowed the necessary distance. The series of exposures made with a Leica, however, resulted in such plunging lines, that the photographs were almost unusable. In this case only a quadratic camera could help, but I didn't own one. After two days, I finally hunted one down, climbed the endless tower stairs for the third time, and thus created the photograph with the accusatory gesture of the stone figure – after a week of drudgery effort and scurrying about."

Peter's photograph appeared in *Dresden – eine Kamera klagt an*, published in 1949 in the former German Democratic Republic with a first run of fifty thousand copies. That the cropped figure in the picture is not the angel of peace, but the personification of 'Bonitas', or Goodness, does nothing to diminish the symbolic character of the photograph. The fact that streets were by then largely cleared of debris and rubble even increases the feeling of emptiness as well as the stillness, which for many people was the most striking characteristic after capitulation in May 1945. Wolfgang Kil once described Richard Peter's completely subjective images, which were intended as affective warnings, as "landscapes of the soul." In these pictures, an entire generation found their experience of the war visually preserved.

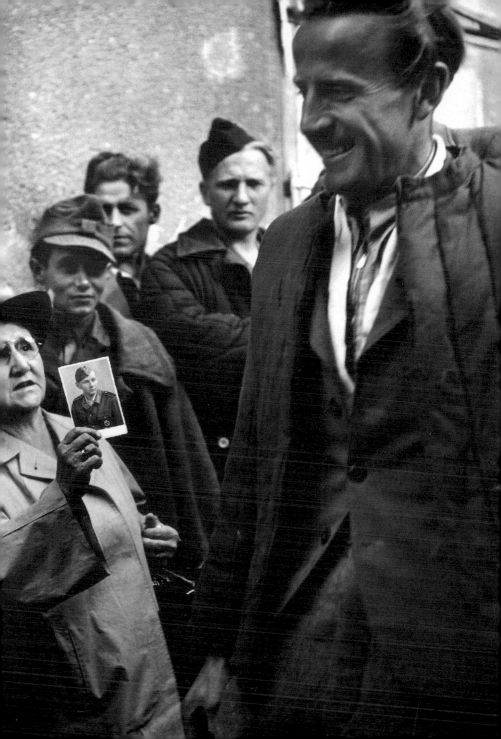

Ernst Haas
Vienna

**Waiting for
a Miracle**

**Until the mid-1950s, the release of German solders
from Allied imprisonment formed one of the major
themes of the growing post-war press in Germany and
Austria. The work of the young photographer Ernst
Haas not only made an important contribution to the
issue, but also carried him to international fame.**

He admitted to a good many credos concerning photography. One can
hardly claim, however, that the majority of his photographic declarations,
delivered in numerous quotations and bon mots, are wholly free from
contradiction. Nonetheless, there is one principle that may well be said to
have reigned supreme throughout his professional career. Pictures, he
once said, are like music: "They communicate themselves immediately,
without any interpretation." The ideal and the real do not always or neces-
sarily coincide, but in the work of the native Viennese photographer Ernst
Haas, the dictum is fulfilled. His photographs – initially in black-and-white,
later in color – exemplify the notion of a 'universal' photographic lan-
guage, a concept which in turn helps to explain the unequalled success of
his free yet firm position in the realm of applied photography – which is to
say: advertising. Wherever it was necessary for pictures to operate sug-
gestively, without an accompanying explanation, Haas was the photo-
grapher of choice. A seducer of the visual realm, Haas saw himself as an
artist, as a poet-photographer, and in precisely this role he was taken as a
model by an international community of amateur photographers during
the 1960s and 1970. His major work, *The Creation* – the outcome of his
contributions to John Huston's epic *The Bible* in book form – sold more
than 350,000 copies. In 1958, *Life* devoted a segment of no fewer than
thirty-six pages of Haas's photographs in an article on "Magic Color in
Motion" in 1958 and, following the trend, the magazine *Popular Photo-
graphy* included him in its list of the world's ten best photographers. Sim-

arly, *twen*, the German trend magazine of the 1960s, also turned to work by Haas when it decided to introduce color into its publication (6/1961). The unheard-of success and influence of the color pioneer Ernst Haas – who was invited to present the first one-man exhibit of color photography in the history of the New York Museum of Modern Art at the initiative of Edward Steichen – make it easy to forget that Haas's roots really lay in photojournalism. Haas had, however, turned away from reportage photography in the widest sense quite early in his career, and later even took to mocking it. "The reporter," he once said, "is someone in a trench coat with a rakishly upturned collar, who runs after events, wants to capture facts, narrates, reports on so-called reality. To be honest, I am not too interested in facts. My issues are of a more artistic nature. These are rather more the problems of the painter. I'm a painter who was too impatient to paint, and therefore became a photographer." And it is true: Haas's experimental work with color shoved his early photographic reports more or less into the background – except for his documentary work on the return of former prisoners of war, which, along with Robert Lebeck's later photo report *Revue* 43/1955), became one of the best known of its genre, and gained Haas entry into the illustrated magazine *Life* as well as membership of the Magnum group. Critics rank his "picture-story on the first repatriated prisoners" to be among the "most powerful pictorial documents of the post-war period." The photograph of course appears in the large, two-volume history of the Magnum agency – even though Haas was not yet a member of the legendary cooperative at the time he took the picture, and was no longer a member when the book was published. In Cornell Capa's catalogue on the thematic exhibit "The Concerned Photographer 2," Haas's photograph of the questioning mother is the feature picture to the chapter on Haas. In his own important photographic volume *Black and White*, Haas also gives prominence to the picture. The photograph has been printed numerous times and has become a part of our collective memory. It even turns up in narrative literature, as for example in Christoph Ransmayr's novel *Morbus Kitahara* (1995), where "pictures of those who disappeared are held out like trumps in a card game against death."

Ernst Haas

Born **1921** in Vienna. Studies medicine without finishing. **1943–49** works in a photographic studio in Vienna. **1949** first large photo-sequence in *Heute*. Accepted in the same year by Magnum. **1951** moves to the USA. Gives up photo-reportage and turns to photographic essays in colour. Publications in *Life, Look, Holiday, Vogue, Esquire, Paris-Match, Queen, Stern, Geo.* **1958** chosen as one of the "World's ten greatest photographers" by *Popular Photography*. Also film stills (from **1954**), cinematography (from **1964**) and advertising (especially Marlboro). **1971** publication of his book *The Creation*. **1972** culture Prize of the DGPh. Dies **1986** in New York

A remarkable humanitarian and charitable performance

A picture within a picture: the photograph of a young man or, rather, a nearly grown-up child in uniform. The photograph forms so to speak the

center of the black-and-white composition, which, taken with a Rolleiflex, was originally square in format. In addition, six more faces can be made out. But the men in the background function rather like the super-numeraries in the small tragedy that was repeated thousands of times in German train stations between 1945 and 1955. The question always hanging in the air is about the whereabouts of another human being, a son. The conventional half-portrait with its traditional deckle-edge, which once had been made for remembrance, now became a kind of 'wanted' photograph, or better a search photo – a phrase that will virtually become a technical term in connection with the work of the Red Cross in the course of the largest identification campaign in history. In 1946 the photojournalist and former war correspondent Hilmar Pabel had begun to take portraits of displaced children for the sake of helping to locate their relatives; Erich Kästner published the photographs in his magazine *Pinguin*. Later, the Red Cross joined the effort with large-scale poster campaigns, and finally in 1951 began an organized research based on filing cards that were able to clarify the fates of more than a million missing persons – a remarkable "humanitarian and charitable performance" that owed much of its success to the medium of photography, and which was awarded the Culture Prize of the German Society in 1975 – three years after Ernst Haas himself had accepted the award.

The confidence and the desire to rebuild

Whereas the Red Cross pursued its well organized investigative work in grand style, Haas confronts us with a form of individual research that had become a routine of daily life for countless people in central Europe after

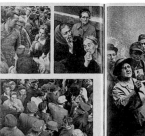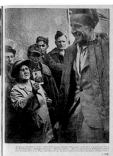

1945. Haas made his photograph in the train station Vienna South in 1947. The photographer consciously focused on a single detail of the scene and excluded the surrounding situation. This concentration has made the picture into a timelessly valid icon, in which the complex history of the period following 1933 is reduced to a simple and moving act of searching and finding. Concretely, the photograph depicts the encounter between two people. On the one hand there is the mother with her questioning and anxious gaze. On the other, there is the returnee who – so we suspect – has already identified his family beyond the edge of the picture. He is beaming. He takes a quick step forward. His posture and gestures, his facial expression, his unseen hand clutching the handle of a bag – all are expressions of confidence and the desire to rebuild. He doesn't even give a passing glance to the short woman who stands as an example for those who lost so much, perhaps all, during the war and the Nazi period. In this way the photograph unites the two realities of post-war society.

Scenes of happiness and moments of disappointment

A total of more than eighty million soldiers were involved in the Second World War. Thirty-five million, including a good eleven million Germans, were incarcerated as war prisoners between 1939 and 1945. The first German prisoners returned home in 1948, the last in 1956. These later came back to a country – or rather: countries – that were already long on the way to an increasingly prosperous everyday life. Often these 'late arrivals' were disturbed by the "'normalcy' that had been achieved with such effort" (Kaminsky). It is no accident that Wolfgang Borchert's drama on this theme, *The Man Outside*, became one of the most discussed works

of the period. But aside from this piece, the problem was treated only rarely in literature and the fine arts. The young Ernst Haas, born in 1921, also came upon the theme somewhat by accident. At that moment, he was accompanying the later Magnum photographer Inge Morath through war-ravaged Vienna looking for a location to shoot a fashion spread. At the train station he ran into a crowd of people awaiting the arrival of the first six hundred Austrian war prisoners to return from Eastern Europe. "It broke one's heart," Haas later recalled. "No one knew who would be arriving. Tension and silence lay on the square until the first prisoners appeared, as if on a stage. What happened now could only be captured with the camera. I worked as if demented... Scenes of happiness gave way to moments of disappointment. Impossible to grasp all of it. Women held bleached-out photographs in the air toward the new arrivals. 'Do you know him? Have you seen my son?' They called out the names of their men. Children with pictures of fathers they had never seen compared the photographs with the faces of the arrivals. It was almost too much. I staggered home as if in a trance."

Heralded his international break-through

Haas had begun studying medicine, but his Jewish background debarred him from completing his studies. After the war, influenced by the work of Werner Bischof, his slightly older contemporary, Haas took up photojournalism. In the months after his experience at the train station, he continued to pursue the theme. As Jim Hughes writes, he accompanied transport after transport with the camera, and finally arrived at his first great photojournalistic report. Haas's work appeared for the first time in 1949 in *Heute*, an illustrated magazine published by the American military government beginning in 1945. Warren Trabant, the chief director of the magazine, was impressed with the work and devoted four double pages to it under the title "And the Women Are Waiting..." (No. 90, 3 August 1949). It was an expansive layout, clearly influenced by *Life*. Haas explained: "I did the layout myself, and because I always came with a proposal and sketches, they just followed along." Trabant, who had initially worked at *Life*, passed the article on to the USA, where it appeared a week later in *Life* in a double-page spread that provided Haas with his international break-through. "Groups of the repatriated," runs the caption under the photograph in *Heute*, "are surrounded by hundreds of

people; well-worn photographs are held up toward them, and those without a picture call out constantly 'Who knows so-and-so? Who knows something about ...?' Some shake their heads silently, while others who have in fact spied a relative in the crowd, step across with eyes that are so happy, they cannot take in any more."

Pictures of repatriated soldiers are a natural part of the world of the post-war German and Austrian pictorial press (which remained under Allied censorship until the lifting of the license requirement in 1949). The Munich illustrated *Heute* carried an article entitled "Return from Russia" as early as 1946, and a four-page photographic report appeared in the Austrian edition of *Stern* as late as October 1958. In France, the already-mentioned photo report by Robert Lebeck on the return of the last war prisoners from Russia had appeared under the headline "Thanks Be to God" in 1955 as the title-story in *Revue*. Admittedly, none of these articles achieved the broad and enduring effect that Ernst Haas had reached with his key picture. His photograph unites joy and pain, hope and sorrow, immediate happiness and an extended waiting for a miracle as fundamental categories of human existence. He had wanted, Haas stated in a later interview, to portray "the woman as the true 'Unknown Soldier'". He did not speak to her, however, or inquire further into her fate.

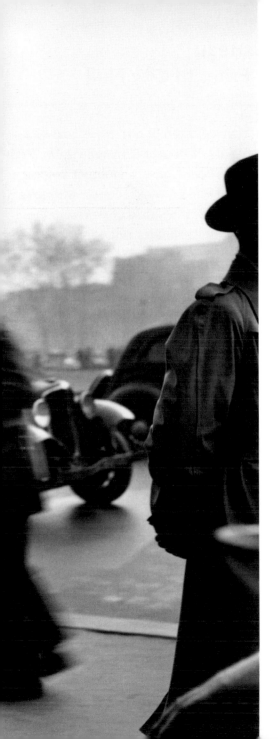

1950 Robert Doisneau
The Kiss in Front of City Hall

**Love on a
March Day**

**There is scarcely a photograph of our times that has
achieved the popularity of Robert Doisneau's *The Kiss
in Front of City Hall*. The image of a fleeting embrace
has become an icon of Paris par excellence. Moreover,
as a gripping metaphor of the sense of post-war life,
the photograph brought its creator not only fame and
wealth.**

This time, he dared to come in closer. Usually, however, he kept his dis-
tance and tried to remain unnoticed. Robert Doisneau was fond of citing
his intrinsic shyness as the reason for his restraint as a photographer.
Making necessity a virtue, he had eventually transformed keeping his dis-
tance into a pictorial style that applied to the entire social and architec-
tural environment of the city. Doisneau is the photographer of the big
picture, so to speak, and is thus the antithesis of a William Klein, who
consciously intermingles with the people he photographs, seeking close-
ness and interaction, letting it be known that he is a photographer,
provoking reactions, and thus turning the very act of taking the picture
into the theme of the work. But if the French term *chasseur d'images*
– literally, picture hunter – is recognized throughout the world as a de-
scription for the action of the photographer, Robert Doisneau always
understood himself in contrast as a *pêcheur d'images*, a fisher of images,
that is, a photographer who waited patiently until the stream of life cast
its more or less rich booty before his feet – a "bystander" (Colin Wester-
beck), who lifted discretion to a pinnacle and placed it at the heart of all
his work. In this sense, Doisneau has entered the history of photography
as the master of the 'candid camera'. Or rather, he would have liked to
have been so recognized, if a widely publicized series of international law
suits toward the end of his life had not revealed that he – Doisneau him-
self – had helped set up the events that are depicted in his photographs.

In any case, what is probably his most famous picture, *The Kiss in Front of City Hall*, was, as we now know, the result of a scene staged with the help of a hired actor and actress. But what does this fact mean for the reception and understanding of a photograph that functions as a 'popular icon' and is one of the most well-known photographic creations of its century?

A staple of every Doisneau retrospective

According to unofficial statistics, *The Kiss in Front of City Hall* has been sold more than two and a half million times as a postcard alone. In addition, around half a million posters bearing the same motif have found buyers. The picture decorates pillows, handkerchiefs, wall and table calendars, greeting cards, and fold-out picture series. Furthermore, it is a staple of every Doisneau retrospective, and not accidentally adorns the cover of the artist's most important publication to date, *Three Seconds from Eternity*. Visitors to Paris come across some form or another of this image on almost every street corner. The question arises: why does this comparatively simply constructed and relatively unspectacular photograph still fascinate the public today.

At the exact center of the square photograph is a young couple, about twenty years old. Quite frankly, there is nothing at all striking about them. They are decently dressed – appropriately for the street. At most, the bright scarf tucked into the neck of the man's double-breasted suit is the only item lending a bohemian flavor to the Right Bank of the Seine. Approaching from the left, the couple is moseying its way down the busily populated street. The man has placed his right arm around the girl's shoulder. Spontaneously – so the picture suggests – he pulls her toward himself and kisses her on the mouth. None of the other pedestrians visible in the picture seem to have noticed the sudden testimony of love. At most the observer in the foreground witnesses the little scene. The consciously chosen 'over-the-shoulder' shot, to borrow a term from filmmaking, suggests this at least.

One of those 'undecided' winter days in Paris

Why Robert Doisneau set this scene in the vicinity of the Paris City Hall, we don't know. In reality, the other bank of the Seine – in particular the Latin Quarter inhabited especially by students – stood for carefree happiness after the war: it was no accident that the Netherlander Ed van der

Robert Doisneau

Born **1912** in Gentilly/Val-de-Marne. **1929** diploma as engraver and lithographer. **1930** commercial photographer for Atelier Ullmann. **1931** assistant to André Vigneau. **1932** first reportage in the illustrated daily *Excelsior*. **1934–39** works as advertising and industrial photographer for Renault. Active in the Résistance. **1946** joins the agency Rapho. **1949** book publication *La Banlieue de Paris* (with Blaise Cendrars). **1949–52** fashion for French *Vogue*. Afterwards freelance photographer in Montrouge near Paris. **1992** major retrospective in the Museum of Modern Art, Oxford. Dies **1994** in Montrouge

Elsken chose the Rive Gauche as the location for his probably most important work in the mid-1950s: *A Love Story in Saint-Germain-des-Prés*. But Robert Doisneau determined upon the Right Bank. Blurred but clearly recognizable, the neo-baroque Paris City Hall stands in the background of the busy street, which must therefore in fact be the rue de Rivoli. The street cafe from which the picture was taken may well be what is today the Café de l'Hôtel de Ville, on the corner of rue du Renard and rue de Rivoli. Doisneau shot the picture with his Rolleiflex looking out toward the street from the second row of tables. The woman walking by in the background has noticed him, her glance giving also the photographer a presence in the picture.

In monographs, the photograph has repeatedly appeared under the title "Sunday." But in fact there is no indication in the picture itself that it is Sunday: we simply associate the idea of a stroll through the city with Sundays and holidays. Doisneau himself dated the photograph March 1950. It must, therefore, have been taken on one of those 'undecided' winter days in Paris: neither cold nor warm, certainly not sunny, but dipped rather in that diffuse light that Doisneau once described as typical of Paris – the light that is part of the perpetual "tender gray tent that the famed sky of the Île-de-France [begins] to unfold at daybreak as one would pull a protective cover over valuable furniture."

Always looking for an eloquent moment

Doisneau's photograph was published for the first time in the legendary illustrated magazine *Life*. At that time, this son of a petty bourgeois Parisian family was thirty-eight years old. At the École Estienne he had learned the craft of engraving, and afterwards had become acquainted with the innovative tendencies of the New Objectivity movement in photography at the studio of André Vigneau. Subsequently Doisneau accepted his first position – admittedly an unsatisfactory one for him – with Renault as an industrial photographer. By 1939 he had been fired for coming to work late once too often. "So there I was on the street again, where everything was happening, I felt very happy, but also slightly worried. Five years in a factory put my initiative to sleep. But asleep or not, material need forced me to make a new beginning."

Doisneau transformed necessity into virtue, and made the street the object of his photographic explorations. It was always the Paris of the

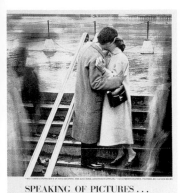

simple people who fascinated him, however – the Paris of pensioners
and casual workers, of tramps and cabbies, easy women, workers, chil-
dren, and of landladies peering down the hall. These are the people he
sought out, always looking for the eloquent moment in which the human,
and all-too-human, was concentrated. Doisneau is the story-teller among
the exponents of a so-called *photographie humaniste*. Whereas Cartier-
Bresson followed the Constructivist dictum and composed his photo-
graphs down to the last detail, Doisneau sought out the anecdote. His
pictures evince wit, but very often there is an irony or even a slight sad-
ness hiding behind the humor. He always defended himself against intel-
lectualizing the taking of a picture. His camera art derived from springs of
sympathy and feeling, sources which ultimately explain the unparalleled
international popularity of his œuvre.

Fame came late to Doisneau – but then all the more enduringly. In the
early 1970s, the market halls were torn down in Paris. For many Parisians,
their demise signified not only the passing of a piece of old Paris, but also
the end of an entire era: that not-always-carefree, but always hopeful
post-war era, in which the metropolis on the Seine once again had ad-
vanced to the artistic and intellectual center of the world, before the city
irrevocably lost its leading position to New York. It is no accident that pre-
cisely at this painful turning point, the work of Robert Doisneau, the core
of whose work largely reflected the 1940s and 1950s, underwent a literally

unparalleled discovery. His friends had warned him: "Don't waste your time with these photos!" But Doisneau had held out, and in the end, there was almost no other photographer of his generation who could offer such a treasury of pictures from 'better times' than the rather quiet and unassuming Doisneau. Rumor has it that his archives contained no fewer that 400,000 negatives – a visual cosmos from which innumerable never-before-seen photographs of Paris still emerge.

A city of relaxed behavior and sensual pleasure

Under the aegis of this belated acceptance of Doisneau, *The Kiss in Front of City Hall* embarked on its march of triumph after a small-format premier in *Life* as one of a total of six black-and-white photographs. The publisher had neither recognized the visual power of the picture nor seen any significance in the name of its creator: the photographer was not in fact mentioned on the double-page spread. The photograph itself was part of a story about Paris as the city of lovers. There, suggested both text and pictures, people might embrace on every street corner without anyone taking notice. Remember: we are still speaking about the 1950s, a markedly prudish era, in which a caress on the open street was hardly the rule. In this context, *Life* once more borrowed the old cliché of Paris as a city of relaxed behavior and sensual pleasure, an image also current in Hollywood films of the time. At root, *The Kiss in Front of City Hall* still functions on this level today: the picture arouses ideas of an undisturbed enjoyment of love a few years after the war. In this sense, the photograph was able to operate in a double sense as an ambassador of a peaceful, yet impetuous, harmonious relationship.

Three kisses at the City Hall, another in the rue de Rivoli, and one more at Place de la Concorde

Doisneau himself continued to maintain an ambivalent attitude toward his famous picture, once even claiming that it represented no photographic achievement. "It's superficial, easy to sell, une image pute, a prostituted picture." All those who bought it, whether as a poster or a puzzle, a shower curtain or a T-shirt, saw it – and still see it – in another light. Throughout his life, Doisneau received enthusiastic letters, including some from people who thought they recognized themselves in the picture. In 1988, however, Denise and Jean-Louis Laverne from Ivry near

Paris contacted the photographer with a claim of the equivalent of approximately $90,000 for lost royalties. The outcome was a much-watched court trial, during which Doisneau admitted that he had staged the picture with paid models. The photograph, according to his argument, had been made under contract with *Life* for shots of couples kissing in Paris. But for fear of judicial problems, it was decided to use actors. Doisneau seated himself in a cafe near Cours Simon, one of the well-known acting schools, and thus discovered "a very pretty girl...She said okay, and brought her boyfriend with her to the scheduled photographic appointment. We took three kisses at the City Hall, another in the rue de Rivoli, and another at Place de la Concorde."

Denise and Jean-Louis Laverne walked out of the trial empty-handed – but the case had stirred up sufficient dust to rouse those who had actually posed for the picture: Jacques Cartaud, then in his mid-sixties, and the former actress Françoise Bornet, who now sued for 100,000 francs in damages. Her claim was also dismissed, even though she produced as evidence an autographed copy of the picture, which the photographer had given to her as a gift after the session. For his part, Doisneau was able to prove that he had paid the young woman what was normal at the time. He thus seemed to be out of the woods, but his artistry as a photographer had suffered damage in the larger sense. Ever since the affair, people have wondered how many of his pictures of post-war Paris Doisneau had in fact staged. The artist admitted arranging "all of my lovers of 1950" – but protested that he had very carefully observed "how people behave in certain situations," before he created the scene.

As paradoxical as it may sound, the discussion over whether the picture was set up or not did very little damage to the incriminated *The Kiss in Front of City Hall* itself: the image had long since left all concern with documentation behind. The photograph became a symbol – and symbols possess a truth of their own.

Dennis Stock
James Dean on Times Square

It started out as an assignment – and became a legacy. Early in 1955, the young Magnum photographer Dennis Stock accompanied the rising screen star James Dean to Fairmont, Indiana, and New York. The resulting photographs would prove to be the best and most intimate portrait this idol of the new youth, who was to die only a few months later in an automobile accident.

Myth in
the Early
Morning

The setting is no accident, even if the weather is. But what would this picture be without the rain? It forces the bare-headed protagonist into a slight slouch, makes him pull his head into his collar. But that's what tall men do anyway. Five feet eight stands written on his passport – in other words, not particularly tall. And it may well be that his height at times was as much of a problem for him as his short-sightedness. In private life he had to wear glasses – and he needed them on the stage, too. But perhaps it was just this blurred perception of his environment that threw him back on himself and led to the oft-described intensity of his acting. New York. Times Square. For a few moments Broadway becomes his theater. But in reality, every place is a theater to him – a stage where in fact he doesn't act, but lives out his life, whether before an audience, or in front of the film camera. The boundary between reality and dream disappears; there is no need for him to take on another form as an actor, but rather to heighten the feelings, dreams, fears, neuroses, and phobias that already reside in him. Even now, at this moment, he is private and public at the same moment. It is not merely by chance that he is making his way across Times Square: what he is now doing for the camera is something that he has already done a thousand times before. And it's not an accident that the Chesterfield happens to be hanging from the corner of his mouth. Nonetheless, he smokes in private, too. He is acting, yes – but he is acting himself. He does it for *Life*; he does it for the photographers; he

does it for the fame and image whose structure he cannot leave to chance.

Of course he's vain. Even in photographs he sometimes gazes into the mirror, even if it is only his reflection in a frozen puddle. This time, it's a rain-slicked street. It's really quite skillful how Dennis Stock takes advantage of the puddle to double the form of his hero, as it were. In reality he should disappear between the skyscrapers of New York. Instead, the canyon of buildings sinks backward into the mist, and he, in spite of his rather short stature, becomes taller. A giant with drawn shoulders – but that's the way he sees himself anyway. And how the photographer manages to convey this self-consciousness graphically is a small stroke of genius. Henri Cartier-Bresson used to look at his pictures upside down to check just how compelling they were. In this case, our picture transfers the attention of the observer from the person to the mirror image. Blurred, jittery, frayed at the edges – an image that easily becomes a metaphor for the high-strung, impatient, restless life of our hero – for his rebellious character, for his ambivalence – which concentrates all the contradictions of a satiated age into an apotheosis. "I don't know who I am," he had claimed even as a seventeen-year-old high-school student. But that doesn't matter.

With the instincts of a wild animal

Now he is twenty-four and approaching the zenith of his career – an observation that sounds strange when one realizes that he will not reach his twenty-fifth birthday. He has performed on stage and has begun to take up small roles in early television. But it is the cinema that will carry him to fame – this comparatively young, popular art form that, as he well knows, guarantees a kind of immortality even better than that of the stage. He has already made one film, and two more will follow in the coming months. His *Rebel Without a Cause* will moreover premier in the very theater, the Astor, that we see to the left at the back of the picture. Not far from here, on 68th Street West, he has a modest apartment, and Lee Strasberg's legendary Actors Studio is only a few steps away from Times Square. He had been accepted there in 1952 – certainly the most important confirmation of his talent until he won the favor of the great public. Perhaps Times Square was now no longer all that it had once been. Nonetheless, as Dennis Stock relates, before James Dean departed for

Hollywood, the Square was his home where he moved about with all the confidence of an animal in its own territory. He could not tolerate staying inside his small apartment, and instead spent the time outdoors, pacing the streets from dusk to the early morning hours.

Anything can become a myth, as Roland Barthes once pointed out. The myth is not primarily an object, a term, or an idea, but a message. The bourgeois age is the era of technical pictures: photography, movies, and television are the vehicles of modern myths. Moving images create them, static pictures lend them stability. James Dean is one of the great myths produced by America in the twentieth century – a genius who touched the nerve of his times, a rebel who made youthful rebellion into the basso profundo of his artistic creativity, and who will always retain his credibility because he was saved from growing old. "Live fast", he is said to have quoted from Nick Ray's *Knock on Any Door*, "die young, and leave a good-looking corpse." Cryptic-sounding advice, but it largely reflects how he directed his own life, in which nothing was left to chance, for his life was a self-dramatization, even if the distance between being and seeming was not especially great. According to Dean's biographer David Dalton, who is one of those most familiar with the actor's legend, the young actor identified totally with his characters.

The craving for pictures in the glossies and fan magazines

Dean is always said to have disliked photographs. But this can at most be only partially true. In any case, his attitude toward the medium was ambivalent, and for a while he in fact took photography lessons from the photographer Roy Schatt. There are pictures showing him with a Leica or Rolleiflex – without, however, anything worthy of notice having come out of his camera. What is more important was and remains his relation toward his own image. Schatt related how the two of them were making portraits when James Dean suddenly said that he wanted to try something. He turned his head slightly to the left and looked downwards. Schatt asked himself what on earth he was up to, and the star replied: "Can't you see? I'm Michelangelo's David." Dean certainly had nothing against being photographed, at least when it flattered his ego – or served his career. Star photos are as much a part of Hollywood as the star is to the film itself, even if the great age of glamour photography, characterized by warm spotlights and retouching, was already over. Now instead

Dennis Stock

Born **1928** in New York. Joins the navy at age 16. After the end of the war turns to photography. **1947–51** trains under Gjon Mili. **1951** first prize in the *Life* young photographers competition. Contact with Robert Capa. Magnum member from **1954**. Moves to Hollywood, where friends with James Dean. From **1957** intensive photographic explorations of the jazz world. **1960** publication of his book *Jazz Street*. **1962** withdraws to the country. Turns to nature photography under the influence of the work of Ernst Haas. In the late sixties spends several months at the Hippie communes of the American South West. **1970** publication of his book *The Alternative*. Has recently shown great interest in film and video. Lives in Centerbrook/USA

there were photojournalists and press photographers, who took over the
job and served the craving for images in the illustrated journals or fan
magazines. In Dean's case, these were names like Roy Schatt, Sanford
Roth, and Dennis Stock. In other words there remained a great deal of
Dean memorabilia in the form of photographs. But when David Dalton
writes that our image of Dean is formed of many elements, it does not
mean that there are not a few photographs standing out from the rest
that have especially defined our sense of Dean.

Dennis Stock and James Dean had met in Hollywood under the auspices
of Nicholas Ray, who was planning to cast Dean as the lead in his next
film, *Rebel Without a Cause*. Elia Kazan's *East of Eden* was already fin-
ished, but had not yet appeared in the theaters. In other words, James
Dean was still a completely unknown entity – at least for those who had
not had a chance to experience him on the New York stage. The names of
Marlon Brando and Elvis Presley signified the idols of a young, increas-
ingly self-confident post-war generation that no longer accepted their
youth as a synonym for immaturity, but rather as a valid state of being. In
the end, however, it would be Dean who would lend the teenage cult its

definitive face, even if at age twenty-three, he was no longer a teen himself. As Dalton points out, Dean bequeathed a new body language to the youth of the times. Dean was a Baudelairean hero in whom the contradictions of youth – the impatience, aggression linked with vulnerability, the arrogance, nervous sensibility, shyness – were creditably lifted up to view. Stock himself was in his mid twenties, a young photographer who had studied with Berenice Abbott and Gjon Mili. Since 1951 he was a member of the Magnum group – and of course always on the lookout for a good story. "Jimmy," as the photographer later came to call him, invited Stock to a preview of *East of Eden*. At the time he was not familiar with Dean's work, but the scene in the bean field convinced the photographer that the young man would become a star. Stock determined that he wanted to do something together with Dean, so he proposed an essay on Dean to *Life*. In February 1955, the pair set out for Fairmont, and later New York, where, among other photographs, *James Dean. New York City. Times Square* was made.

The ideal of happily lived materialism

Fairmont, Indiana. Dean biographers have consistently pointed out that this is the true East of Eden. A flat piece of earth, fields as far as the eye can see – and people whose Puritanism forms virtually the opposite pole to the American ideal of happily lived materialism. Here, or more precisely in the small town of Marion, James Byron Dean was born on 8 February 1931 – 'Byron' being a hint from his mother who, as all mothers, had great expectations for her son, and apparently wanted to underline this by a reference to the great poet. Jimmy Dean spent his early years in Marion, and later the family moved to Fairmont where, after the early and traumatic death of his mother, he grew up with his Uncle Marcus and Aunt Ortense. The pair operated a small farm: "Winslow Farm."

It was here that Stock and Dean returned in 1955. The little cabin on Back Creek represented the country roots, so to speak, of the demi-god James Dean. His simple – extremely simple – background is significant; it offers hope, and at the same time belongs as much as his early, fateful death to the components of the myth, to the process of legend-making. Stock and Dean visited the local cemetery where an ancestor named Cal Dean lay buried. For his photographer, the rising star sat down again at his school

desk. He wandered around Fairmont, hands in his pockets, Chesterfield in the corner of his mouth. He looked at himself absentmindedly in a frozen puddle – or tested out a coffin at the undertaker's, just to try it out. Dean's longing for death has since become the object of a great deal of speculation. In any case, Stock found a valid metaphor for his hero's necrophilic tendencies by translating Dean's isolation into pictorial form: James Dean in the midst of cows; with a dog; with a pig. The affinity for animals that the star took as a matter course can in fact be read as a metaphor for loneliness.

Dean and Stock remained a week in Fairmont. It was simultaneously a reunion and a farewell. Stock later wrote that James Dean knew that he would never see the farm again, and for that reason insisted that the last shots were taken of him before the farmhouse. James posed himself, looking straight ahead, while his dog Tuck turned away. It was, according to Stock, the actor's interpretation of 'you will never return home again'. Fairmont had formed him, New York had changed him. New York was his laboratory, in which parts of him flew apart only to form together in an arbitrary manner. In New York, he had been discovered by Elia Kazan, director of *East of Eden*, the son of the land had become a god-in-the-making. Even if it took Hollywood to form his image definitively, New York was where the career of the coming star had been launched. Blue jeans, T-shirt, closed windbreaker belong to the Dean mythos just as much as the cigarette and the only partially tamed hair. Dennis Stock wrote "James Dean haunted Times Square", beneath his perhaps most famous portrait of the young actor. "For a novice actor in the fifties this was THE place to go. The Actors Studio, directed by Lee Strasberg, was in its heyday and just a block away." Dean is wearing a dark coat – because of the weather, of course. But the way in which he hides himself in it may also be interpreted as a reference to his vulnerability – it is a cocoon, even if it is in fact black. One should not perhaps over-interpret the color, even though we know that Dean will not live to see the premier of *Rebel Without a Cause*. On 30 September 1955 at 5:45 p.m., his Porsche Speedster will crash into a Ford sedan. It cannot be claimed that he made a "good-looking corpse"; but he had succeeded in living fast, and dying young – at age twenty-four.

For Dennis Stock, his short friendship with James Dean was perhaps the most important station in his life as a photographer. If he is known for

Dennis Stock: In the old schoolhouse of Fairmont

Pictures like this made a major contribution to cementing the James Dean myth.

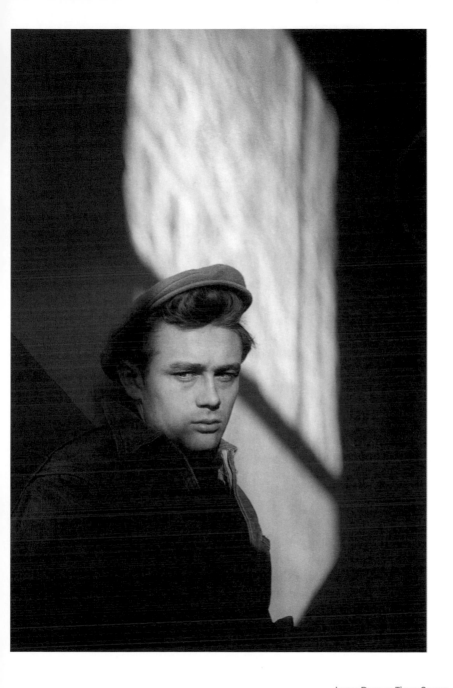

"Moody New Star" in Life, 7 March 1955: Stock's photograph James Dean on Times Square *was published here for the first time, albeit heavily cropped.*

anything, then it is for his pictures of Dean, which also circulate as post cards and posters. They form a part of every retrospective of Stock. Gottfried Hellnwein used our key picture as the motif for his own interpretation – and by not observing the copyright, underlined the quasi universal nature of the image.

James Dean on Times Square is somewhat reminiscent of Cartier-Bresson's portrait of Giacometti (here, also, it is raining), and it is no longer possible to imagine the core of the Dean iconography without it. Even today, the photograph remains among the most often printed images of "Hollywood's ultimate god." As Richard Whelan summed it up, Dean's bequest to Stock was a certain financial independence that allowed him to dedicate himself to work that really interested him. In return, the photographer made a movie in homage to his friend: in 1991 Dennis Stock filmed *Comme une image, James Dean?* as a thirty-eight-minute documentary on the star. And what was the image of James Dean? Towards the end of the film, Stock observes that although he was one of the last of James Dean's friends still to be alive, not one of the fans he had met during his travels had asked who Dean really was and what he had actually been like. The reason being, as Stock answers his own

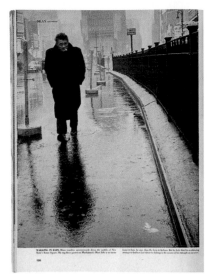

question of why this was so, that everyone creates their own James Dean, according to their own tastes and their own personal needs. Which allows him to be a hero in what has become a very complicated world, someone in fact who is pretty different to the 24-year-old boy Stock had known and photographed.

1960 Robert Lebeck
Leopoldville

Dagger in a Black Hand

This photograph quickly made its way around the world: a young Black stealing the ceremonial dagger of the Belgian King Baudouin. Robert Lebeck, at the time working in Africa for the illustrated magazine *Kristall*, captured the picture with all its symbolic character during the freedom celebrations in the Belgian Congo in June 1960.

Being at the right place at the right time, a working camera in hand, fitted with the correct lens and loaded with sufficient film: a patent recipe for creating a 'photograph of the century' – providing, of course, that the scene is not staged. But even if the photographer also knows what he or she is doing professionally, and the 'tool' is in good working order, there still remains something that needs to be explained – something that the 'picture hunter' terms the luck of the chase; the lay person, chance; the romantic, fate.

Leopoldville, 1960. Robert Lebeck is not the only photojournalist who has come to Africa to follow the independence process of the Congo with his camera. In one picture, we recognize Hilmar Pabel, equipped with two Leicas with lenses of different focal lengths. The escort has already passed by Robert Lebeck on the right. Others have hurried out in front of the limousine carrying President Kasavubu and Belgian's King Baudouin. According to the rules of the trade, they catch the approach of the protagonists, either not realizing or only suspecting that at this moment the decisive scene is being played out elsewhere. Namely, a few steps further to the left, where 'fate' places the decisive picture into the hands of Robert Lebeck, whose position already seemed to have been 'written off': a young black man suddenly sees his chance. He has already been running for some time alongside the open, dark-colored limousine. On the rear seat he spots the royal dagger which the king has laid aside, grabs it,

and runs directly toward Robert Lebeck, who now – in a certain sense as the culminating point of a sequence of before-and-after pictures – succeeds in capturing the key picture.

Zero hour of the Dark Continent

"King's Sword in a Black Hand." Lebeck's report first appeared in *Paris Match*, No. 587 (9 July 1960). Two days later, *Life* published the crucial motif under the title; "King gives up a colony – and his sword," followed by *Kristall* and the Italian magazine *Epoca* – not to mention the many books, anthologies, exhibitions, and catalogues that have pushed Lebeck's image again and again into our consciousness and assured its position as a kind of icon, a symbolic metaphor for the end of colonialism and Africa's entry into a new age.

1960 was an important year for the African continent, bringing as it did independence to a series of largely west and central African states: Cameroon and Togo, Mali, Dahomey, Niger and Upper Volta, the Ivory Coast, Gabun and Mauritania. The Belgian Congo, too, by far the largest of the group of colonies, received its independence. The talk was already of an "African year," and of the "zero hour" of the Dark Continent – phrases signaling confidence in the political future and expressing a strong and independent Africa.

Beautiful and rich in mineral resources

The Congo was 'given' to Belgium at the end of the nineteenth century. King Leopold II had been attempting to acquire the colony with the support of Bismarck in Germany, which sought to stymie the advance of England and France across the Dark Continent. Then at the Berlin-Congo Conference of 1884/1885, the territory left of the Congo River was finally allotted to Belgium. Thus the history of the Belgian Congo began: beautiful, rich in mineral resources, and, with its more than half a million square miles, approximately eighty times larger than its so-called mother country. In 1960, the Congo contained about two and a half million inhabitants, including eighty thousand Whites; of the native population, at the time, not more than fifteen had a university diploma – testimony to how ill-prepared the land was for independence. In fact, it had long been assumed that independence would not come until the 1980s, or at the earliest the 1970s. As late as 1957, the Antwerp scientist A. A. van Bilsen had

Robert Lebeck

Born **1929** in Berlin. **1944–45** military service at the Eastern Front. POW until summer **1945**. Studies in Zurich and New York. **1951** returns to Germany. From **1952** first photographic experiments. First photos are published that same year. Freelance photojournalist for various newspapers in Heidelberg. From **1955** director of the Frankfurt office of *Revue*. **1960** changes to *Kristall*. **1966–77** photo-reporter for *Stern* magazine. **1977–78** chief editor of *Geo*. From **1979** works once more for *Stern*. Numerous prizes, most recently Dr. Erich Salomon Prize of the DGPh. Lives in Port de Richard/France

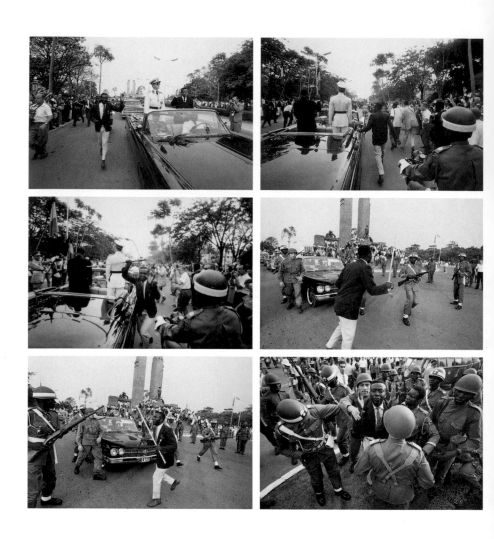

The complete sequence underlines the advantages of 35 mm
cameras for dynamic series of shots.

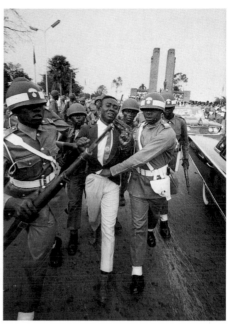

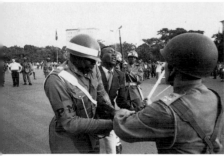

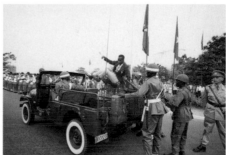

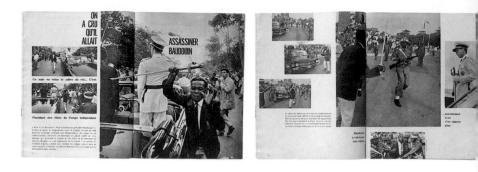

Paris Match, 9 July 1960: The French illustrated was the first to publish Lebeck's sensational photo report.

set up a "Thirty-Year Plan for the Political Emancipation of Belgian Africa." But in the end, everything happened far quicker than was planned. The riots in January 1960 had started the process in motion. From today's standpoint, it looks as if Belgium could not have ridded itself of its colony more quickly. King Baudouin set the day of independence for 30 June 1960, and already in early July the first mutinies started in portions of the "Force Publique," the 23,000-man army of the Congo. Then came plundering and attacks on the white officers, which resulted in the flight of thousands of Belgians from the land. Belgian paratroopers attacked, and Moise Tshombé took advantage of the opportunity of the moment to declare independence for the mineral-rich province of Katanga. UN troops landed in Leopoldville. Taking advantage of the rivalry between President Kasavubu and Prime Minister Lumumba, Colonel Mobutu putsched his way to power – and delivered Lumumba over to Katanga, where he was shortly found dead. The Congo, according to the headlines in the world press, was sinking into chaos.

But at the moment our photograph was taken, there was no trace of all that was to come. It is 29 June 1960 – a warm and sunny Wednesday morning. The entire country is rushing deliriously toward independence. In the streets, crows are gathering, church bells are tolling, flags are flying everywhere. King Baudouin is due to arrive any moment at the airport of the capital city of Leopoldville, and tomorrow, Thursday, there will be a festive Te Deum service in the church of Notre Dame du Congo. Observers from all over the world are present to report on the historical event. At the end of the church service, a ceremony is scheduled in which President Kasavubu will address "the slow awakening of the Congo's sense of

nationhood" and praise "the wisdom of Belgium… which did not stand in the way of history." Then Premier Patrice Lumumba will take the podium, whose description of "the sufferings of the native population during the colonial period" will have the effect of a diplomatic bombshell. At 11:00, the colonial history of the Belgian Congo will come to an end, and with the words, "May God protect the Congo," King Baudouin will send the land on its way into independence. "Of all the new states that are being founded, the most exciting experiment is beginning," according to the correspondent of the German newspaper *Süddeutsche Zeitung*, "here in the middle of the heart of Africa."

A petrified symbol of the end of an era

So much for Thursday, 30 June. But today is still only Wednesday, and the King has not yet landed. Robert Lebeck is sitting with his colleagues in a Belgian restaurant enjoying a leisurely lunch. Some of his companions have left in order to catch Baudouin at the airport, but Lebeck is taking his time. After all, nothing important is going to happen at the airport. He goes instead directly to the city, to Boulevard Albert, where the convoy containing king and president is awaited. A crowd of people is already lining the main street with its monument to Leopold II, which has now become a petrified symbol of the era approaching its definitive end. Lebeck passes through the barriers: he wants to place himself exactly by the guard of honor and the waving flags, where the convoy will probably slow down. Finally the cavalcade approaches. Standing in an open automobile, Baudouin and President Kasavubu receive the ovation of the multitude. A young black man, elegantly dressed, is running in tempo at the side of the automobile. Through the viewfinder of his Leica M3 with its 21 mm Super Angulon lens, Robert Lebeck is tracking the action. Supposing the man to be a security guard, the photographer expects to be chased any moment from his position in the street. Instead, the young man runs past him, followed by a motorized police escort. Lebeck begins shooting again. At this point, the young man seems to have spotted the sword lying on the back seat of the car. A second later, he reaches for it.

Building on the achievements of modern reporting

Once asked by a British publisher to define his understanding of himself as a photographer, Robert Lebeck gave a short, clear answer: "I am a

"Turmoil in the Congo": Kristall *dedicated the Lebeck report the greatest space of any magazine.*

journalist." Lebeck sees himself as a craftsman – someone who is sent out on a job and returns with usable photographs. His model for this approach has always been Alfred Eisenstaedt, a photographer for all seasons. But there are also others with whom Lebeck feels himself tied: Felice Beato, for example, or Robert Capa, Eugene Smith, and Erich Salomon, whose discrete manner continued to define the standard for Lebeck.

Born in 1929 in Berlin, Robert Lebeck sees himself in the tradition of the 'classical' photojournalism that assumed the task of providing visual information along with the rise of the illustrated magazines in the 1920s. More precisely, Lebeck, who first published his reports in the mid-1950s in *Revue*, and then moved on to *Kristall*, and finally in 1966 to *Stern*, numbers among the mid-twentieth-century generation of well-known international photojournalists. The impact of the large – primarily American – magazines after the war aroused his curiosity, and Lebeck succeeded in building on the achievements of modern reporting, without having to fear the overly powerful competition of today's television. Lebeck is a story-teller in pictures, and is loath to let himself be classified according to a certain style, strategy, or aesthetic. Nor does he pursue a single theory of reporting. At most, one might speak of a certain cinematic approach that structures its theme, dissects it, circles around it, and describes it from various standpoints. His reporting on the Congo can well be taken as exemplary of his approach: from the first appearance to the arrest of the young enthusiast whom the *Kristall* editors arbitrarily dubbed "Joseph Kalonda," the story is told in a mere dozen pictures.

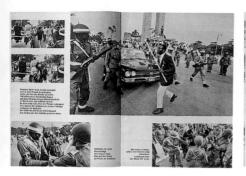 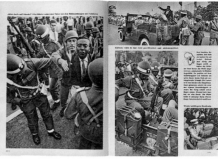

That Lebeck in fact took an interest in the people who appeared in his reports and in the circumstances of their lives is certainly not one of the necessary and self-evident properties of his profession. But these are in fact the characteristics of a photographer who numbers today among the most famed of the post-war photojournalists. On a later trip to Africa, Robert Lebeck sought to discover from President Mobutu the whereabouts of the young man who had been carried away under military guard. But there are times that one may search without finding an answer: the fate of "Joseph Kalonda" remains sealed in the depths of history.

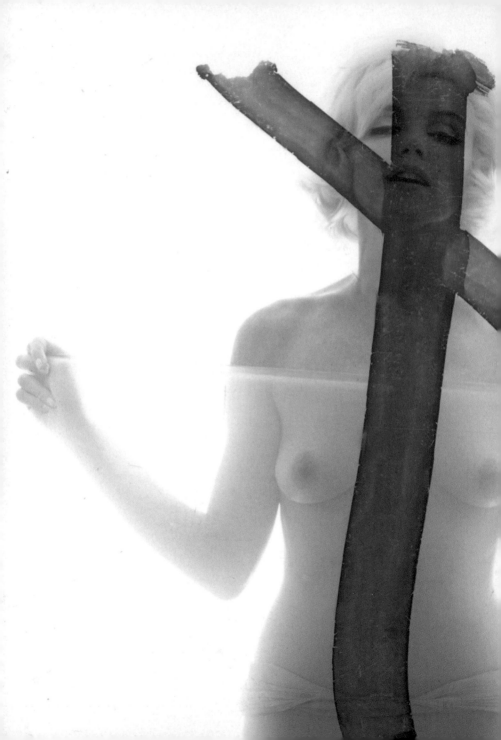

1962

Bert Stern
Marilyn's Last Sitting

He may not have been the first to photograph her, but he was certainly the last. In July 1962, the young photographer Bert Stern succeeded in three sittings in capturing a many-faceted portrait of an unusually relaxed and playful, close and direct Marilyn Monroe. A few weeks later she was dead. What had begun as an eight-page homage to the screen star in *Vogue* became an obituary, and has entered photographic history as *Marilyn's Last Sitting*.

His first words upon meeting her were short and simple: "You're beautiful" – perhaps not exactly the most original start to a conversation, but Bert Stern does not seem to have been a man of many words. Moreover, what does a man say when he suddenly finds himself face to face with a woman whose screen presence and sex appeal have already caused millions of men throughout the world to lose their reason? A true "Stradivarius of sex," as Norman Mailer once described her. And as such, she might just as well have been a mere invention of film, a creation of make-up and curlers, light and direction. Seen in this way, Stern's entrée was nothing less than the translation of a myth into reality. Furthermore, the words were honest and spontaneous – and they seemed to have pleased her. "Really? What a nice thing to say," she answered – which also sounded self-confident: not the content, but the manner in which it was said, evoked her comment – not the 'what' but the 'how'. For she well knew that she was attractive. And she also knew that the way she looked was her capital in a world which in other respects had hardly treated her well. After a comfortless childhood with bigoted foster-parents came three broken marriages and a round dozen abortions and miscarriages. Finally an unhappy affair with the American president. She had tried to challenge the omnipotence of the studios – and lost. Nonetheless, she

had succeeded in making fifteen films – admittedly none of them productions that critics considered worth entering in the annals of film history. Furthermore, she was not even fairly paid for her work, in comparison with the brunette Liz Taylor, who was in a sense Marilyn's opposite number throughout her life. For filming *Cleopatra*, Liz received as much in one week as Marilyn did for an entire film. It may be that for Marilyn Monroe a glance in the mirror compensated for a great deal. She was beautiful, in fact, and no one could take her beauty away from her – or at any rate, only time, alcohol, and sleeping tablets, which in this phase of her life had already formed into an unholy alliance. And perhaps it was really true, as Clare Booth Luce formulated in her obituary in *Life*, that Marilyn Monroe was moved by the fear of becoming old and ugly when she took that mixture of Dom Pérignon and barbiturates that carried her from a state of drowsiness to an eternal sleep on the night of 4 August 1962. Or perhaps it was indeed murder, as many still whisper today, ordered from on high – from the very highest levels – to hide something or other? The death of Marilyn Monroe remains until today one of the great unsolved riddles of the twentieth century.

But now it is still only July. We find ourselves in the Bel Air Hotel in Los Angeles. Not a bad address, and presumably the most suitable location to realize an idea that the photographer Bert Stern hardly dares to dream about. At the time of the photograph, he was thirty-six years old and already one of the best-paid photographers in New York, which is to say, the world. Ever since he had helped a brand of vodka named 'Smirnoff' to truly sensational profits through a spectacular advertising photograph – no small feat at the time of the Cold War – he had become one of the most sought-after photographers in the branch. In addition, he had a lucrative contract with the American *Vogue*, both then and now the Olympia of all those for whom the camera is the true medium to lend a certain durability to the appearance of beauty. Stern had been eighteen years old when he saw a still life by Irving Penn, which opened a door in his mind. Nonetheless, it would not be still lifes that would inspire him and finally drive him to a career in photography, but rather life itself, especially in those places where it is sensual and full, exciting and erotic. Here Stern reflects precisely the pattern that Michelangelo Antonioni had made into an ideal in the 1960s with his film *Blow Up*. In this sense, Bert Stern dreamed his dream, although even before Antonioni he had discovered

Bert Stern

Born **1929** in Brooklyn/New York. Self-taught photographer. **1946–47** employee at the Wall Street Bank, New York. **1947** moves to *Look*, where initially works in the postal department. From **1948** assistant to Art Director Herschel Bramson. **1951** Art Director of the magazine *Mayfair*. Subsequently photographer in New York. Does campaigns for among others Smirnoff, DuPont, IBM, Pepsi-Cola, Volkswagen. Editorial photography for *Vogue, Esquire, Look, Life, Glamour* and *Holiday*. **1974** closes his New York studio and moves to Spain. Active once more since **1976** as an advertising photographer in New York, working for Polaroid and Pirelli among others. Editorial work for American *Vogue* and other New York magazines. **1982** publication of the book *The Last Sitting*. Lives in New York

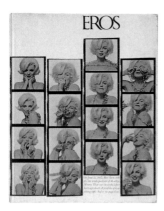

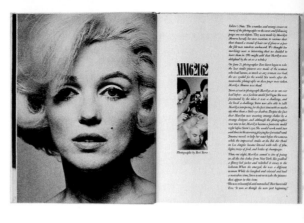

Not the first, but to date the loveliest magazine feature on Bert Stern's cycle: lead in Eros, *Autumn 1962*

the camera to be the ideal "dream machine" that it became for at least a generation of photographers who followed upon David Hemmings. And as he noted, it was amazing all the things it allowed him to get and the people he was able to get, as long as he had a camera on him. In this way, some of his boldest dreams came to be realized.

Lighthouse on the horizon

And the boldest of bold ideas? To photograph Marilyn Monroe – naked. One must place oneself mentally back in the 1950s or early 1960s – furnished with a good measure of fantasy and sympathy – to evaluate the full audacity of Stern's longing. In addition, the photographer was, in spite of his promising career in photography, still a nobody – at least compared with Monroe, the superlative, who could claim to be "America's greatest sex symbol" (Joan Mellen). And that would probably be an understatement. She was already long an international idol, a global pin-up girl, and the lighthouse on the horizon of male fantasies around the globe. She was, as Normal Mailer phrased it, "the sweet angel of sex... Across five continents the men who knew the most about love would covet her, and the classical pimples of the adolescent working his first gas pump would also pump for her, since Marilyn was deliverance." Innumerable photographers had done her portrait in more or less provocative poses. And they were an impressive group: André de Dienes, for example, who can claim the credit for discovering Marilyn; or Cecil Beaton, the master of glamour in fashion; or Alfred Eisenstaedt, Ernst Haas,

Henri Cartier-Bresson – in other words, the top rung of international photojournalists. In addition, she had modeled for Richard Avedon and Milton Greene. Philippe Halsman, not to mention Frank Powolny or Leonard McCombe, had done her portrait. She liked to be photographed. She loved the presence of a camera. She knew how to pose. Completely without clothes, however, she had been photographed only once. That was in 1949, and when Tom Kelley's photograph appeared years later in a pin-up catalogue in March 1952, it almost brought her Hollywood career to an end. Her films crackled with eroticism; she was always playing the easy girl. And the most memorable scene from *The Seven Year Itch* – that is, Marilyn standing on the subway vent – became one of the most famous in movie history. But then, after all, an ambivalent attitude toward sexuality was one of the many contradictions endemic to the 1950s.

Bert Stern was exactly twenty-six years old when he met Marilyn Monroe for the first time. That was the upstroke, so to speak, to a fixed idea that would take shape on this late July day in 1962 in the most beautiful sense of the word. After Dienes and Beaton, Avedon and Green, now he, Bert Stern, was allowed to photograph Marilyn Monroe – that same Marilyn who had given wings to his thoughts ever since 1955, and whom he had 'desired' since that time, as he himself admitted. "The first time I saw her", he relates, "was at a party for the Actors Studio, in New York City. It was 1955. A friend and I had been invited, and when walked in, there was Marilyn Monroe. She was the center of attention. All the men were around her, and all the light in the room seemed focused on her. Or was the light coming from her? It seemed to be, because she glowed. She had that blond hair and luminous skin, she wore a gleaming sheath of emerald-green that fit her body like a coat of wet green paint. 'Look at that dress,' I said to my friend. 'I hear they sew her into it,' he said. How could you get her out of it, I wondered, with a razor blade? I'd laid eyes on Marilyn Monroe only moments before and already ideas about taking her clothes off were going through my mind."

The goal of his dreams and secret fantasies

In the meantime it is 1962, and Bert Stern is about to reach the goal of his dreams and secret fantasies. The Dom Pérignon vintage 1953 has been chilled, and Suite Number 261 in the upper floor of the Bel Air has been transformed into a temporary studio. The lighting is in place, the portable

pp. 106–107: Double-page spread from Eros (Autumn 1962): even some of the shots Marilyn that rejected were published here for the first time.

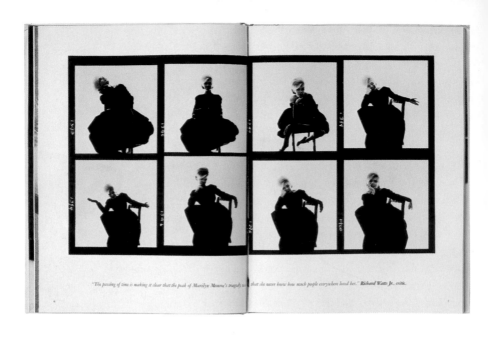

"The passing of time is making it clear that the peak of Marilyn Monroe's tragedy was that she never knew how much people everywhere loved her." *Richard Watts Jr., critic.*

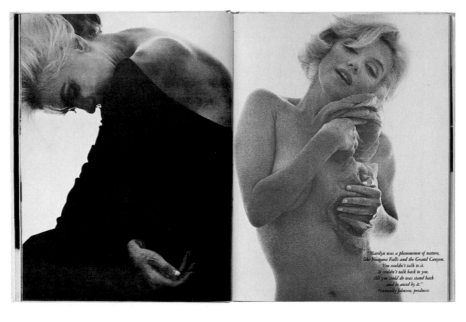

"Marilyn was a phenomenon of nature, like Niagara Falls and the Grand Canyon. You couldn't talk to it. It couldn't talk back to you. All you could do was stand back and be awed by it." *Nunnally Johnson, producer.*

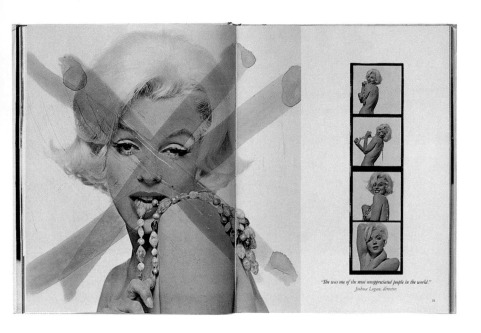

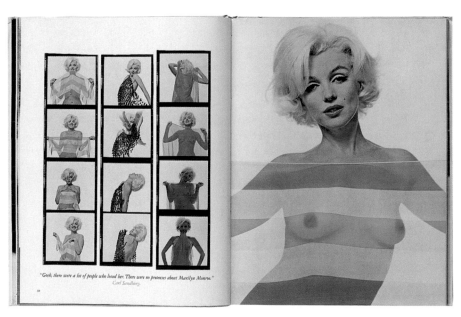

"Monroe's great attraction was the playing of a frankly sensual, frankly voluptuous, frankly interested woman who was not evil, not dangerous, not destructive.

She could venture on the most dangerous territory without shocking audiences or suggesting that she was morally depraved."
Marilyn Monroe

Too daring for the times: Eros *publisher Ralph Ginsburg was charged and sentenced for disseminating pornography – "The last thing the magazine was about"* (David Hillman).

hi-fi set up. He wanted not only to create a space out of light, as he said, but also an environment of sounds. In this case, it was not Sinatra, as Avedon had used, but the Everly Brothers. The people at *Vogue* had done him a favor and gotten him some gauze-thin cloths. That the editors had accepted his proposal to supply a portrait of Monroe had been no less surprising than the spontaneous "yes" from Marilyn Monroe herself. The luxury liner among the magazines had never published anything about Marilyn – who, it was known, really was named Norma Jean Baker, an illegitimate child hardly stemming from the social sphere to which *Vogue* usually devoted its attention and its pages. But in the meantime, Marilyn had become such an integral part of the American Dream that even *Vogue*, where dreaming was naturally at home, could no longer ignore her. The photo session was intended as her entry into Condé Nast. It became her epitaph.

It was getting toward seven o'clock and Bert Stern was beginning to get restless. He knew that Marilyn Monroe was notoriously unpunctual, but he had already been waiting for a good five hours now. What if she came only for a short time? he began to ask himself. What if the dream Marilyn had little to do with the real Marilyn Monroe? After all, the fact was that she was "well into her thirties, and she really was a little chubby", as he had seen in *The Misfits*. Still on the evening before, alone in the atmo-

"She could have made it with a little luck." Arthur Miller.

spheric illumination of the Bel Air garden, the wildest ideas had coursed through Bert Stern's head – thoughts that a married man and father of a little daughter had better not entertain. "I was preparing for Marilyn's arrival like a lover," Stern recalled, "and yet I was here to take photographs. Not to take her in my arms, but to turn her into tones, and planes, and shapes, and ultimately into an image for the printed page." The photographer found himself back in reality as the telephone finally rang: Miss Monroe had arrived. "I slowly put down the phone and took a deep breath."

Better than the full-blooded girl I had seen in the movies

He met her in the lobby of the hotel. To his great surprise, she had come alone. No bodyguards, no press agents, not even her PR girl, Pat New-comb, had accompanied her. "She had lost weight, and the loss had transformed her. She was *better* than the full-blooded, almost over-blown girl I had seen in the movies. In her pale-green slacks and cashmere sweater she was slender and trim, with just enough softness in the right places – all of it hers. She had wrapped a scarf around her hair, and wore no make-up. Nothing. And she was gorgeous. I had expected – feared – an elaborate imitation. No. She was the real thing." In a moment he would ask her whether she was in a hurry, "No," she would answer,

"why?" – "I thought you were going to have like five minutes," he would reply. "Are you kidding," she will smilingly say, entirely the professional. "Well," he will carefully announce; "How much time have you got?" "All the time that we want!"

In the end, it would amount to almost twelve hours. And Bert Stern, the child of a lower middle-class Brooklyn family, as he described himself at one point, is able to get what he hoped for. Everything. Almost everything. At his request, Marilyn does without make-up, or applies at most a bit of eye-liner and lipstick; under his direction, she drapes herself in a boa. Even the transparent veils come into play. "You want me to do nudes?" she asks, and the stammering Stern replies: "Uh, well I – I guess so!", adding "...it wouldn't be exactly nude. You'd have the scarf." – "Well, how much would you see through?" – "That depends on how I light it." And will her scar be visible? Stern does not understand what she is referring to, but she explains that six weeks ago, her gall bladder was removed. Bert Stern assures her that it will be no problem to retouch it, and recalls a statement of Diana Vreeland that "...a woman is beautiful by her scars". Marilyn is like putty in the photographer's hand. "I didn't have to tell her what to do", as he later recalled. "We hardly talked to each other at all. We just worked it out. I'd photographed a lot of women, and Marilyn was the best. She'd move into an idea, I'd see it, quickly lock it in, click it, and my strobes would go off like a lightning flash – PKCHEWW!! – and get it with a zillionth of a second."

Vogue liked the pictures. Alexander Liberman, at that time still the all-powerful art director of the magazine, pronounced them "fabulous" – but Stern knew that with Liberman, everything was "divine." This time, however, he seemed to be serious: *Vogue* devoted eight pages to Stern's pictures. The magazine apparently realized that it had gotten onto something good – and wanted more. But, as *Vogue* let Stern know, they needed more black-and-white. Stern understood immediately: "That meant fashion pages. And that meant that they didn't want to run just nudes. They were probably going to get a lot of clothes, cover her up." There were in fact two more photo sessions in the Bel Air, to which *Vogue* sent along its best editor – a sign Stern interpreted as meaning that the magazine was indeed serious about the project. And so once again, the Everly Brothers sounded forth on the portable hi-fi, and once more the lightning storm of flash bulbs blitzed down on a tender Marilyn, whose

"The blonde – a revelation". Title page of the Swiss magazine Du, July 1999, using Bert Stern's picture

weight coroner Dr. Thomas Noguchi would determine just three weeks later at 115 lb – further describing her in his report as a well-nourished woman, 5'5" tall. But for now, the *Vogue* editor Babs Simpson had brought mountains of fashion clothing and furs along with her. And the Dom Pérignon is present once again as Bert Stern takes his photographs. In the end, he suddenly remembered the "picture I came for – that one black and white that was going to last for ever Like Steichen's Garbo". Stern entered "that space where everything is silent but the clicking of the strobes". Then all at once, as he recalled, Marilyn tossed her head, "laughing, and her arm was up, like waving farewell. I saw what I wanted, I pressed the button, and she was mine. It was the last picture."

Not only the photos were crossed through

Vogue decided in the end for the black-and-white photographs, and by the beginning of August, the chosen pictures were in the layout, and the text had been composed. It was scheduled to be printed on Monday 6 August. Stern had sent Marilyn a set of pictures, but received two thirds of them back crossed out: "On the contact sheets she had made x's in magic marker. That was all right," as he later reflected. "But she had x-ed out the color transparencies with a hairpin, right on the film. The ones she had x-ed out were mutilated. Destroyed." Bert Stern was upset, even felt "some anger"; but as he later realized "she hadn't just scratched out my pictures, she'd scratched out herself." Weeks later, friends invited him to brunch. It was Saturday, 4 August, and the television in the hallway was beaming out the usual American interiors. Suddenly the program was interrupted: "Marilyn Monroe," the speaker announced, "committed suicide last night."

"I didn't know what I felt," Stern recalled. "I was just paralyzed, shocked in a dumb, numb way." But the photographer claims that "there was some way in which I was not surprised... I'd smelled trouble." And *Vogue*? They stopped the weekend presses in order to create a new headline and compose another text. "Greetings" became "a last greeting from Marilyn," at the end of which Bert Stern's final portrait came to stand. It was in any case the last large picture of the series, just as Stern's cycle is the last of the great series on the "American love goddess" who still calls to us through these pictures, as Bert Stern phrased it, like to "a moth flying around a candle."

1963 René Burri
Che

Mythic
Moments

When Ernesto (Che) Guevara met his death at the hands of the Bolivian army in October 1967, he was transformed from a living legend into a true cult figure. Four years earlier, René Burri had made a portrait of Che which, together with the portrait by Alberto Korda – is probably the most-reproduced icon of this twentieth-century martyr.

January 1963: the two men who met in the Havana ministry office could not have been more different from each other. Nonetheless, one can, as usual, cite a number of elements they shared in common: a bourgeois background, for example; or a solid education, including university diploma, or a love of German literature – although in the one case it tended more toward Goethe, and in the other toward Brecht. Furthermore, both men were markedly urbane, curious about the world at large, enthusiastic about traveling and, last but not least, more or less strongly skeptical toward everything having to do with North America. In short, they had a basis for their conversation, which was conducted in French, since René Burri could not speak Spanish, and Ernesto Guevara's knowledge of German was too meager. Conversing with Che, however, was not the assignment of the young Swiss photographer. The interviewer was the then well-known journalist Laura Bergquist, who, as René Burri recalled, went at her job with a pointedness bordering on provocation. After all, wasn't she sitting here next to the man whom the USA hated more than any other in South America – except for Fidel Castro himself?

Fully human in such moments

We find ourselves in the Ministry of Industry in Havana, Cuba, specifically in the office of Ernesto Guevara, familiarly known – and not only to his friends, comrades, and disciples – Che. It is a sunny January afternoon in

1963. A glance out the window should provide a peaceful panorama of the roofs of the capital city, but the Venetian blind remains decidedly closed, allowing only a milky light to enter the room. But the gleam of several ceiling lamps is sufficient to mean that Burri, who on principle rejects the use of flashbulbs, does not have to work against the light. To the session he has brought two Leicas and a Nikon fitted with 35, 50, and 85-mm lenses, and in the course of the three-hour discussion, he will shoot a total of six rolls of film. This occasion will not be Burri's only chance to photograph Che, however; a few days later the photographer will join Ernesto Guevara at a festival in honor of especially worthy workers. On this second occasion, the minister will in fact make a much more jovial impression, winking at the photographer; in such moments, Che seems fully human. Nonetheless, it is not a relaxed photograph that the course of time will designate as the valid icon of the Che. But it takes time to become a myth, and Burri's portrait, appearing on page 27 of the article in *Look* dated 9 April 1963, is too small and strongly cropped to serve as an icon. The cover of the magazine features a photograph of Fidel Castro – also taken by Burri – who remains America's number-one nightmare. Only later will the square-format portrait of a self-confident Che forge itself into an icon in its own right and, transformed into the sanctified image of a martyr, be found on postcards, posters, book covers, and catalogues.

Model of a classless, communist society

Che is smoking. The large Havana, still bearing its label, is perhaps what first strikes the eye of the unprejudiced observer. The cigar appears to have just been lit, and tobacco smoke is curling its way toward the ceiling. Ernesto Guevara is leaning back, looking self-confidently and even defiantly at his interview partner, who presumably has just posed a question. Notably absent from the face is any trace of self-doubt. Other photographs from this sequence present a Che who is tired or excited, or who uses his hands to express his agitation or to explain something. But in this picture he seems completely relaxed as he peers almost arrogantly past the camera into the face of his questioner. Clearly, here is a man who looks the world squarely in the face – and thus will the photograph be later interpreted by those who reproduce it over and over again. As usual, Che Guevara is wearing a uniform; more precisely, he is wearing

René Burri

Born **1933** in Zurich. **1949–53** studies at the Arts and Crafts School in Zurich. **1953–54** military service. During this time growing interest in 35 mm photography. **1955** first photo published in *Life*. That year becomes an associate member, in **1959** full member of Magnum. **1962** publication of his book *Die Deutschen*. **1963** Cuba trip. Meets Fidel Castro and Che Guevara. Numerous pictures are published in *Life, Look, Bunte, Stern, Paris-Match, Schweizer Illustrierte, Du*, among other magazines. Several films, including *The Two Faces of China* and *Jean Tinguely*. **1984** major retrospective at Kunsthaus Zürich. **1998** Dr. Erich Salomon Prize of the DGPh. Lives in Paris

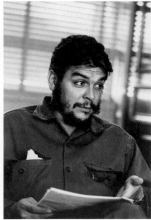
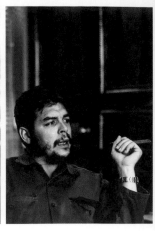

*Conversation before
closed blinds: René
Burri: Che, 1963.
Rarely published
variants*

those same inconspicuous combat fatigues that transform even a power-ful Minister of Industry – his post at present – into a battle-ready guerrilla at a moment's notice. His hair is shorter than in other photographs, his beard longer; on either side of his chin, the two patches of almost bare skin have virtually disappeared. Out of focus but unmistakable in the background are the closed Venetian blinds. In a moment René Burri's question whether they might be opened a bit will call forth an unusually gruff answer from Che: the blinds remain closed! What is he afraid of? Or is his irritation rather the response to the pointed questions of the equally self-confident Laura Bergquist?

Burri and Che had met for the first time during 1962. Che – at that time thirty-four years old and already a legend – was in New York visiting the United Nations. Together with Fidel Castro, he had managed to carry off a successful revolution on the very doorstep of the USA, whose active sup-port for the counterrevolution culminated in the debacle of the Bay of Pigs landing in 196. The American failure served only to enhance the glory of Castro and the Argentina-born Ernesto Guevara, a medical doctor who had taken his leave from bourgeois life in order to establish his model of a classless communistic society not only in South America, but through-out the world. Whether in the role of a revolutionary or national bank president (which he became immediately after the revolution), or as Min-ister of Industry – his assignment since February 1962 – Che was at the peak of his power during these months.

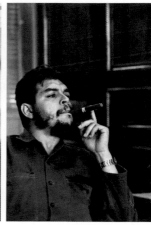

A Yanqui journalist on the Communist island

Laura Bergquist had also been present as one of the reporters in New York in 1962. Blond and good-looking, a skilled and critical interviewer, she seems to have made a particular impression on Che with her unusually direct, not to say aggressive, questions. In any case, she subsequently received an invitation to inspect the successes of the Cuban revolution herself. Note well: it is only a few months after the end of the so-called Cuban Crisis, which had carried the world to the brink of nuclear war – a fact which makes the 28-day research visit of a yanqui journalist to the island all the more remarkable. *Look* intends to publish the results of this visit – which is, moreover, a visit without restriction, as Bergquist has insisted. With a circulation of 7.3 million, *Look*, together with *Life*, was at the time the most important illustrated journal. Accompanying Bergquist as photographer on the tour is the young photojournalist René Burri, whose Swiss citizenship has the advantage of raising him above ideological suspicion.

Burri, who was born in 1933, had studied under the legendary Hans Finsler at the Zurich School of Commercial Art, and was the author of a highly respected photographic volume entitled *Die Deutschen* (The Germans), which he also compiled in 1962. He had begun his photographic career in the late 1950s with a report on deaf-and-dumb children – a sensitive work in the tradition of humane photojournalism that soon led to publication in *Life* and inclusion in the famous photographic group Magnum. Later

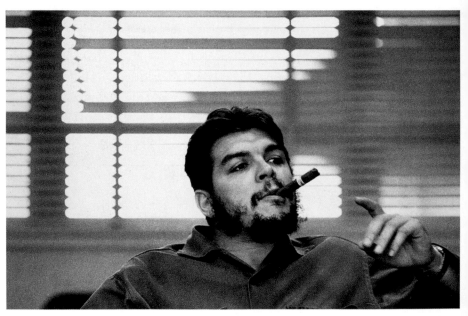

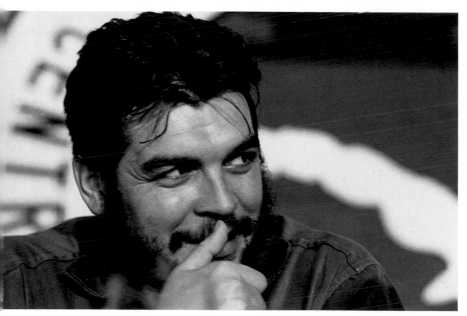

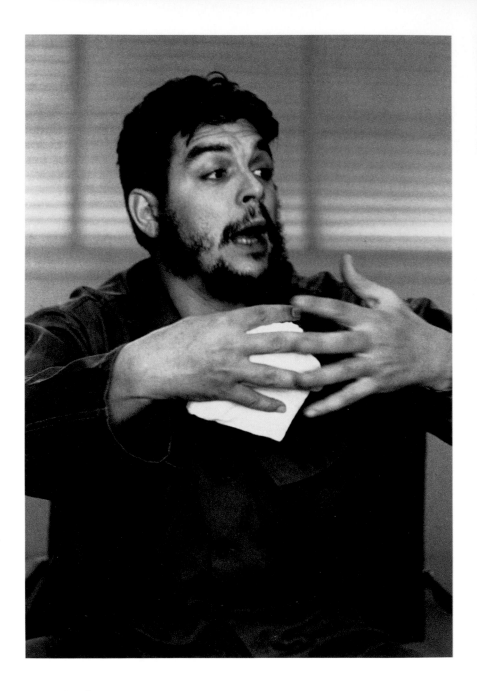

Look, *issue from
9 April 1963. Cover
and double-page
spread. The key pic-
ture was printed quite
small and heavily
cropped.*

Burri not only served as reporter in practically all the world's crisis spots, but also supplied photographs to illustrate essays and current news reports, took portraits of artist friends, and shot individual pieces whose formal austerity are reminiscent of Finsler's school. A reviewer once termed him a "complete photographer." Although his square portrait of Che Guevara is only one of many thousand pictures in his archive, it is his most famous work.

Burri had landed in Cuba on the day before. Even en route from the airport to the hotel, he had turned his camera on tanks returning from a parade. From this moment on, Cuba became a lifelong subject for him. But the high point of the visit nonetheless was the personal meeting with Ernesto Che Guevara – who in fact hardly paid attention to the photographer at his work. Che made, in fact, a nervous, driven impression on the photographer. Later Burri would compare him to a caged animal, a metaphor which supports the closed Venetian blind. Che saw his place in the armed struggle, not behind a desk, and it would not be much longer before a speech critical of the Soviet Union would marginalize him politically at home and make him decide to leave Cuba. His last public appearance would be in the middle of March 1963. At this point, Che went underground, turning up in Bolivia in 1966 under an assumed name. Barely one year later, in October 1967, Ernesto Guevara was tracked down in the jungle by the Bolivian military, captured, and executed. But the photographs of the dead revolutionary caught the public's eye for only a relatively short period of time. The student revolt of 1968 brought other pictures to the fore, namely the portraits by René Burri and Alberto Korda, both of which became ubiquitous icons of the protest movement. Commandante Che, returning as myth, had thus made himself immortal.

Che: *The last big
interview. Photo-
graph: René Burri*

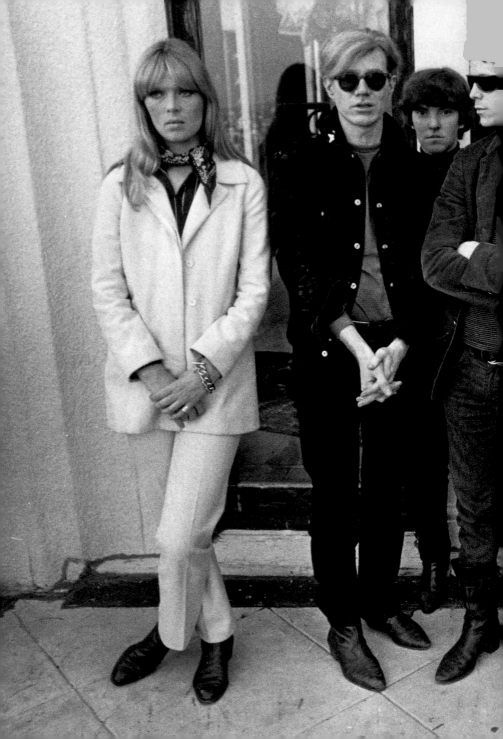

1966 Gerard Malanga
Andy Warhol and The Velvet Underground

Group Portrait with Nico

May 1966: Andy Warhol is making a guest appearance in Los Angeles together with the pop group The Velvet Underground and Nico. This is hardly his first visit to the city, but it marks his premier as a band 'member'. Also present on the occasion is Gerard Malanga, who can hardly have imagined that his rather relaxed group portrait will go down in the history of photography as proof of Andy Warhol's short but passionate excursion into Rock music.

The arrangement of the group expresses a historical reality, as it were: it reflects the actual dynamics of the band, even if the photographer, Gerard Malanga, has always stressed that nothing was set up or staged. "This picture almost didn't happen," says Malanga, by which he means that he stumbled into it almost by accident. That is, it was nothing more than a mere snapshot, a quick press of the button without any attempt at making 'art'. But this very artlessness is probably what lends the photograph its intrinsic charm. From left to right: Nico, Andy Warhol, and The Velvets in a relaxed atmosphere – cool and at ease because, after all, they are just posing for their friend with a borrowed Pentax, not for eternity. All that Gerard Malanga wants is a small photograph, for as a poet, performance artist, and co-worker in Andy Warhol's Factory, Malanga has not yet felt the call to become a photographer, and he only picks up a camera on rare occasions. But even so, he is nonetheless conforming to one of Henri Cartier-Bresson's famous dicta: "You can't photograph a memory." In other words: when should you photograph something, if not now?

Career in the Land of Unlimited Opportunity

It is May 1966. They've all come together on the terrace of the 'Castle': Lou Reed, the only one refusing to look into the camera; behind him, almost hidden, the androgynous-looking Maureen Tucker; standing to the right of Lou is Sterling Morrison. John Cale is seated. It is obvious that he and Lou Reed form the great antipodes of the group. Without their even wishing it, the conflict between them is palpable in the photograph, which almost brilliantly reflects the deep rift within the band. To the far left and completely in white is the beautiful Nico, the lead singer of The Velvet Underground. She is a discovery of Andy Warhol's whom he has described as weird and silent. "You ask her something, and she answers you maybe five minutes later." Warhol has cast himself once again in the role of a little boy, a game that he greatly enjoyed, according to Malanga. Warhol's pose in the photograph might be described as awkward, even inhibited. But one shouldn't be fooled by appearances, for with Andy Warhol everything is calculated, including the mannered way he uses his hands. Malanga says that it's a style that he picked up from Cocteau, and adds: "Andy was very aware of this."

Andy was aware of everything. And as befits this consciousness, he began to work on his image early in his career, and the first step was a change of name. An appellation like 'Andrei Warhola' scarcely provides a ticket to success in the Land of Unlimited Opportunity, and the man who was described by John Lennon as the world's best publicity star was aware of this from the beginning. 'Warhola' pointed back to his Slavic roots, stamped him as a weird stranger, underlined his origins as a poor immigrant. And this was precisely what Andy wanted to get away from – the entire milieu, and in particular the city where he spent his childhood: Pittsburgh, a dirty, soot-filled Moloch, center of America's vast iron and steel industry, with all the charm of the notorious Ruhr Valley, or Manchester at the height of the Industrial Revolution. He wanted to escape from all that, to get out into the great land beyond, to share in the "American Dream," to make his mark and become rich and famous – it really didn't matter how.

Typical symptoms of a poor-boy-made-good

When he finally 'arrived' – after he had gotten rich and became a star – Warhol manifested the typical symptoms of a poor-boy-made-good. Dur-

Gerard
Malanga

Born **1943** in New York Bronx. Collaborates clos with Andy Warhol the **1960**s. Designated by the *New York Times* as "Warhol's most important associate". **1964–66** collaboration on over 500 different 3 minute *Screen Tests*. **1967** publication of the book of the same name. Publication of his own photographic works in the form of four monographs to date, the last being *Resistance to Memory* (**1998**) and *Screen Tests, Portraits, Nudes 1964–1996* (**2000**). In addition, some one dozen literary works and two CDs. **1999** major retrospective in Brussels. Lives as photographer and Warhol expert in New York

ing the week, he took on the role of provocateur, but on Sunday, he crept back into church. Warhol donated alms to ensure himself a place in heaven, but was irresponsible in paying his employees and helpers. A consummate Scrooge who appreciated nothing more than the crinkle of a crisp new dollar bill. An artist who loved money so much that he even painted it. A petty bourgeois who slept on pillows filled with crumpled greenbacks. A pack rat who couldn't let anything go, who checked every bit of trash for fear that someone might comb through it and start selling the contents as souvenirs. A peacock who let himself be chauffeured around in a Rolls Royce, all the while complaining about his financial troubles. And yet at the same time, Andy Warhol was an extremely creative spirit who left almost no field of art untouched. He was a writer and poet, a film-maker and photographer, and the founder and publisher of the now-legendary magazine *Interview*.

Through his engagement with The Velvet Underground, he even fulfilled his dream of having his 'own' rock band. With some degree of success he also designed album covers: for The Velvets, of course, but also for the Rolling Stones' famous album *Sticky Fingers*. And, if one takes his constant self-staging into account, Andy Warhol was also an actor – or rather, a

*Gerard Malanga:
Andy Warhol with
The Velvet Underground & Nico, The
Castle, 1966 (contact
sheet, detail)*

twenty-four-hour performance artist. And of course, above all he was a painter.

One has to admit, whatever he took up, he rubbed it against the grain. Every discipline to which he submitted himself (if the word 'submission' can be applied to Warhol's approach), he grasped with the naive intuition of a child – and ended up doing whatever he wanted with it, flaunting every rule of the game in the process. Thus, as a matter of principle, the book that he wrote had to be bad; that is, it was intentionally full of spelling errors and other problems. His numerous underground films transgressed not only the rules of narrative cinematography but also the sitting power of the average movie-goer. And naturally the rock group that he joined was something which, as Cher phrased it at the time, "will replace nothing – except maybe suicide" – a critique that The Velvets of course immediately conscripted into their own PR. Last but not least, Warhol was a painter; but also here, his 'painting' had nothing to do with the canvases created by the ingenious hand of the traditional artist.

Adoption of everyday, banal objects

Andy Warhol's first coup was the creation of a new canon of motifs. Truly revolutionary for the early 1960s, a period still stamped by the abstract expressionism of a Pollock or de Kooning, Warhol's adoption of everyday, banal objects, his interest in the trivial myths of America from Coca Cola to Campbell's Soup, was truly revolutionary. But Pop – that is, the artistic treatment of everyday objects – had had its practitioners before Warhol. His true significance for recent art history lies elsewhere: Warhol taught us to redefine the concept of the artist, artistry, and art itself. In this sense, he in no way saw himself as an ingenious artist-individualist, but rather as the boss of a fractious troupe. Significantly, Warhol did not maintain a studio, but a "Factory"; and the Marilyns, Elvis Presleys, dollar bills that were produced there on the assembly line had more to do with photo-mechanic reproduction than with talented brush strokes. Lawrence Guiles describes Warhol's somewhat complicated process: first the artist searched through newspapers and magazines for a picture that intrigued him; he cut it out, and reproduced it to whatever size he wanted. Then he coated a silk screen with a light-sensitive layer and produced a stencil that enabled him to make innumerable copies of his image. As Guiles points out, photography lay at the root of the process.

Photography as a mode of artistic expression

But in May of 1966, neither Andy Warhol nor his 'student' and co-worker Gerard Malanga had yet discovered photography as a mode of artistic expression. As a child, the latter had used his Kodak box camera to shoot a photo of his beloved Third Avenue El – the New York elevated railway – before it was torn down, and later, in 1965, he had worked with Andy Warhol on his so-called 'screen tests', activities which in a sense served as an entrance into the medium. But not until 1969 did his portrait of the writer Charles Olson and the multiple prints that he immediately produced from it become the starting point for Malanga's intensive engagement with the art of photography. Meanwhile, Warhol for his part began increasingly to take Polaroids – probably as an outgrowth of his work for Jimmy Carter, Willy Brandt, and Golda Meir – and then to produce screened patterns from them in the fashion described above. Warhol also carried his small-format Minox along with him, but, as the photographer Christopher Makos explains, a Minox requires focusing, which was not at all of interest to Warhol. As a result, Makos introduced the artist to the new auto-focus cameras.

Warhol acquired a modern Canon in addition to his small Minox camera. According to the historian David Bourdon, it was the Canon that enabled Warhol to take his notoriously indiscreet snapshots of, for example, Truman Capote visiting a plastic surgeon, or Liza Minelli stepping out of the shower. In all, there were several hundred of these candid photographs that Warhol did not hesitate to publish in his book *Exposures*. In other words, in the early 1970s, Andy Warhol emerged a diligent photographer. His importance to the history of photography, however, does not lie so much in his prima facie assemblage of photographs in itself. As paradoxical as it may sound, his real significance as a photographer arises from his painting: insofar as Warhol won recognition in the field of art through his pictures created with mechanical means and produced (i.e. printed) in great numbers, he also broke the ice for a new photography based on mechanical production and 'endless' reproducibility.

And yet, as everyone knows, Andy Warhol had begun his career in the early 1950s as a commercial and advertising artist. The work that he produced during this period for Condé Nast (*Vogue*) and I. Miller (shoes) is among his best. But Warhol wanted to be more than a simple, anonymous 'hand', and he felt himself drawn toward art without, however, having

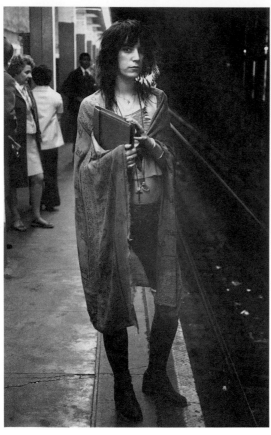

Gerard Malanga:
Patti Smith on plat-
form in the 68th
Street/Lexington
Ave. subway station,
New York City, *1971*

any particular theme in mind, let alone a message. Even later he managed without 'messages', of course; and in fact many critics found his pictures fascinatingly empty – candy-colored nothings. On the other hand, Warhol's biographer Guiles argues that Warhol presented this 'nothing' in such a bold and striking manner that it was impossible to overlook. At the end of the 1950s, Warhol decided to turn to Pop, that is to the artistic translation of popular objects – such as comics. But here it was already too late, for comics were already the domain of Roy Lichtenstein. Depressed, Andy complained to his friend Muriel Latow that he didn't know where to begin, and asked for some inspiration. Latow's answer: he should choose a common object, something ordinary that one sees every day, but takes for granted – for example a can of soup. Andy Warhol's face lit up in a smile: the suggestion proved the turning point both of the evening and of the history of painting.

Thus, Andy Warhol took up painting Campbell's Soup: Noodle, Tomato, Chicken. And he became famous – but such fame was still a far cry from recognition as an artist. Until the end of his life, many considered him no more than a seasoned charlatan: a talented draftsman, certainly, but as an artist, a dud – and as a human being, the dregs. The New York Museum of Modern Art, for example, stubbornly refused to mount a retrospective of his works. Only after his death – and then without hesitation – did the MoMA finally mount the show that the artist had so long wished, and afterwards, it moved on to Chicago, London, Cologne, Paris,

and Venice. In other words, the curve of Andy Warhol's career was anything but steep and continuous. His beginnings as an artist were in fact rather discouraging; for many years, his attempts to find a niche in respected galleries remained unsuccessful. "Andy, lay off," the *New York Times* advised at regular intervals; "you're not real art." Willem de Kooning, the exponent of an abstract expressionism that in many way constituted the antithesis to Warhol, spoke out even more clearly, screaming out his hatred of the Pop artist in public, and accusing him of killing beauty and joy.

Everybody's plastic, but I love plastic

Andy Warhol understood very well how to polarize anything he touched – including his comparatively brief excursion into rock music. He had set out searching for a band already in late 1965. Theater producer Michael Myerberg was in the process of opening a new club in an abandoned airplane hangar in Queens, and declared himself ready to christen the shed "Andy Warhol's Up," on the condition that the Pop artist would provide the music. Before Christmas, on a lead from Barbara Rubin, Warhol listened to a rock group called The Velvet Underground in the New York café Bizarre. Right from the start, Warhol got along brilliantly with Lou Reed, as Warhol's biographer Victor Bockris reports. And thus, several days later, negotiations began in the Factory. Bockris tells how the 'coked-up' Velvets felt almost magically drawn to Warhol, and that Lou Reed was hit the hardest, because, like Billy Linich and Gerard Malanga, he had simply been waiting to be formed by a master hand. Andy gave Lou ideas for songs, and hammered the importance of work into him. The appearances that Warhol organized and directed turned into multimedial events. In short, he professionalized the Velvs and made them famous. But as to the identity of the true star of the show, Bockris leaves no doubt. After all, almost no one had heard of The Velvet Underground or Nico, but Andy was already a celebrity. And there he sat, elevated high above the dance floor, operating the projectors and exchanging the light filters.

At the beginning of May, the group had a gig in Los Angeles, and 3–15 May, Warhol and The Velvets were scheduled to appear with Nico in the "Trip." The group was staying in what was known as the Castle, a private house modeled along medieval lines, and probably conforming fairly

well to Warhol's taste. "I love L.A.," he once announced, "I love Holly-wood. They're beautiful. Everybody's plastic, but I love plastic. I want to be plastic." Our picture was taken on the terrace of the Castle. Gerard Malanga set the borrowed Pentax on a stand, which accounts for his own inclusion in several variants of the photograph. In the first versions of the picture, The Velvets are laughing, or at least smiling. Here, however, they are serious, almost ill-tempered. After only a few weeks, their "Trip" had been closed down by order of the local sheriff. The local press expressed a less negative response to The Velvets, calling the arrival of Andy, the super-hippie, on Sunset Strip the greatest match since French fries dis-covered ketchup.

Enter Valerie Solanas, radical feminist

Thirty-seven years old in 1966, Andy Warhol was almost at the height of his international fame – which is not, however, to be mistaken for popu-larity. The manner in which he stylized himself – his Gay affectations; his waxy, elfin-like being; his almost albino coloring, accented by pimples and nylon wig; his feeble charm combined with an eloquence that hardly rose above "Uhmm," "Crazy!" and "Super!" – these were not the sort of things to turn him into a national favorite. On the contrary, he had ene-mies, including some who were not content to leave the matter at verbal attacks. On 1 June 1968, for example, exactly two years after our picture was taken, Valerie Solanas, a radical feminist, turned up at Warhol's New York Factory and in a state of fury laid the artist low with several bullets. Warhol, although given up by the doctors, nonetheless survived. Robert Kennedy, also the victim of an assassination attempt in the summer of 1968, died. "That's the way things are in this world," Warhol's artist col-league Frank Stella is reputed to have said.

There's no question: two bullets from the barrel of a crazed feminist would have been precisely the fitting end for the publicity-seeking Warhol – at any rate more suitable than the simple gall bladder operation that Warhol in fact succumbed to at age fifty-nine in 1987. A few days after his unexpected death, his body was carried back to Pittsburgh, where he was buried. The city of his childhood had claimed him once again – and the local grave-digger reveled in what he termed his first famous burial. Andy Warhol's chapter in history by no means ended with his death, however. The mountain of pictures, antiques, and knickknacks that the

social climber – forever plagued by insecurity about the future – had collected in his various domiciles now awaited new owners: On 23 April 1988, Sotheby's in New York began a ten-day auction of Warhol's estate. The five volumes of the catalogue comprised 3,429 items, and more than six thousand people wanted to attend. These figures were harbingers of what was to come. As Victor Bockris reports, the auction house had underestimated the hammer price in almost every case. For example, at $77,000, Warhol's Rolls Royce brought in more than five times what had been reckoned; a ring estimated at $2,000 went for $28,000; and a Cy Twombly was taken up to a record price of $990,000. Last but not least, Andy Warhol's candy jars, with a market worth of perhaps $2,000, were sold for a total of $247,830. The entire estate, which Sotheby's had estimated at a value of $15 million brought in more than $25 million. And what would Warhol have said to all this? Fran Lebovitz, a friend and co-worker on *Interview*, is reported to have glanced heavenward and said: "Andy must be furious that he's dead."

Gerard Malanga: Andy Warhol/"Factory" group photo, New York City, 1968

Top row, left to right: Nico, Brigid Polk, Louis Waldon, Taylor Mead, Ultra Violet, Paul Morrissey, Viva, International Velvet, unknown.
Below, left to right: Ingrid Superstar, Ondine, Tom Baker, Tiger Morse, Billy Name, Andy Warhol

1973

Barbara Klemm
Leonid Brezhnev, Willy Brandt, Bonn

In May 1973, Leonid Brezhnev, Chairman of the Soviet Communist Party, visited Bonn, Germany. This first appearance of a Kremlin leader in West Germany since the end of the war had been preceded by a controversial visit of German Chancellor Willy Brandt to the Soviet Union. Now, after so many years of Cold War, the road finally seemed to be cleared for good neighborly relations, in the words of the Soviet journalist Valentin Falin.

The small group of three has retired into a room in the Bonn Chancellery. The date is Saturday, 19 May 1973. Actually, a standing reception had been scheduled to take place before lunch, but owing to circumstances, the men had now settled down into the dark-upholstered suite of chairs. The figures are easy to identify: from left to right are the Soviet Communist Party Chairman Leonid Brezhnev, German Chancellor Willy Brandt, and the German Foreign Minister Walter Scheel. Undoubtedly, there were other people also present in the room, but the camera concentrated on the protagonists of a meeting that appears to have entered the critical phase at just this moment. The atmosphere seems tense in the photograph, even though none of the participants are indicating any agitation or excitement by means of wild gestures. Quite the contrary, in fact: Brezhnev appears to be thinking something over; Willy Brandt, whose suit jacket has slipped up somewhat, looks at him questioningly; and Scheel, Foreign Minister and chairman of the liberal Free Democratic Party, seems at this moment more or less relegated to the role of an onlooker. Looking at this picture, one might be inclined to say that there is a sense of excitement emanating from the group of five translators and advisers who are whispering together as they stand or bend over the protagonists.

Guests from the fields of politics, economics, and culture

The press had been regularly reporting on what the group was eating and drinking; in the picture, we see only water and what appears to be orange juice; to the right, someone finds a moment to munch on some biscuits. But the leaders had been able to pamper their palates the previous evening at a banquet in Brezhnev's honor in the Palace Schaumburg, to which the chancellor had invited more than sixty guests from the fields of politics, economics, and culture. Helmut Kohl (then the CDU opposition leader in parliament) had turned down the invitation, however; officially the reason was his displeasure that Rainer Barzel, CDU party chairman, and Gerhard Stoltenberg, chairman of Foreign Relations Committee in the Bundesrat, had not also been invited. In general, however, the German press had treated such internal political concerns as side issues. The newspaper headlines devoted themselves to what they felt was a historic visit, even if it was not at all clear what the political results might be. The arrival of the General Secretary of the Communist Party of the Soviet Union in Bonn on 18 May marked the first official state visit of a Soviet party chief since the Second World War. In terms of internal Soviet politics, Brezhnev had laid the groundwork for his journey carefully. The Germans in turn had had to be particularly careful, lest a relaxed German-Soviet dialogue cause ripples among the western Allies. In addition, there were doubts from diplomatic quarters as to whether Brezhnev – who was the head of the Communist Party, but not of the Soviet state – was the right political partner for discussion. But here, too, pragmatism ruled the day. The conservative *Frankfurter Allgemeine Zeitung*, for example, granted in its end-of-the-week edition of 18 May that in meeting with Brezhnev, Brandt was in fact conferring with the top Soviet official. According to the paper, Brezhnev had in fact as much competence as the West might wish for – "and not only because he had unobtrusively begun to co-sign international treaties for the Soviet Union."

On the whole, the signs looked favorable. The headline of the Moscow newspaper *Novge Vrenia* announced that the barometer forecast good weather, and expressed the hope for a lasting peace between the peoples of The West and the East. Fifty-one percent of the Germans rated the visit as "good and useful" – a judgment which might well have been called forth by Brezhnev himself, who behaved in a markedly jovial manner, and seemed much more open and 'western' than any of his predecessors,

Barbara Klemm

Born **1939** in Münster. Trains in a studio for portrait photography. From **1959** works for the *Frankfurter Allgemeine Zeitung*. Since **1970** editorial photographer for the *FAZ*. Member of the Academy of Arts Berlin-Brandenburg since **1992**. Numerous awards, including **1989** Dr. Erich Salomon Prize of the DGPh. Numerous exhibitions, most recently **1999** a major retrospective in Berlin. Lives in Frankfurt am Main

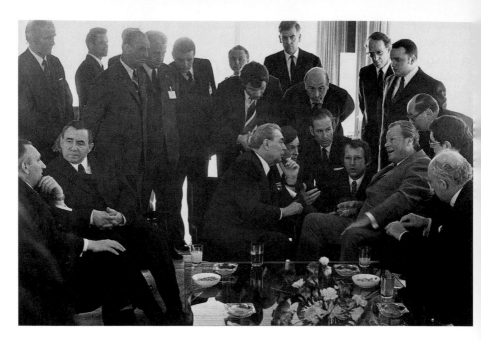

Barbara Klemm:
Brezhnev and Brandt
in Bonn, 1973

One of the lesser-
known variants of the
shot, with Egon Bahr
and Andrei Gromyko
left of the picture

ranging from Beria to Khrushchev. Even the Party's chief's "well-fitting
gray suit" won praise from the press, which described Brezhnev as being
a head shorter than the German chancellor, and went on to comment
that in spite of the Russian's broad face, he was in fact thinner than Willy
Brandt – who was in turn described as having acquired a "rather portly
figure" since he had given up smoking.

Aware of the particular significance of the visit

All the participants were undoubtedly aware of the particular significance
of the visit. According to the *Frankfurter Allgemeine Zeitung*, "the most
powerful man in the Eastern World is now on the soil of the Federal
Republic of Germany." The security measures were correspondingly high:
there were reputed to be approximately twenty-thousand security police,
both in uniform and plain clothes, protecting the Soviet party chief so
closely "that even the vast majority of the journalists were hardly able to
see the whites of his eyes."

For the occasion, nine hundred journalists had gathered in Bonn. Among
them was Barbara Klemm, born 1939 as the daughter of the well-known

painter Fritz Klemm. Since 1970, she had been the editorial photographer for the *FAZ*, and Brezhnev's visit was her first assignment in the West German capital. She and three colleagues were the only photographers to gain admission to the room with Brezhnev, Brandt, and Scheel; film and TV cameras were forbidden. In total, Klemm shot three or four rolls of film, and in the process caught the attention of the Communist Party leader. Brezhnev expressed surprise, so the story goes, that in Germany a woman was able to pursue "the difficult profession of a news photographer."

At the moment of the shot, however, Brandt and Brezhnev are deep in conversation. Their initial optimism appears to have given way to a skeptical reserve. At any rate, there is no trace of the hearty laughter with which Brezhnev had rung in his visit of state. What is remarkable is that the *FAZ* did not publish the key picture until several years later, namely in 1976 in connection with a report on an exhibit of Barbara Klemm's work in Hamburg. The rotogravure weekend supplement for 26–27 May 1973 gave preference instead to a total of four rather less impressive photographs.

The beginning of day-to-day German-Soviet cooperation

The discussions between Brezhnev and Brandt – between Russians and Germans · turned out in fact to be more difficult than originally expected. Two years after the initial meeting in Crimea, which had been termed a milestone on the road to normalization, and one year after the signing of the Moscow Treaty, the constructive dialogue ground to a halt once again over the status of Berlin. The leaders by no means reached a consensus on the issue; on the contrary, negotiations were tough: ten hours on Sunday alone in order to turn the visit into a political success. The tense atmosphere so palpable in Barbara Klemm's picture, however, arises from a much more mundane cause. According to reports, the Communist Party Secretary had begun to suffer from a toothache; thus a change of schedule needed to be discussed. For this reason, a press photograph came to mirror a meeting whose political results were thin, but whose long-range significance can hardly be overestimated in terms of subsequent history – in the words of the *Frankfurter Allgemeine Zeitung*, neither more nor less than an age of "day-to-day German-Soviet cooperation" had begun.

Barbara Klemm:
Brezhnev, Falin and
Brandt

The photogravure
supplement of the
FAZ on 26–27 May
1973 had this group
portrait as the lead.
The actual "icon"
remain unprinted at
the time.

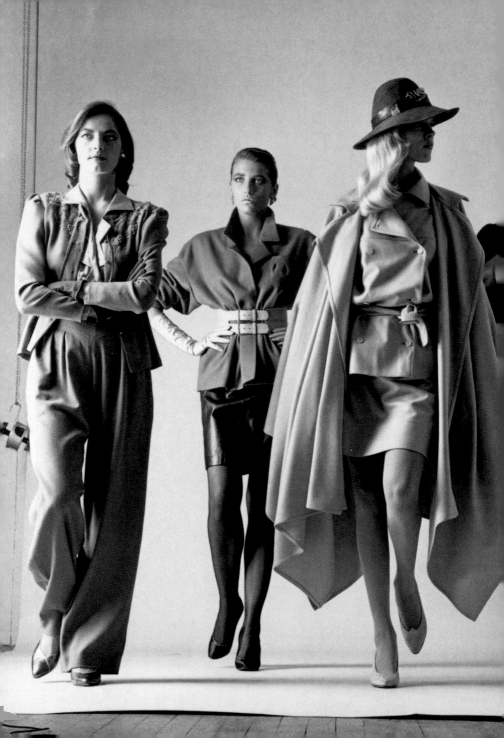

1981 Helmut Newton They're Coming!

Ice-Cold
Self-Con-
sciousness

The photograph marked a turning point – and it was, of course, intended to be provocative. In fact, not until 1981 did the French *Vogue* feel ready to publish Helmut Newton's diptych *Sie kommen!* as an erotic metaphor for the changing image of woman.

This time there were no Italian gardens or fin-de-siècle hotel rooms, no beaches on the Côte d'Azur, no promenades, no New York apartments with a view, or well-appointed rooms in the 16th Arrondissement. In their place, only the sober, empty chamber of a professional studio. That was unusual for Helmut Newton, who loved to stage scenes, especially in settings that exuded life and vitality (or at least he did at one time). His photographs, which many believe to have been schooled in the German cinema between the wars, were sometimes set even on bridges or in underground passageways, in train stations or airports. It all depended on what Newton's fat notebook – that irreplaceable store room bursting with ideas that have feasted on reality – proposed. Newton was a realist – if one accepts the idea that dreams, desires, and fantasies also belong to the inventory of reality. But his inventory had one important difference from the world of things that surround us: namely, one does not need a drawer for them. Helmut Newton provided images for those forces that move the world beneath the skin, as it were – our collective passions, fantasies, suppressed desires, and sublime wishes. And he did this not for the sake of the public, but for his own sake. If he had concerned himself about what the public might like, he would never have created another picture, he said. "No, I do only what pleases me."
Helmut Newton was a gardener of our secret desires. And without doubt, he was the best-known gardener of the kind, and was therefore automatically the most controversial botanist of our collective longings. He was a latter-day pupil of Freud, whose medium was of course not the couch,

but the camera. Whether small format or 6 x 6-inch, whether ring flash or daylight – technical data are of little help in mapping the rich idea-landscape of a Helmut Newton. He created a cosmos enclosed within itself, subject to its own rules, which Newton, with his aversion to all theories, never attempted to organize into a program, but which nonetheless allow themselves to be distilled in retrospect. Newton's "film stills", his frozen scenes, are clearly artificial, but at the same time thoroughly consistent with the interior world created by the photographer; the scenes revolve around power and submission, around force and passion, seduction, pleasure, and physical love. His arrangement of his realm is unmistakably vertical: there is no sense of egalitarian togetherness among his figures, but rather clear hierarchies of power, although – and we will return to this point later – the woman is clearly given the determining role. Boots and whips, saddles and spurs, German shepherds, chains, high heels, are recurring symbols in a complex system of visual symbols set always against mirrors and broad corridors, stairs and balconies that rise to dizzying heights, swimming pools and bridge railings: in other words, flight and fall, plummeting and death are always at least implicated in Newton's pictorial world.

Fashion as an excuse for something else

Helmut Newton loved to arrange scenes and thus to achieve absolute control over his picture. Moreover, the writer Michael Stoeber finds this to have been a tendency throughout the artist's life. Anyone who, like Newton, has been cheated out of a life plan – however it may be defined – in the course of time compensates for the loss if possible by searching for some form of "absolute control over his own life." Born the son of a Berlin button-factory owner in 1920, Newton left – that is, felt compelled to leave – Germany at age eighteen. His decision proved correct, as the fate of his photography teacher Yva in Auschwitz demonstrates, even though both his journey to Australia and his entry into the field of professional photography were difficult. In the early 1960s, Newton returned to Europe, where he found a congenial platform for his work, particularly with the French *Vogue* under its courageous editor-in-chief, Francine Crescent. Note well: at this point in time, moral boundaries were still quite narrow. Nevertheless, the unmistakable signs of change were beginning to emerge – at first (cautiously) in Ed van der Elsken's volume of photo-

Helmut Newton

Born the son of a button manufacturer in **1920** in Berlin. **1936–38** apprenticed to the studio of the Berlin photographer Else Simon (Yva). **1938** flees from Germany. From **1940** in Australia. Australian citizen from **1944**. Marriage to the actress June Brown (alias Alice Springs). **1956** return to Europe. One year in London. **1957** moves to Paris. Works for *Vogue, Elle, Marie Claire, Jardin des Modes, Nova, Queen*. From **1971** on an increasing number of autonomous projects. **1975** first one-man show in the Paris Nikon Galerie. **1976** publication of his first book, *White Women*. **1987** major retrospective in the Rheinische Landesmuseum, Bonn. **1992** awarded the Order of the Federal Republic of Germany. **2000** retrospective at the Neue Nationalgalerie, Berlin. Dies **2004** in Los Angeles

Helmut Newton: They're Coming! (naked), 1981. The shot unquestionably ranks among Newton's best known images from the eighties.

graphy, *Love in Saint Germain-des-Prés*, in 1956, and later (openly) in the much-cited 'sexual revolution' around 1968. In a certain sense, Helmut Newton was, or became, a part of this movement. On the one hand, he and the pictorial world he created profited from the increasingly liberal morality of the age. On the other hand, his constant exploration of the possibilities also led to an expansion of the limits of tolerance. Newton

thus simultaneously functioned as a catalyzer and an exploiter of the development.

Helmut Newton was a fashion photographer – and nothing less than that. He photographed clothes or, as one calls them in the industry, 'collections'. The cut or the fabrics – the 'buttons and bows' in the language of the fashion editors – interested him only peripherally, however. For Newton, fashion was rather a pretext for something else, although – and this makes his work easier – the path from fashion to his passion was not a long one, when one recalls that fashion, in the sense of the age-old game of revealing and concealing, lies also at the core of all sensuality. Newton's visualizations may have been connected with a contract, but they are nonetheless steeped in his personal desires, wishes and dreams, delights and fears. Furthermore, his success only goes to show that his photographs touch the depths of collective longings. Newton translated into pictures that which many hardly dare to think.

The voice whispering to Newton was that of reality. He loaded his creative batteries, so to speak, from everyday life. The artist always insisted that he was little more than a voyeur, a claim which coquettishly borders on understatement, but nonetheless reveals the conceptual core of his photographic work – an art, moreover, which is schooled in life at its fullest, gaudiest, and most pleasurable, or conversely when it radiates on lighter and softer frequencies. Newton's powers of perception were both alert and selective: the "bad boy of photography," as he liked to call himself, picked up the lascivious signals that he then translated into pictures that succeed in being provocative even in an age that is largely without taboos. "I am," as Helmut Newton pointed out, "a good observer of people." That is, he was a seismographer of those waves which people – preferably "cool girls" – emit through gestures, glances, their way of walking, or even their clothing. The street was the costume room for his pictorial ideas, enriched through a bit of haute-volé that transcends the trivial and passes into the fabulous. "The people in my pictures," according to Helmut Newton, who did not at all attempt to hide the parameters of his creations, "have been 'arranged', as on a stage. Nonetheless my pictures are not counterfeit; they reflect what I see in life with my own eyes."

In this connection, Newton liked to refer to a photograph titled *Eiffel Tower* (1974), initially published in *White Women* – Newton's first book, which was particularly important in laying the groundwork for the later

reception of his photographs. "Tower" is a late-evening view into the rear seat of a limousine that has been transformed into a 'bedroom'. A beautiful young blonde woman is lounging In the midst of the black leather cushions; apart from her leather jacket, which is already pulled open, she is wearing only transparent undies embroidered with an Eiffel Tower – images that sing of Helmut Newton's penchant for double meanings and ambiguity, in the words of Klaus Honnef. In the background, an anonymous man has begun to work on her, fumbling with the zipper and helping her out of her high-heeled boots. "The scene," according to Newton, "undoubtedly takes place after work – a business man has a date with his girl friend. He is wearing a blue suit, handsome cufflinks, and drives a black Citroen DS – the typical auto of the bourgeoisie and of civil servants in France. Lying on the seat next to the woman is a copy of the establishment newspaper *Le Monde*. And what the man is doing before he drives home – he has not yet gotten to the stage of going to a hotel with his girlfriend – is undressing her in the automobile. That happens all day long in the Bois de Boulogne," explained Helmut Newton; "the autos are lined up as in an American lover's lane."

Basso continuo to his performance with the camera

Helmut Newton was fascinated by the idea that hiding under every woman in 'full dress' is a more (or less) well-formed body. Fashion was the theater curtain that must be pulled aside. And possibly – no, certainly – this nakedness, this ceremony, remained something of a basso continuo to his performance with the camera. Already in the mid-1970s, Newton started photographing girls in the Paris Métro: stark naked under a fur coat. An undertaking not entirely without danger, as the photographer admitted. "You can land in jail for something like that, because the Métro has very strict rules." But Newton loved to test the borders of the possible, in daily life as in art – which for him in any case flowed together. That these borders have clearly moved since the 1970s has a good deal to do with Newton himself, as mentioned earlier. Opening the curtain slowly, Newton radically altered our idea of what is allowed and what is forbidden. At the end of this process of development, his models were completely naked – without coat or furs – provided at most with the black stilettos that are a staple of his iconography: "When I look at a woman," said Newton, "my first glance goes to her shoes and I hope

that they are high. High heels make a woman very sexy and give her
something threatening."

An increasing obsession

Helmut Newton was an artist whose work has found its way into the
sacred halls of international art museums – which is all the more surpri-
sing considering that most of his photographs have a commercial back-
ground, and that he did not at all attempt to hide his origins in editing
and advertising. Newton succeeded in blurring the distinction be-
tween 'free' and 'applied' art for us – just as he himself never took the
border seriously. "Whenever I've worked on a commission, whether edi-
torial or advertising, I have always found my inspiration," he admitted.
"Not all, but almost all of my best photographs stem from these assign-
ments." Newton's ideas, as Sotheby curator Philippe Garner once noted,
were elaborate; they demanded the noblest raw materials and masterly
skill from experts – makeup artists, hairdressers, stylists. Newton, in
other words, needs a 'back office' that could be offered only by large
newspapers and publishing houses, with all the logistic and financial sup-
port they provide. Therefore, the humus from which his work grew was
the commission – even if not everything thrived in this soil, at least not in
the early years. This was a situation that bothered Newton, at least in
the official legend. "A dream of a contract," the photographer recalled;
"I'm supposed to take photographs in this grand hotel for the magazine
Réalités. I've got two interesting models, but I've also got a problem: my
first book, *White Women*, is almost done – just a few pictures are miss-
ing. For the book, the pictures should be rather bold nudes, but for
Réalités, I need elegant photos to fit in with the character of the maga-
zine. I decided to make two versions: one nude, the other clothed."
From then on, Newton admitted, his interest in the opposition between
'naked' and 'dressed' developed more and more into a passion.
They're Coming! was published for the first time in the November issue of
the French *Vogue*, and represented naturally the high point, and even in a
sense the crowning moment, of a passion which seemed hardly cap-
able of being carried any further. The editor-in-chief Francine Crescent
devoted a bold eight pages to Newton's series, a decision which, as Karl
Lagerfeld recalls, "placed her job at risk" once again. Admittedly, com-
plete nakedness combined with stilettos is almost part of the basic vo-

cabulary of Newtonian photographic art; one needs only think of *Rue Aubriot* (1975) or *Mannequins quai d'Orsay II* from Newton's second book, *Sleepless Nights*, which twice took up the opposition between 'naked' and 'dressed' (not to mention the artist's explorations of lesbian love, a theme which always intrigued the photographer). But the one picture was taken under protection of darkness, so to speak, and the other in the seclusion of a salon. Both photographs therefore exude something of an intimacy that Newton's pictorial vision clearly passed beyond – from his *Big Nudes* to the sequence discussed here.

The title *They're Coming!* – applied to the photographs only after their appearance in *Vogue* – underlines the resolution behind a nudity that is now 'worn' as a matter of course, but which also and especially signifies vulnerability. Seen in this way, Newton's women of the 1980s are "big nudes" in a double sense: large, strong, goal-oriented, and – whether 'dressed up' or unclothed – ready to conquer the world of men.

A horror of too much smoothness, too much perfection

The idea of dissolving the opposition between 'naked' and 'clothed' in diptychs is one Newton had already experimented with earlier in Brescia during the summer of 1981, in a sea-side Fascist-style villa. "The same situation, the same woman," recalled Karl Lagerfeld; "once dressed and once naked (but with high heels – for Newton, a woman isn't naked unless she's wearing high heels). The reconstruction is perfect; only one thing could not be replicated – the light. The sun had changed, and the unique hours were gone forever." Helmut Newton learned from his work in northern Italy; afterwards, he exchanged the admittedly charming ambiance of a summer villa for the antiseptic atmosphere of a Paris studio. The single model furthermore gave way to a group of well-built graces. The unclarity of motion that had been suggested in the Italian sequence was now replaced in favor of a truly 'frozen' entry in *They're Coming!*. Careful observers will note, however, that not all the details are logically followed through. Somehow, the pumps have gotten mixed. And the model on the back left has reversed the stationary and moving leg. In film one would say that the continuity is missing. Oversight – or intention deriving from a horror of too much smoothness, too much perfection? Newton emulated his women. He always valued dominant femininity. The high-heeled shoes, the strong upshot, the light, neutral background

UNE TAILLE FINE ET UN BUSTE PARFAIT

against which the contours of the women stand out as if chiseled all
strengthen the impression of the threat, especially in the 'undressed' ver-
sion. In the magazine business, the right side is usually considered to be
the more important. In the *Vogue* premier, the naked variant is to the left,
the clothed to the right – a layout that seems logical as long as one fol-
lows the direction of reading and reckons that the human being is initially
naked and only afterwards clothed. When, however, Newton was re-
sponsible for the order of the sequence, as in his *Big Nudes*, he reversed
them – perhaps indicating which of the motifs held more importance for
him. At the same time, the charm of the two photographs clearly resides
in their character as a diptych: only in terms of such a thesis and anti-
thesis does the theme develop its full interest. *Vogue* presented the
sequence under the title "Beauté – Silhouette 82". The lead-in was brief:
"Work on your body so it can wear the fashions of the coming season
with grace." Interestingly, in the autumn of 1939 a similar theme had
appeared in the French *Vogue*: looking toward the coming lines that were
fitted to the contours of the body: the corset had been reinvented and
was now being recommended once more to women. Today, one offers
them a fitness studio and hand-weights. Helmut Newton was without a
doubt a witness of the dramatically changing role of women in society.
And he was their important, if often misunderstood, iconographer.

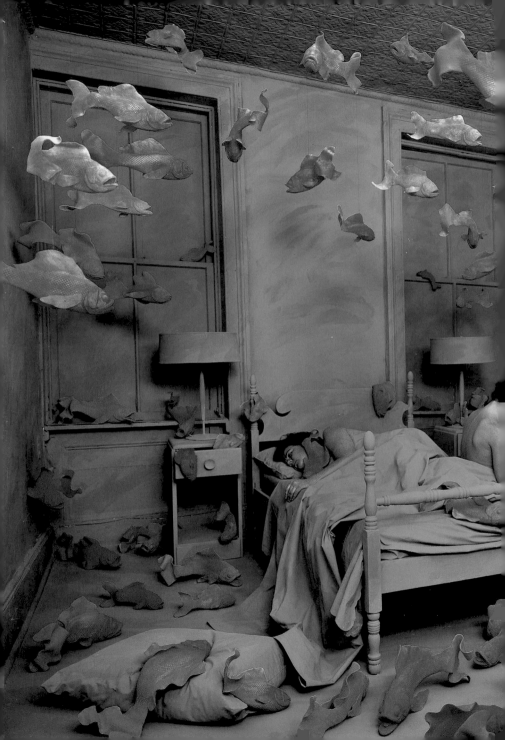

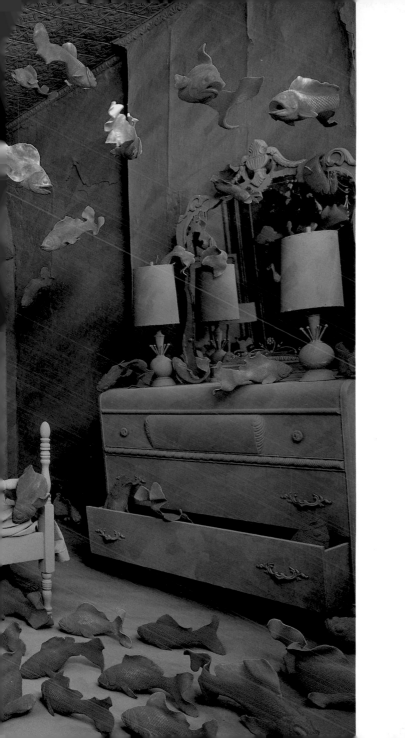

1981 Sandy Skoglund
Revenge of the Goldfish

The Mel-
lowest of
Night-
mares

Since the 1980s, photographic artists have increasingly taken to 'designing' their pictures. Consciously following the trail blazed by advertising, they have used imagination and wit to overcome the strictures of the Classical Modern. Rather than seeking themes in reality and 'taking' it straight, they invent new pictorial worlds. They often manipulate their pictures in the name of brilliant and outrageous ideas, and thereby take up the challenges posed by the Postmodern. Along with Cindy Sherman and David LaChapelle, Sandy Skoglund numbers among the outstanding exponents of this so-called 'staged photography' — although the New-York-based artist also wishes her constructed environments to be understood as art in their own right.

Revenge of the Goldfish: it's impossible not to feel the contradiction in the name given by Sandy Skoglund to the work she created in 1981. Her later tableaus would feature foxes– or dogs. The viewer may well be overcome by disgust on seeing *Germs are Everywhere* (1984), or succumb to a sense of discomfort in the face of the shimmering green felines in *Radioactive Cats* (1980). Even the fidgety squirrels in *Gathering Paradise* (1991) somehow seem more threatening than the over-sized goldfish that have somehow found their way into a middle-class bedroom. In fact, the two protagonists of the scene – mother and son (or is it brother and sister?) – seem to not even have noticed the arrival of the fish. The woman is sleeping, the boy is dozing as he sits on the edge of the bed. The scene oscillates oddly between the real and the surreal. What sounds threatening in the title reveals itself in the picture to be markedly peaceful and relaxed.

At most, it is the mass of the reddish-orange creatures taken as a whole that creates a rather alarming effect – fish that somehow have mistakenly wandered into an environment where they really do not belong. Much easier to understand is the room, in which we find everything that a conventional bedroom ought to offer: bed, dresser, lamp, mirror, latticed window. Admittedly, everything has been dipped into a swampy green wash – in fact the whole scene is somewhat reminiscent of an oversize aquarium. Can it be that the picture is thematizing the reverse of a standard assumption? Namely, that the people have become captives of nature, caught as it were in a foreign environment, just as in a 'normal' household aquarium, nature has been imprisoned by people?

Sculptures of papier-mâché, plaster, or polyester

Anyone confronting the photographic works of the American artist Sandy Skoglund for the first time – anyone who has recovered sufficiently from the trompe-l'œil effects of her minutely detailed installations to make out her goldfish, squirrels, cats, dogs, or babies for what they in fact are, namely sculptures made from papier-mâché, plaster, or polyester – will inevitably ask how she does it. In other words, once viewers realize that the scenes are amazing theater sets, located somewhere between fact and fiction, reality and artifice, they inevitably inquire after the technical and artistic processes she employs. To set the cards straight right from the beginning: Sandy Skoglund is responsible for all the creative steps involved in her work; she is consummately the author of her photographs, in the sense introduced by the French nouvelle vague. Skoglund develops her ideas and constructs her worlds in her gigantic Soho studio located in the midst of New York's art district. Here she designs and models her figures from photographic patterns that she has abstracted from magazines and other printed matter; she sets up her 8-by-10-inch large-format camera, checks the development of her 'scene' through the focusing screen, arranges the lighting – and then takes her photograph.

A plethora of photographic 'power acts'

According to her own understanding, Skoglund is neither sculptress, nor painter, nor photographer. Douglas Crimp once denoted the phenomenon of her work as a 'hybridization' of the arts. More precisely, Skoglund belongs to the generation of artists who are applying academic skills ori-

Sandy Skoglund

Born **1946** in Quincy/Massachusetts. **1964** high school degree. **1964–68** Smith College, Northampton/Massachusetts. One year in France studying art at the Sorbonne. **1969–72** studies Film and Multimedia Art at University of Iowa (M.F.A). **1972** moves to New York. Panel painting along the lines of Minimal Art. **1979** move to photography. Breakthrough **1981** at the Whitney Biennale with *Radioactive Cats* **1980** and *Revenge of the Goldfish* **1981**. Numerous one-woman shows, including **1992** in Paris, **1995** in Arolsen, **1998** in Northampton and **2000** in West Palm Beach. Lives and works in New York City

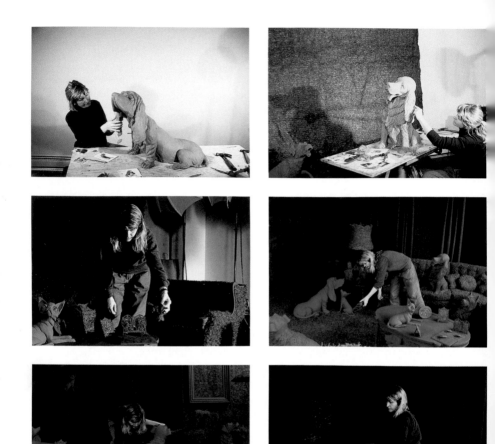

Sandy Skoglund: The Green House. *Preliminaries to her work finished in 1990. The artist only began in the late eighties to document the growth of her elaborate installations.*
Still more or less alone at the time, Sandy Skoglund now has her own team which helps her in the realization of her complex ideas.

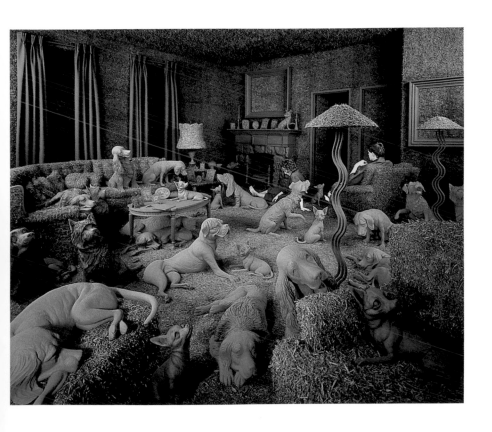

The Green House: *The finished piece. Skoglund's works exist both as installations as well as on celluloid.*

ginally acquired in the areas of sculpture or painting to what has become known since the beginning of the 1980s as 'staged photography'. The photographer may either find or invent what appears before the lens. The resulting picture may be a documentation, or a reaction to a situation specially created or arranged for the camera. "Document and discovery" – thus Jörg Boström has termed (1989) the two fundamentally divergent paths that photography has unconsciously pursued ever since Niépce's *View Out of the Window* (1827), on the one hand, and Daguerre's *Still Life* (1837) on the other. Whereas the Classical Modern apotheosized Paul Strand's definition of absolute objectivity as the ultimate task of all photography, including 'artistic' photography, the Postmodern photographer has in contrast shown a fascination for design. "Right now we are experiencing a plethora of photographic 'power acts' within the original medium of photography," Gottfried Jäger points out concerning the trend. He enumerates "staged works, montages, decollages, expansions of every sort that run directly and completely against the original intentions of the photographic process, and begin to undermine it, dissolve it. The picture's truth-to-reality is thus shaken and confronted with radical questions that make this 'truth' itself into the theme."

Cindy Sherman, Jeff Koons, and Teun Hocks 'stage' themselves before the camera; Joel-Peter Witkin and Joe Gantz on the other hand create narrative tableaus of sometimes shocking character. Arthur Tress and David Levinthal have meanwhile specialized in miniature stages; Calum Colvin and Victor Schrager, in still lifes. In a highly respected analysis published at the end of the 1980s, Michael Köhler comprehensively addressed these various approaches to staged photography, and brought Sandy Skoglund's work to the attention of a European audience, which in fact tended to be surprised, particularly by the fineness of the details. In America, Skoglund's work has been praised as towering over anything else being done in the pictorial field. Skoglund herself admits that her work demands much effort – not only on her part, but also on that of her viewers. "Obsession and repetition in the process of making things is one constant element in my work," the author has noted.

Traces of the American horror film

Oscillating as it does between the witty and the ridiculous, Skoglund's œuvre has been hard to place. Critics have variously attempted to locate

. somewhere between dream and nightmare, or within the art-historical tradition of Duchamp and Magritte, or under the categories of Dada and Surrealism. But strictly speaking, Skoglund's œuvre reveals the inspiration of much more trivial influences. Disneyland and the colorfulness of American West-Coast photography in general have made their mark on Skoglund. Also present are traces of American horror films and, naturally, the anxieties of middle-class America, which Skoglund handles with ironic flair. A breath of suburban tristesse wafts unmistakably through her work. She admits that mediocrity interests her, and "My own background is middle class, and class perceptions in terms of taste are at the root of a lot of the choices that I make."

Skoglund, the descendant of Swedish immigrants, knows what she is talking about. Born in Quincy in 1946, she grew up in California and went to school in the Midwest. 'Middle America' – the petty-bourgeois underside of the U.S. – is thus as familiar to the artist as the back of her hand. Hitchcock sent forth his flocks of gulls and crows in an attempt to crack open deadening small-town assumptions; Skoglund does the same with the cats, foxes, squirrels, and new-born babies that swarm forth to transform petty-bourgeois dreams into nightmares. Skoglund has been strongly influenced not only by American cinema, but also by European. As a nineteen-year-old art student, she spent a year in Paris, where she became fascinated by the possibilities of film. She acquainted herself with the nouvelle vague, watched movies by Chabrol and Godard, and flirted with the idea of film herself, but the division of work and responsibility in film-making contradicted her perfectionist impulses. Sandy Skoglund requires absolute control over every step, every detail. She ended her studies in the U.S., moved to New York, and took up minimalist painting. After years of searching and experimentation, she finally turned to photography: She found herself thoroughly bored by the work of traditional masters such as Steichen, Stieglitz, or Weston: even commercial art seemed preferable to that! She discovered the work of Ed Ruscha, terming it "the first photography...I really related to. I loved the anti-aesthetic – the dust, the scratches, the stupidity of the repetition..." What she basically values in photodesign is the calculability and manipulability of the end product – the contradiction between being and seeming, reality and artificiality. Skoglund feels that turning to natural images for stimulation is deeply embedded somehow in the American culture.

With her first, full-colored still life in hand, Skoglund approached a gallerist. Marvin Heifermann, at the time director of photography for Castelli Graphics. In spite of his interest in color photography, he initially found the artist's work exaggeratedly shrill. Skoglund did not give up, however, and Heifermann soon found himself fascinated and genuinely amused both by the detailed realism and the eclectic content he discovered in Skoglund's photographs – everything from Walt Disney to horror films. With *Ferns* and *Radioactive Cats* at the end of the 1970s, Skoglund had in fact discovered an art strategy for herself that corresponded equally to her affinity for painting, film, and photography. Now she could successively take on the role of script-writer, stage designer, painter, sculptress, director, and, ultimately, photographer. "In this approach," remarks Michael Köhler, "the whole point is to use photography as an aid in presenting imaginary worlds, inventing pictures. Out of this, an interesting double-layered base is called into existence, because observers assume that what has been photographed is real, but by looking more closely, they notice that they have been fooled. This whole trend plays with this reverse, or flip-flop, effect."

Environments with unparalleled attention to detail

As mentioned earlier, Sandy Skoglund is by no means the sole exponent of staged photography, but she is the only artist who conceives, constructs, and sells her installations as works of art alongside their photographic representations. The critic Ann Sievers speaks of the "interdependence and equal status" of the two forms. Carol Squiers explains; "The photo and the installation are nominally the same and yet they are different in both obvious and maddeningly subtle ways." Skoglund's procedure is correspondingly exact; she is not satisfied to make a sham just for the camera, but instead, creates complete environments with unparalleled attention to detail, working a half year to produce a single scene. Her work is extremely labor intensive, requiring far more effort than would be needed to produce a photograph alone.

Today, viewers may respond to Skoglund's elaborate tableaus with fascination, shock, or amusement, but in the early days, her scenes chiefly elicited confusion and irritation in the art world. Diane Vanderlip, curator of the Denver Museum of Art, recalls a conversation with Lucas Samaras and Philip Tsiaras in the early 1980s in which she asked for their opinion

of two of Skoglund's works. They
pronounced it highly intelligent, but
questioned whether it was serious
art. Vanderlip let the works go; later
she discovered her errors and pur-
chased *Fox Games* for the Denver
Museum of Art – at a price of
$40,000.

Cindy Sherman has staked out
media and cultural criticism as the
special areas for her self-stagings.
Skoglund, by contrast, does not
pursue any similarly identifiable

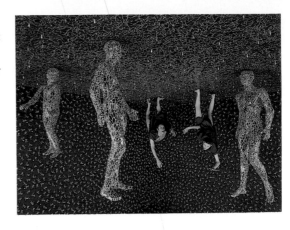

*Sandy Skoglund:
Breathing Glass, 2000*

*An example of Sandy
Skoglund's more recent
work. Once again live
performers become part
of a surreal staging.*

intention with her pictures. The artist denies that her works reflect a
single intention. Nonetheless, many viewers sense a connection between
Radioactive Cats and the debates on the atom, or interpret *The Green
House* as a contribution to the discussion about the greenhouse effect,
and take *Maybe Babies* as a comment on the abortion debate. According
to the artist, however, similarities with contemporary problems are, so to
speak, merely accidental. She defends a less narrow approach, arguing:
"If the politics are open rather than closed, the piece adapts to the envi-
ronment rather than the other way around."

Skoglund's works appeal more to the senses than to the intellect. As an
artist, she relies upon the emotional intensity of her work and finds a
similarity between their effect and the manner in which Hollywood films
manipulate emotions. So-called 'high art' does not interest her. In a
moment of epiphany early in her career, she realized "the idea of making
[conceptual] art was not a good way to approach things… Instead, I saw
myself as trying to make something that my relatives could understand."
This direct approach has been her trademark through the decades.

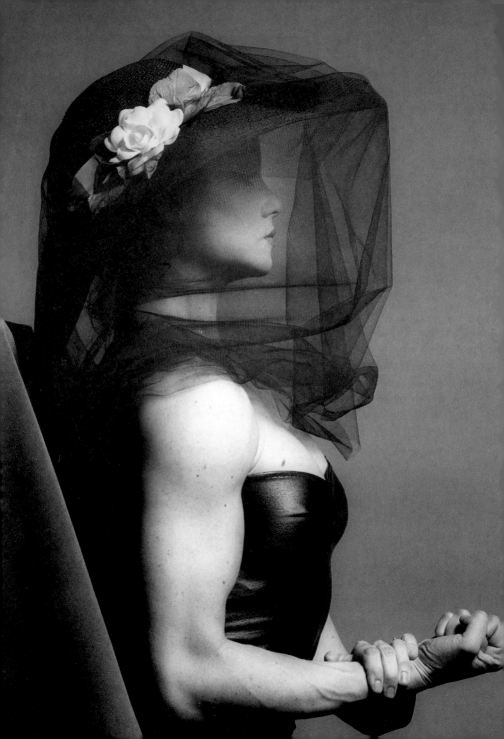

Robert Mapplethorpe
Lisa Lyon

1982

The most-talked-about photographer of the 1980s, Robert Mapplethorpe was a belated classicist who understood how to present provocative themes in catchy visual images. After his photographic work with the New York leather scene, male nudes, and erotically-charged flower studies, Mapplethorpe turned his lens on the first female world champion in body-building. The resulting cycle is probably his most comprehensive work, and at the same time constitutes an homage to the new, strong woman, who is aware of her body.

Portrait of a Lady

The name of the woman is Lyon. Lady Lisa Lyon. The alliteration is no accident. The same holds for the reference – at least phonetically – to the king of the beasts, for this, too, is part of a broader strategy. The young woman has a sense for effective publicity gestures. Furthermore, the physical strength of a wild animal – natural, untamed, and by no means the sole province of the male sex – has in any case always been her ideal. And it has aided her in defending women's body building when she has had to it in the face of a generally skeptical public. As she admits in 1981 in her best-selling *Lisa Lyon's Body-Building*, she feels like an animal. For her, physical signs of strength, charm, and suppleness do not have to be limited to a single sex. This association only exists in people's limited conception of things.

Formerly a rather uptight individual

Lisa Lyon is admittedly not the first woman to take pleasure in strikingly well-developed biceps. In her book, she reminisces about the Viennese strong-woman Caterina Baumann, one of the greatest athletes in history, who was able to lift ten times her own weight in the 1920s. But it was Lisa

Lyon who brought the discipline out of the ghetto of the circus, removed it from its historical niche in bourgeois reform movements, and declared it to be a matter of course in the life of the 'new woman'. Her timing was unquestionably right. The utopian ideals of the 1960s were now history; the 1970s were nearing their end, and values were once again undergoing a turnover. It was a good moment to introduce a fresh concept: that of a new, physically conscious, and above all physically powerful woman, and to integrate this ideal into the developing consciousness of the 1980s. In this sense, Lisa Lyon is unmistakably a child of the Reagan era, even if at first glance her entry, armed with dumbbells, seems not precisely to coincide with the ultraconservative spirit of the times. But in the struggle for wealth and success, in the glorification of power and the fetishism of material happiness (it's no accident that *Dallas* and *Denver Clan* are ruling the air-waves at this time), there was a meeting of the minds. As part of her fitness program, Lisa Lyon recommends zero tolerance towards what she designates as losers. As cynical as it may sound, the advice corresponded fairly well to the political climate of the day.

Lisa Lyon is dressed in mourning. But that doesn't signify anything – except that the creator of the picture, Robert Mapplethorpe, had been raised a Catholic and throughout his life retained an affinity with everything smacking of Catholicism. Robert Mapplethorpe is also obsessed with sex – a combination which may appear to be a self-contradiction, but on the other hand, explains his approach to his own homosexuality: an unusually long road marked by repression and denial. To claim that precisely the artist who had made homosexuality the theme of his photography at the end of the 1970s had once been a rather uptight individual is therefore not far from the truth. But Mapplethorpe, who had so many problems with his own coming-out, discovered in photography a medium for self-exploration – and applied it excessively. The cold smoothness of his emphatically formalistic photography, so well-schooled in principles of design, has made it easy to overlook this exploratory aspect of his work. His pictures give the impression of being finished pieces, at least at first glance. But they are just the opposite. His work abounds in contradictions – along with a good shot of irony – all of which indicate that his creations are in fact children of Postmodernism.

Lisa Lyon, 1982. What do we see here? A young woman, perhaps in her early twenties. One could call it a profile portrait – to be more exact, a

half-length portrait – but with this difference: the side-view is rather unusual within the genre of portrait photography. A traditional professional photographer would invariably choose the more flattering half- or quarter-profile, all the while giving the subject precise instructions on the direction in which to turn their gaze – above all, course, to look past the camera. But our young woman is standing or sitting with an admirably erect posture, looking straight ahead. One is almost reminded of the photographs of criminals systematically taken by the French photographer Alphonse Bertillon around 1890: his strategy for identification rested on only two exposures, one of which was precisely this 'hard' profile. The dark veil with its suggestion of sorrow, however, provides an ironic comment on this association. What we can make out under the veil is correspondingly little. For example, that the subject has carefully painted lips, and seems to be waiting without expression for whatever might come her way. That she is looking straight ahead, we have already noted – but is this really true? Hasn't she in fact closed her eyes? The veil obscures her gaze and, together with the elegant hat decorated with artificial flowers, stands in clear contradiction to the erotic appeal of the gleaming black bustier. The picture, one might say, splits into a 'serious' upper half and a less 'serious' lower half. It is the combination of the two that gives the scene its fascination. In addition, what the observer will certainly notice first and then give more attention to: the steely upper arm with its large number of unretouched moles – certainly a contradiction to the ideal of the self-confidently presented, beautifully formed body? Or can it be that these 'impurities' not only belong to the iconography of the image, but also to the ideology of a new ideal of beauty?

Someone from a different planet

Depending on the version one follows, they met for the first time in 1979 or 1980 at a party in Soho. Lyon was wearing a leather jacket and black rubber pants, an outfit that Mapplethorpe, with his unwavering interest in bizarre eroticism, could not help but notice. "Mapplethorpe," according to his biographer Patricia Morrisroe, invited her to Bond Street the following afternoon for a photo session, and she appeared at his door in a miniskirt, thigh-high leather boots, and a wide-brimmed hat decorated with feathers. He immediately responded to what was then an exotic notion – a muscle-packed woman – by photographing her in the frilly hat,

Robert Mapplethorpe

Born **1946** in Queens, New York. **1963–69** studies fine art at the Pratt Institute, Brooklyn. From **1970** growing interest in photography. First instant photographs. **1973** first exhibition in the New York Light Gallery. **1976** changes to square medium format photography. **1977** included in the "documenta VI" at Kassel. **1979** first one-man show in Europe (Galerie Jurka, Amsterdam). **1980–83** cycle *Lisa Lyon*. Films, book projects, exhibitions. **1988** major retrospective in the Whitney Museum of American Art in New York. In the same year the Robert Mapplethorpe Foundation is inaugurated to support Aids research and artistic photo projects. Dies **1989** in Boston

flexing her biceps. Never before, as Morrisroe relates, had he seen such a woman: "It was like looking at someone from another planet."

Robert Mapplethorpe was thirty years old at the time – not yet a star, but well on his way to becoming the most internationally known photographer of the 1980s. Born in Queens, New York, in 1946, he had, so to speak, photographed his way out of his petty bourgeois background and over the rim of the New York subculture, all the way to the top – an amazing trajectory that is only partially explained by the active support of his influential friend Sam Wagstaff. With his simple but elegant, classically oriented interpretation of the "unspeakable", Mapplethorpe had touched the nerve of the age – an era in which the emancipation of homosexuals had already advanced considerably, without the increased gay self-confidence having yet developed an appropriate aesthetic of its own. Precisely herein lies the importance, and moreover the achievement, of Robert Mapplethorpe. Certainly, there had been photographers with homosexual interests earlier; one needs only to recall Fred Holland Day, Thomas Eakins, or George Platt Lynes. Or the illustrations of Tom of Finland might be considered here. But what these artists had created under cover, or at best in the context of the subculture, Robert Mapplethorpe made palatable, consumable, for wider circles, and thus moved the theme into the mainstream of art. But the protection provided by the success of his work fostered more that a broader recognition of gay eroticism. The move in the understanding of photography in the 1980s from merely a technical picture-producing medium to an art form with a place in the museums is very largely thanks to Robert Mapplethorpe. The only other artist to achieve such a strong and international reception was Mapplethorpe's original model, Andy Warhol.

An androgynous manifestation with unkempt hair and a man's shirt
To the same extent that Mapplethorpe defined a new image of the male, who was now allowed to be black and horny, strong and beautiful, physically conscious of his body, sexy, and capable of taking pleasure in himself, he also participated in the transformation of the contemporary image of woman. The artist's black-and-white portraits of the Rock poet Patti Smith, whom Mapplethorpe had lived with for an extended period at the beginning of his artistic career, provide an example. Smith's pale, elf-like being flew in the face of all standard ideals of beauty, extending

Robert Mapplethorpe:
Lady Lisa Lyon
viewed slightly from
below

*A strategy consciously
employed by the
artist in order to lend
heroic stature to the
comparatively short
athlete*

from Veruschka to Raquel Welch. Mapplethorpe took numerous photographs of Smith, the most famous probably being an androgynous manifestation with unkempt hair, a white man's shirt, and tie. The record company is said to have repeatedly refused to use the photograph on the cover of Patti Smith's first record, *Horses*. Years later, when the music magazine *Rolling Stone* made a list of the 100 best covers of all time, *Horses* was number twenty-six on the list.

Mapplethorpe's liaison with Patti Smith had already come to an end when he met Lisa Lyon in 1979/80. For the photographer it was, so to speak,

like the continuance of a fascination by other means. Where Patti Smith clearly represented the ideals of the 60s generation in her life and art, Lisa Lyon was an unmistakable product of the 1980s: ambitious, success-oriented, goal-directed and, last but not least, clever in a very pragmatic way. While still at university, the five-foot-three young woman – not precisely tall – had become acquainted with kendo, the traditional Japanese martial art. She enjoyed discovering what her body could do, testing it to its very limits, and eventually joined Gold's Gym in Los Angeles, the center of body-building in the USA – initially, in must be said, with the opposition of her male environment. Hormonal differences, so it was then assumed, would prevent a woman from developing her muscles. Furthermore, Lyon faced doubts about her perseverance. But inspired by her great example Arnold Schwarzenegger, and guided by well-known body-builders like Franco Colombo or Robbie Robinson, she threw herself into training, "rigorously counting bicep curls and leg lifts" (Morrisroe). In the evening, she trained at home in her apartment – taking, instead of steroids, LSD in order to "reprogram her cellular structure". In 1979, in the virtual absence of competition, Lisa Lyon won the first world championship in women's body-building; the following year, she did not even bother to enter. From this perspective, she had a short but effective career. Even before the sport had been properly born, Gaine and Butler claim in their 'bible' of heavy athletics, Lisa Lyon was not only the leading protagonist for female body-building, but also its media star, making numerous appearances on television and radio, and presciently extolling the virtues of (strong) girl-power.

Cover and double-page spreads from Lady Lisa Lyon: the original edition of the book was published 1983 by The Viking Press, New York

Homage to the erotic force of the human body

For Robert Mapplethorpe, Lisa Lyon offered a welcome opportunity to at least balance out his image as a gay or sado-masochistic photographer. He took the first pictures in his loft at 24 Bond Street, with others to follow in an unnamed fitness studio and outdoors under the Californian sun. It is probably fitting that the Lisa Lyon cycle is considered the most comprehensive of all Mapplethorpe's works. Just how many exposures were made between 1980 and 1982 we do not know; in any case, 117 black-and-white, largely square, pictures found their way into the first volume of *Lady Lisa Lyon*, published in 1983. Some of the images are obviously drawn from the fashion photography of Horst P. Horst, others

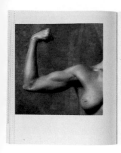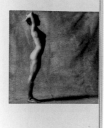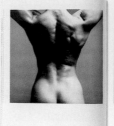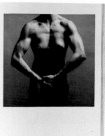

refer to the Art Deco pictorial language of Hoyningen-Huene. Borrowings are also recognizable from Weston's dune nudes as well as the early photography of the nudity movement. Mapplethorpe likes to quote. In return, his pictorial style had an influence on photodesign and on the advertising of the 1980s. Contemporary art criticism, however, looks at his work rather critically. Ulf Erdmann Ziegler speaks of "technoid pomp," A. D. Coleman of "warmed-over pictorialism." However it may be, Mapplethorpe's work remains an expression of its time. In retrospect, his pictorial homage to the erotic force of the human/male body seems almost like a futile protest against the latter-day plague that in the end also claimed his life. Robert Mapplethorpe died of AIDS early in 1989. By then, Lisa Lyon had already long since fallen back into anonymity. Their meeting was short, but powerful – and not without results for our understanding of the being and appearance of the modern woman.

1987 Joel-Peter Witkin
Un Santo Oscuro

A Martyr of Life

Some see his bizarre allegories as the quintessence of western decadence and moral decline; others compare him to Goya or call him the Hieronymous Bosch of photography. No other photographer of our age has polarized both art critics and the general public more than the American artist Joel-Peter Witkin.

Taken unaware, the unprepared gaze finds itself looking at what seems quite unbelievable. What are we looking at? A man? A human figure? Or simply a masquerade? A nightmare from another age, or perhaps an image created by contemporary Postmodernism? The uncertainties are multi-layered, resulting in alienation coupled with curiosity and a vague sense of horror.

As a rule, we are able to assign a photographic image spontaneously and confidently to a certain time frame or epoch – the nineteenth or early twentieth century, the 1950s, or a more recent date. This picture, however, seems to want to withdraw grotesquely from all temporal parameters. On the one hand, the observer has the impression that the image stems from a strange, sinister world, which has somehow left its traces on the photograph as it journeyed to the present: spots, scratches, a 'leap', such as one identifies with the age of the glass negative. On the other hand, the prosthesis, at least, points to the late twentieth century. Ergo, a digitally created horror vision, using the most modern technology to present a stifling variation of St. Sebastian, pierced with arrows – an image which has been a part of Christian art since the Renaissance and Baroque?

Incredible even to more tolerant contemporaries

To set matters straight right from the start: the American photographer Joel-Peter Witkin does not work with a computer, but with traditional pho-

tographic means. A twin-lens Rolleiflex vintage 1960 remains his camera of choice; he uses conventional roll film, and rarely shoots more than two frames per motif. And nor does he make collages or montages. The sole way in which he distances himself from the normal photography that takes 'straight' shots of its subjects is the way he works the negative – but more on that later. And, of course, by the way he creates scenes, a process in which he does not simply take the world as seen through the viewer, but creates rather a universe according to his pre-formulated ideas, visions, and fantasies – a cosmos rich with allusion, references, quotations – whose 'inhabitants' Witkin discovers in those places from which the proponents of more conventional ideals of beauty normally shy. And what is he interested in? Witkin unashamedly calls a spade a spade, and lists: freaks of every kind, idiots, dwarves, giants, deformations, pre-op trans-sexuals ... All the people who were born without arms, legs, eyes, breasts, genitals, ears, noses, lips. All those with unusually large genitals, dominas and slaves...Recently, Witkin has added dismembered bits of corpses to his list, which he arranges in the manner of seventeenth-century Flemish still lifes – an approach which must seem incredible even to his more tolerant contemporaries – and which especially in the USA has repeatedly stirred up the ire of district attorneys and self-appointed cultural censors. Without a doubt, Joel-Peter Witkin is one of the most controversial artists of his time. But where fundamentalist preachers stamp him as a monster in front of millions of TV viewers, the art world has come to recognize him as one of the most original and profound of contemporary artists. Accordingly, the prices of his limited editions, rarely consisting of more than a dozen prints, are the highest that Postmodern photography commands.

Joel-Peter Witkin

Born **1939** in Brooklyn/New York. **1961–64** military service as war correspondent. Studies sculpture at the Cooper Union School of Fine Art (B.F.A.). **1969** first one-man show at the Moore College of Art, Philadelphia. **1975** moves to Albuquerque. **1976** studies photography at the University of New Mexico. **1984** much acclaimed one-man exhibition at Pace/MacGill, New York. **1985** publication of his first book *Joel-Peter Witkin*. Also edits various works on the history of medicinal photography: *Masterpieces of Medical Photography*, **1987**, and *Harms Way*, **1994**. Lives in Albuquerque/New Mexico

The extraordinary as part of everyday life

Anyone who looks will find that Witkin's biography gives more than enough evidence for what at first glance seems to be a morbid obsession, but which is in fact nothing more than an attempt to examine the basis of earthly existence, to take issue with categories of norms and deviations, to transgress boundaries with open eyes, in order to discover pictorially what Witkin likes to term the 'divine'. As a child, equipped with a used Rolleicord, he once tried to photograph God: someone had told him of a rabbi who had seen God. Witkin visited the rabbi, but God remained in-

visible. Where was God to be found, he asked himself. In people, as the Christian message teaches? And if so, then in which people? Might it not be that God reveals himself in a special way precisely thorough those beings who are clearly different from the majority bodily or mentally? It is, in fact, philosophical-religious reflections like these which lie at the core of Joel-Peter Witkin's œuvre. Witkin was born in Brooklyn in 1939 as the son of poor immigrants. His father was an Orthodox Russian Jew, his mother an Italian with strong Catholic beliefs – differences that were to become the primary reason for the couple's separation. Joel-Peter and his twin brothers were raised by his mother and his grandmother. "My grandmother had only one leg," Witkin recalls, "and in the morning I would wake up and smell her gangrenous leg. Where most kids would wake up and smell coffee, I would wake up and smell grandmother's rotting leg." Witkin thus became early acquainted with the strange, and the extraordinary became a natural part of everyday life. He learned to accept illness and suffering in life, of which death was also necessarily a part, even if the thought is often suppressed. "My first conscious recollection occurred when I was 6 years old. It happened on a Sunday when my mother was escorting my twin brother and me down the steps of the tenement where we lived. We were going to church. While walking through the hallway to the entrance of the building, we heard an incredible crash mixed with screaming and cries for help. The accident had involved three cars, all with families in them. Somehow, in the confusion, I was no longer holding my mother's hand. At the place where I stood at the curb, I could see something rolling from one of the overturned cars. It stopped at the curb where I stood. It was the head of a

little girl. I bent down to touch the face, to ask it – but before I could touch it – someone carried me away."

His own world of personal fantasies

Already at age sixteen, Joel-Peter Witkin began taking a serious interest in photography. At the Museum of Modern Art, he introduced himself to Edward Steichen, who in fact accepted one of his pictures into the permanent exhibit. This experience motivated him to become a photographer. Witkin made a trek to Coney Island, where a freak show particularly caught his interest. He photographed the three-legged man, the 'Chicken Lady', and the hermaphrodite, with whom he claimed he had his first sexual experience. The freak show became his "home", the true environment where his lively fantasies could play themselves out. Unfortunately, they didn't need a photographer, and nor was he a freak, for otherwise Witkin would have gone on the road with them. So he remained in New York and worked in commercial studios, while at home he began to create my own world of personal fantasies that he could photograph. Witkin was drafted into the army in 1961, where he documented accidents that occurred on maneuver – and the fatalities they sometimes resulted in. He volunteered for Vietnam, attempted suicide, and was released from the army. He then took up studies at the Cooper Union School in New York, switching later to the University of New Mexico, where he graduated in 1981 with a Master of Fine Arts degree. By 1980, with his first one-man show curated by Sam Wagstaff in New York, Witkin became the object of passionate and controversial discussion.

Christian taboos of Eros and the body

"Witkin's philosophical/spiritual beliefs," according to Hal Fisher, "are exceptionally complex, a not particularly decipherable synthesis of Jewish cabalistic thought, Roman Catholic practice, Eastern philosophy and 1960s counterculture consciousness." Last but not least, Witkin's work can be read as an artistic revolt against both traditional Jewish iconoclasm and the Christian taboos of Eros and the body. Witkin mistrusts established norms and places them consciously in question. He even uses his own medium 'against the grain': for Witkin, recognition and understanding do not grow out of the mere duplication of reality, but only from the creation of an artificial world at whose center hermaphrodites,

dwarves, cripples, Siamese twins, and amputees function as the catalysts of an expanded spiritual horizon. Probably the most common protest against Witkin's photography is that he misuses the handicapped to create a macabre spectacle. Jackie Tellalian, New York theatrical agent and lead actress in Witkin's *Woman in the Blue Hat* (1985), who is herself confined to a wheelchair, reacted to these charges saying: "I've had many people say: 'Didn't you feel exploited by that?' and I always said no, because first of all he never made me feel as though he was using my disability as a sensational aspect in the picture."

Others have also reacted in a similar manner, openly speaking of the humane manner in which Witkin treats them, how he makes them into the subject of his art, and thereby open to public view with full dignity, in contrast to the society which had hidden them away and pushed them aside. And in fact, in Witkin's photographic creations, deficiencies acquire

a metaphysical power. "The formless and misshapen, the lowly and that which causes shudders are brought back into the light" (Germano Celant).

Created in 1987, *Un Santo Oscuro* exemplifies Witkin's artistic approach. As so often, also in this case, it was a person with a physical handicap who inspired the photograph. Friends had told him about a man in a wheelchair who lacked a face and arms. On the spur of the moment, Witkin made a first draft – a scribble or sketch – of an idea. But where in Los Angeles could he possibly find the man? "With my friend," Wirkin recalls, "we went down to the area where we thought he lived. There was an old run-down hotel, and when we got inside we finally saw him, because the door was open on the room he lived in. He was asleep. What we saw was this kind of plastic head, this little body, and we didn't want to disturb him. It was our conviction that we had to wait for other people to arrive,

and sure enough they did. Two men actually arrived to take care of him.
We got into the room and talked. We found out from our conversation
that this man was a Thalidomide victim. He was Canadian. His mother
took Thalidomide, and he was born without skin, without arms or legs,
without hair, eyelashes or eyelids. Early on, from the time he was a child,
he was the subject of ridicule and curiosity and wanted by side-shows and
freak-shows. I talked about how I wanted to photograph him. I wanted to
photograph him as clerics would have been depicted, mostly in seven-
teenth and eighteenth-century Spain, as martyrs, and I told this man that
he was a martyr to life."

A popular subject for religious painting commissions
Joel-Peter Witkin's photographs are the result of elaborate staging in the
studio, during which an interior image, a vision, finds its outward expres-

sion. Often works of the great masters – Velásquez, Cimabue, Giotto, Rembrandt, Arcimboldo, Picasso, Goya, Delacroix – stand at the start of Witkin's artistic creations. Without hesitation, he reaches back to myths, fairy tales, the traditions of western art history, all of which he seems to know well. The titles of works like *Sander's Wife, Courbet in Rejlander's Pool,* or *Von Gloeden in Asia* make the sources of his inspiration clear. In addition to painting and graphics, the photography of Ernest James Bellocq, Eadweard J. Muybridge, and Charles Nègre also provided stimulation. *Un Santo Oscuro,* however, does not draw from a particular individual picture, but rather from a pictorial genre that was a popular subject for religious painting commissions, in particular during the Spanish Baroque. Priests appeared in the pose of honored saints in order to increase their own power by association, their social position, and their clerical aura. What remained a mere travesty, however, in the historical panel painting, Witkin creates from real earthly torture. "Instead of a voluntary, playful masochism, Witkin cites real pain" (Chris Townsend).

The darkroom becomes a kind of holy house

Witkin may arrange his scenes, but he does not manipulate his pictures. The photographs are called into being without any technical tricks; they are therefore 'straight'. All the elements of the given scene are components of an often slowly and painstakingly arranged ensemble. Only later is the negative reworked to acquire the patina that gives Witkin's pictures the aura of being withdrawn from time. In the author's own description, he becomes a kind of priest of aesthetics. "I work alone during printing and begin by communicating with my equipment and chemistry, thanking them in advance. I place a negative in the enlarger and the darkroom becomes a kind of holy house, a refuge for phenomena..." By changing the texture of the picture, Witkin effectively moves it in time and space. As if through a hidden crack, we catch a glimpse into a strange cabinet. Witkin's pictures, as the writer Ludwig Fels states, are "Witnesses of a profound spirituality that creates from archaic sources." Witkin's art takes up the basic categories of human existence: love and pain, joy and suffering, Eros and Thanatos. He is the philosopher among the photographers of our age.

Sebastião Salgado
Kuwait

1991

Saddam Hussein's troops have been vanquished, but
Kuwait is in flames: the Iraqis have set approximately
900 oil wells on fire. Now international specialists are
trying to extinguish the fire. Sebastião Salgado observ-
ed them – labor heroes in an age of automation.

Apocalypse
in Oil

Like every well-made play, this drama too has three acts, and we find our-
selves at the beginning of the third. It is April 1991, and no one knows
how the act will end. The man who staged it left the ending open – with
an option for a *Götterdämmerung*. Dictators seem to like binding their
personal finale together with a universal apocalypse. Saddam Hussein
remains, as before, in power. Somewhere beneath Baghdad, he's holed
up in a bunker built by German or British or American specialists. And
this is not the only cynical aspect of a conflict that will go down in the
annals of the 1990s as the Gulf War, and that will cost an estimated hun-
dred to hundred and fifty thousand lives before it's over. Much of Iraq has
been destroyed. The newest technical weapons – cluster bombs, smart
bombs, and cruise missiles – have thrown the biblical cradle of Middle
Eastern culture back to medieval conditions. But beyond this, the war has
changed little, if we take Saddam's attack on Kuwait on 2 August 1990 as
its starting point. It has certainly brought about no changes in the map,
nor in the tendency of human beings to turn to violence in settling dis-
putes, nor even in the balance of power in the region. Saddam has been
weakened, but he's not yet been banished to oblivion, as America's pres-
ident George Bush would gladly see, without knowing precisely whom he
would set up in Saddam's place. And the Kuwaiti rulers are also back on
their old thrones as if nothing had happened. Apart from which, the
balance stands at 138 dead and 66 listed missing on the side of the Allied
forces – along with a series of new experiences. For example: in the psy-
chology of conducting a war. Or in the way the military deals with the

media. Or in the question how one gets the upper hand over almost 1,000 burning oil wells.

On 28 February, after exactly 210 days of combat, the Gulf War comes to an end – at least the military part of the drama. Saddam's troops have more or less withdrawn from Kuwait, but not before fulfilling the threat the Iraqi dictator had made from the beginning, namely, "to set the whole region, including the oil fields, on fire." Before the war, Kuwait had the world's highest average income; its oil reserves, the third-largest in the world, overflowed, creating prosperity for the approximately one million Kuwaitis. Now the liquid gold was in flames: the advancing Allied troops were greeted by a single vast inferno. The German news magazine *Der Spiegel* was moved to comparison with the Bible to describe the extent of the catastrophe: the destruction of Sodom and Gomorra, so it seemed, could now be assigned a date, namely March–April 1991. Everything was on fire. At least nine hundred of the once wealth-producing oil wells – pessimists spoke of up to a thousand torches in the desert sands – were burning up to a height of nearly a thousand feet. A cloud of soot and smoke darkened the heavens, causing a decline in temperatures throughout the Gulf region. In Kashmir, nearly 1,700 miles away, black snow was falling; in the deserts and savannas of East Africa, dirty rain. A natural catastrophe of unimagined dimensions seemed to be approaching. Scientists prognosticated abnormal weather patterns and questioned whether India would still receive its critical monsoon rains. If not, the result would be hundreds of thousands of deaths by famine on the subcontinent. Health risks were discussed, including possible delayed reactions after people had breathed in the poisonous soot particles. By the middle of the year, according to the estimates, forty million tons of raw oil had been burned, releasing two hundred and fifty thousand tons of nitrous oxide into the atmosphere, along with thirty millions tons of carbon dioxide. And no end of the catastrophe was in sight. Asked by the German magazine *Stern* in early 1991 whether all of the Kuwaiti oil fires could be extinguished within a half year, the American fire expert Paul Neal Adair, nicknamed 'Red,' had a simple answer: "Nonsense." Cautious estimates reckoned two to three years would be needed. Even more skeptical was Ali Qabudi of the Kuwait Oil Company at the end of March, who spoke of a worst-case scenario of ten years before all the fires were extinguished.

Additional problems in extinguishing the fires

What made the situation so difficult was not merely the number of fires. The area had been studded with mines, which greatly restricted the mobility of the fire-fighting troops who had been sent to the region. Furthermore, the oil flowed from the Kuwaiti wells under natural pressure. The force which had once made it easy to obtain the raw material now caused additional problems in extinguishing the fires. In addition, there was the problem of the proximity of the burning wells to each other: some were less than a mile apart. This concentration increased the temperatures to infernal levels, causing the desert sand to melt to glass. Red Adair joked that they had not even brought a thermometer along with them, because if they knew how hot it really was, no one would stay there to work. Texas-born Red Adair is already a legend among fire-fighters, "the most famous fireman in the world" (*Stern*). His specialty is blowing out burning shafts with a carefully placed load of dynamite, but Kuwait seems to be more than even an expert can handle. In the end, other teams from the USA and Canada, Romania, Italy, France, China, Hungary, Iran, and Russia also arrive to help solve the problem – attracted naturally by the impressive rewards that are being offered. And they try everything – every conceivable idea or plan – for time is money. Three million barrels – that is, ten per cent of the world's daily oil consumption – is going up in flames every day; which in turn means a forty-three billion dollar loss in two years for the Kuwait oil industry. "Big job, big money," as Red Adair succinctly phrases it. In other words: no matter how much it costs, the work of his team will not be too expensive for the country. After all, as he and his co-workers realize – and only for this reason are they willing to face these hellish temperatures – every one of them will return home a millionaire. That is, those who return home at all – for, as the *Spiegel* emphasizes, "the work is fraught with mortal danger."

An inferno of oil and mud, heat and gas

A man is taking a break. Possibly waiting for supplies. As reported by the western media, there's not enough of anything here. Not enough water for extinguishing and cooling – instead, it must be pumped for miles through pipelines from the sea. Not enough specialized equipment and machines, nor welding gear and bore heads. Red Adair speaks of a Mickey Mouse job, a remark which sounds like a bad joke. But he doesn't

Sebastião Salgado

Born the sixth of eight children **1944** in Aimorés/Brazil. **1964–67** studies economics at Vitoria/Brazil. **1968** employed at the Brazilian Ministry of Economic Affairs. **1969** moves to Europe. Research studies in Paris. **1971–73** works from London for the International Coffee Organisation. Move to photography. **1973** reportage on the drought-ridden Sahel zone begins his international acclaim. **1974** member of the newly-founded agency Sygma. **1975** changes to Gamma. **1979–94** member of Magnum. Subsequently sets up his own agency (Amazonas Images). Numerous prizes, including **1985** and **1992** Oskar Barnack Prize, **1988** Dr. Erich Salomon Prize, and **1989** Hasselblad Prize. Lives in Paris

mean it comically. The issue is survival: for the firefighters on the job, for the country, for the region. There's nothing funny about it. And if we think we see something like a smile on the face of the man in the picture, then it arises more likely from complete exhaustion than from any sort of amusement. The worker is clearly at the end of his strength. Kaput. Dreaming of nothing as he stares into space – minutes of regeneration amid an inferno of oil and mud, heat and gas, soot and stench. He is covered from head to toe in slippery oil. Anyone who has worked on an automobile will wonder how he will ever get himself clean again. But it's even worse, for he stands under this shower of oil every day. The observer's response to such a filthy layer of oil might be disgust. But here the opposite is the case. What we are looking at is an anonymous labor hero – no ordinary human being, but an icon: not a mere 'hand', but a monument, cast in bronze for eternity.

Sebastião Salgado: Workers. An Archaeology of the Industrial Age, *Aperture,* New York, 1993

With the passion of an adherent of liberation theology

Sebastião Salgado is a specialist in icons. Whatever he photographs becomes a formula for pathos. His pictures – always in black-and-white – are well-composed, suggestive, direct, and believable in their depiction of the world's misery. Salgado is a master at making the frightening into something beautiful, and as a result is certainly the most admired international photographer today. In terms of his influence on present-day photojournalism – his function as a role model – one can designate him justly as the most important camera artist of the times – a kind of Cartier-Bresson of the late twentieth century. But whereas Cartier approached his work with the knife-sharp calculation of the Constructivists, Salgado pursues the emotions. Compared to what one finds in the sensational press, his pictures do not look spectacular; rather, their effect lies in the manner in which they lift up an event. Every one of his photographs thus becomes something special: "Their pathos," says the *Zeit* author Peter Sager, "their elegiac gesture derives from the subject itself, but also from the way it is presented. Mother-and-child groups, scenes of passion, masses of people caught up in a great movement – such pictures narrate biblical stories, and Salgado quotes them with the passion of a Marxist-oriented adherent of liberation theology."

Salgado sees himself as a documentary photographer, and he can celebrate his success not only in the illustrated press throughout the world,

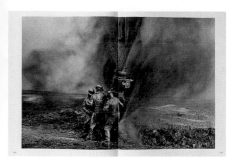
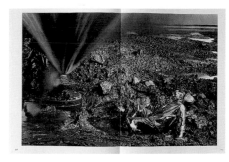
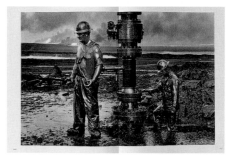
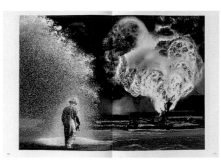
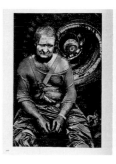

Double-page spreads from Sebastião Salgado's
Workers. An Archaeology of the Industrial Age,
Aperture, New York, 1993

but also in the realm of galleries and museums – a rather unique and much admired triumph in the world of photography. It is sometimes said that he aestheticizes suffering, that he exploits the misery of others for the sake of his art. But one thing is certain. There are few who have gotten as close as he, and with such an alert and interested eye, to misery. Salgado, as the writer Márcio Souza points out, has brought a completely new element to photography, one which is perhaps traceable to his Brazilian origins: namely, the complete absence of a bad conscience in relation to poverty, suffering, and social injustice. This does not mean, however, that Salgado feels no sympathy for what he sees. What distinguishes him from others is his attitude toward those he photographs. As oil engineer Dave Wilson puts it: "It's kind of an aggressive act to take someone's picture. Somehow or other, he melts all that away." Salgado was born in 1944 in southwestern Brazil, the only boy in a family of eight children. He studied in São Paulo and Paris, and seemed to be headed for a career with the World Bank. But then, almost overnight, he changed his mind. Inspired by the engagement of photographers such as Lewis Hine and Dorothea Lange, Salgado took up the camera and set out for Africa to document the famine in the desert regions of the Sahel. That Salgado was the photographer who caught the attempted assassination of Reagan in 1981 seems today to be almost a mistake, for Salgado – the global player with a touch of Marx – is primarily interested in the Third World. At the core of his engagement stand the peoples of Latin America, Asia, and Africa, or the International Union of Manual Workers, about whom he has been working on a major cycle since 1980, calling his project on the dignity of labor simply *Workers*. According to Salgado, he is not necessarily directing criticism at a certain development, but rather trying to "portray the disappearance of the community of laborers."
This is not his first excursion into the Near East. At the end of the 1980s, he had accompanied a troop of Iraqi military actors at the front during the war between Iraq and Iran. Western media had actually been denied access to the war, but on occasion a Brazilian passport can have its advantages.

On average twelve rolls of film per day
Here, in the midst of the burning oil fields, Salgado is of course not the only reporter. Stephane Compoint is present, and will eventually receive a

photography prize for his work. Also the Magnum photographer Bruno Barbey is on the scene, as well as the photographers Steve McCurry (*National Geographic*) and Peter Menzel (*Stern*). What distinguishes Salgado from the others, though, is that he photographs in black-and-white. Equipped with three Leicas and 28 mm, 35 mm, and 60 mm lenses, he shoots on average twelve rolls per day. In Kuwait, he made approximately seven thousand exposures, from which six per roll are processed as work prints. On average he presents fifty photographs to magazines, who then make their selections. Salgado's report with the working title "Oil Wells" appeared for the first time in the *New York Times Magazine* on 9 June 1991 under the title "The Eye of the Photojournalist." The *Spiegel* published several samples of his work in issue 24 of the same year (10 June). In the World Press Contest, Salgado's work secured him the Oskar Barnack Prize. And the Kuwait cycle is also represented in his thematically-oriented book *Workers* (1993): our picture occurs as a full-page print on page 340.

At the beginning of November 1991, against all expectations, the last fire in Kuwait was extinguished. Red Adair and his workers, the gang from Boots & Coots, Wild Well Control, and Safety Boss have returned to their various homes. In the meantime, the catastrophe has become history, and as such, is (almost) forgotten. What still remains are the photographs by Sebastião Salgado: icons that transcend time, made not for the daily press, but for the collective pictorial memory. Salgado's pictures are a visualized Bible which extol the core of all that we find human. This is why his pictures are understood – and treasured – around the world.

Bibliography

General historical overviews of photography

Benteler, Petra: *Deutsche Fotografie nach 1945.* Kassel, 1979
Honnef, Klaus: *Pantheon der Photographie im XX. Jahrhundert.* Cat. Kunst- und Ausstellungshalle der Bundesrepublik Deutschland, Bonn, Stuttgart, 1992
Kemp, Wolfgang: *Theorie der Fotografie I–III. 1945–1980.* Munich, 1983

Newhall, Beaumont: *History of photography.* New York, 1982
Newhall, Beaumont (ed.): *Photography: Essays & Images.* New York, 1980
Tausk, Peter: *Geschichte der Fotografie.* Cologne, 1977

About the photographers

Burri, René
Burri, René/François Maspero: *Che Guevara.* Paris, 1997
Burri, René: *One World.* Zurich, 1984
Che. Fotografisches Album. Berlin, 1991
Look, 9 April 1963
"Los Cubanos. Metamorphosen einer Revolution. Aufnahmen von René Burri". In: *Du,* no. 12/ 1993, pp. 12–73
Loviny, Christophe: *Che. Die Fotobiografie.* Munich, 1997
Ulmer, Brigitte: "Ich dachte, Burri, du spinnst". In: *Cash Extra,* no. 49, 5 December 1997

Capa, Robert
Born, Katharina/Rita Grosvenor: "Dem die Stunde schlug". In: *Stern,* no. 41, 1996
Capa, Cornell (ed.): *The concerned photographer.* New York, 1968
Capa, Cornell/Richard Whelan: *Children of War, Children of Peace. Photographs by Robert Capa.* Boston, 1991
Capa, Robert: *Death in the Making.* New York, 1938
Capa, Robert: *War Photographs.* Cat. Museum of Modern Art, New York, 1960
Fabian, Rainer/Hans Christian Adam: *Bilder vom Krieg. 130 Jahres Kriegsfotografie – eine Anklage.* Hamburg, 1983
Heart of Spain. Robert Capa's Photographs of the Spanish Civil War. New York, 1999
Squiers, Carol: "Capa is Cleared. A famed photo is proven authentic". In: *American Photo,* May/June, 1998

Cartier-Bresson, Henri
Burri, René: "Alter Meister". In: *Süddeutsche Zeitung Magazin,* no. 31, 1998
Cartier-Bresson, Henri: *Europeans.* London, 1998
Cartier-Bresson, Henri: *Images à la Sauvette.* Paris, 1952
Cartier-Bresson, Henri: *Die Photographien.* Munich, 1992
Cartier-Bresson, Henri: *The Decisive Moment.* New York, 1952
Eger, Christian: "Schnappschuss wurde eine Fotolegende". In: *Mitteldeutsche Zeitung,* 27. 7. 1995

Kirstein, Lincoln/Beaumont Newhall: *The photographs of Henri Cartier-Bresson.* Cat. Museum of Modern Art, New York, 1947
Montier, Jean-Pierre: *Henri Cartier-Bresson and the Artless Art.* Boston, 1996

Doisneau, Robert
Anon.: "Ein Klassiker unter den Küssen". In: *Süddeutsche Zeitung,* 24. 12. 1992
Anon.: "Der Kuss der Küsse". In: *Süddeutsche Zeitung,* 4. 6. 1993
Anon.: "Der schönste Kuß – nur ein Bluff". In: *Abendzeitung München,* 4. 6. 1993
Doisneau, Robert. Paris, 1983
Doisneau, Robert: *Three Seconds from Eternity.* Boston, 1979
Doisneau, Robert: *A l'imparfait de l'objectif. Souvenirs et portraits.* Paris, 1989
Doisneau, Robert: *Trois Secondes d'Éternité.* Paris, 1979
Gautrand, Jean-Claude: "Au revoir Monsieur Doisneau!". In: *Le Photographe,* no. 1514, May 1994, pp. 8–11
Hamilton, Peter: *Retrospective Robert Doisneau.* London, 1992
Hamilton, Peter: "Robert Doisneau. Born Gentilly, 14 April 1912, died Paris, 1 April 1994". In: *The British Journal of Photography,* 13 April 1994, pp. 16–17
Koetzle, Michael (ed.): *Robert Doisneau – Renault. Die Dreißiger Jahre.* Berlin, 1990
Langer, Freddy: "Das Flüchtige des Glücks. Zum Tod des französischen Fotografen Robert Doisneau". In: *Frankfurter Allgemeine Zeitung,* no. 78, 5 April 1994
Ollier, Brigitte: *Doisneau Paris.* Paris, 1996
Zollner, Manfred: "Der Foto-Poet". In: *Foto-Magazin,* no. 5, 1992, pp. 34–41

Haas, Ernst
After the War was over ... London, 1985
Andies, Helmut/Ernst Haas: *Ende und Anfang.* Vienna/Hamburg/Düsseldorf, 1975
Campbell, Bryn: *Ernst Haas. The great photographers.* London, 1983
Capa, Cornell (ed.): *The Concerned Photographer 2.* New York, 1972
Eskildsen, Ute: *Fotografie in deutschen Zeitschriften*

1946–1984. Cat. Institut für Auslandsbeziehungen, Stuttgart, 1985

Gruber, L. Fritz/Renate Gruber: *Große Photographen unseres Jahrhunderts*. Darmstadt, 1964

Haas, Ernst: *In Black and White*. Boston/Toronto/London, 1992

Heute, no. 90, 3 August 1949

d'Hooge, Robert: "Journalismus und Abstraktion: der Fotograf Ernst Haas". In: *Leica Fotografie*, no. 1, 1956

Langer, Freddy: *Ernst Haas*. Hamburg, 1992

Mauracher, Michael: "Heimkehrer. Ein Gespräch mit Ernst Haas". In: *Wiener Zeitung*, 31. 7. 1987 (first part) and 7. 8. 1987 (second part)

Horst, Horst P.

Brugger, Ingried (ed.): *Modefotografie von 1900 bis heute*. Cat. Kunstforum Länderbank, Vienna, 1990

Devlin, Polly: *Vogue Book of Fashion Photography. The First Sixty Years*. New York, 1979

Ewing, William A./Nancy Hall-Duncan: *Horst P. Horst. Photographs 1931–1984*. Milan, 1985

Honnef, Klaus/Frank Weyers: *Und sie haben Deutschland verlassen ... müssen. Fotografen und ihre Bilder 1928–1997*. Cat. Rheinisches Landesmuseum, Bonn, 1997

Horst. Cat. Münchner Stadtmuseum et al, Milan, 1987

Horst P. Horst: Photographs of a Decade. New York, 1944

Horst P. Horst/George Hoyningen-Huene: *Salute to the Thirties*. New York, 1971

Lawford, Valentine: *Horst. His Work and His World*. New York, 1984

Tardiff, Richard J./Lothar Schirmer (ed.): *Horst. Photographien aus sechs Jahrzehnten*. Munich, 1991

Vogue (France), no. 9 and no. 12, 1939

Kertész, André

Aperture Masters of Photography: André Kertész. New York, 1993

Borhan, Pierre: *André Kertész. La biographie d'une œuvre*. Cat. Pavillon des Arts, Paris, 1994

Kertész, André: *Day of Paris*. New York, 1945

Kertész, André: *A. K. in Paris. Photographien 1925–1936*. Munich, 1992

Kertész on Kertész. A Self-Portrait. Photos and Text by André Kertész. New York, 1983

Lemagny, Jean-Claude: *L'ombre et le temps*. Paris, 1992

Phillips, Sandra S.: *The Photographic Work of André Kertész in France 1925–1936*. A Critical Essay and Catalogue. The City University of New York, 1985

Phillips, Sandra S./David Travis/Weston J. Naef: *André Kertész. Of Paris and New York*. Cat. The Art Institute of Chicago, Chicago, 1985

Klemm, Barbara

Frankfurter Allgemeine Zeitung, editions from 18 until 22 May 1973, 26 May 1973 and 9 April 1976

Hess, Hans-Eberhard: "Die Zeitungsfotografin". In: *Photo Technik International*, no. 6, 1995, pp. 74–83

Klemm, Barbara: *Bilder*. Frankfurt on the Main, 1986

Klemm, Barbara: *Unsere Jahre. Bilder aus Deutschland 1968–1998*, Munich, 1999

Lange, Dorothea

Davis, Keith F.: *The Photographs of Dorothea Lange*. Kansas City, 1995

Dixon, Daniel: *Dorothea Lange: Eloquent Witness*. Chicago, 1989

Doherty, R. J.: *Social-Documentary Photography in the USA*. New York, 1976

Elliott, George P.: *Dorothea Lange*. Cat. Museum of Modern Art, New York, 1966

Heyman, Therese Thau/Sandra S. Phillips/John Szarkowski: *Dorothea Lange: American Photographs*. San Francisco, 1994

Dorothea Lange. Cat. Caisse nationale des monuments historiques et des sites, Paris, 1998

Lange, Dorothea: *American Photographs*. San Francisco, 1994

"Lange, Dorothea: An Assignment I'll Never Forget". In: Liz Heron/Val Williams (ed.): *Illuminations. Women Writing on Photography from the 1850s to the Present*. London, 1996, pp. 151–153

Lange, Dorothea/Paul Schuster Taylor: *An American Exodus. A Record of Human Erosion*. New York, 1939

Levin, Howard M./Katherine Northrup (ed.): *Dorothea Lange: Farm Security Administration Photographs, 1935–1939*. Glencoe, 1980

Meltzer, Milton: *Dorothea Lange. A Photographer's Life*. New York, 1978

Partridge, Elizabeth: *Dorothea Lange: A Visual Life*, Washington/London, 1994

Steichen, Edward: *The Family of Man*. Cat. Museum of Modern Art, New York, 1955

Stryker, Roy Emerson/Nancy Wood: *In this Proud Land: America As Seen in the FSA Photographs*. Greenwich, 1973

Lebeck, Robert

Koetzle, Michael: "Zeitzeuge mit der Kamera". In: *foto-scene*, no. 6, 1991/92

Lebeck, Robert: *Afrika im Jahre Null. Eine Kristall-Reportage*. Hamburg, 1961

Lebeck, Robert: *Begegnungen mit Großen der Zeit*. Schaffhausen, 1987

Lebeck, Robert: *Rückblende*. Düsseldorf, 1999

Lebeck, Robert: *Vis-à-vis*. Göttingen, 1999

Steinorth, Karl/Meinrad Maria Grewenig (ed.): *Robert Lebeck – Fotoreportagen*. Ostfildern, 1993

Tabel-Gerster, Margit: *Durchschnitt fotografiert sich (nicht) doch! Ein Gespräch mit Robert Lebeck*. Hamburg, 1988

Malanga, Gerard

Avedon, Richard: *Evidence. 1944–1994*. Cat. Witney Museum of American Art, New York, 1994

Avedon, Richard/Doon Arbus: *The Sixties*. New York, 1999

Bockris, Victor/Gerard Malanga: *Up-tight. The Velvet Underground Story*. London, 1983

Malanga, Gerard: *Genesis of an Installation.* New York, 1988

Malanga, Gerard: *Screen Tests, Portraits, Nudes 1964–1996.* Göttingen, 2000

Malanga, Gerard: *Selbstporträt eines Dichters.* Frankfurt on the Main, 1970

McShine, Kynaston (ed.): *Andy Warhol. Retrospektive.* Cat. Museum Ludwig Köln, Munich, 1989

Steinorth, Karl/Thomas Buchsteiner (ed.): *Social Disease. Photographs '76–'79.* Cat. Kodak Kulturprogramm, Ostfildern, 1992

Andy Warhol: Photography. Cat. Hamburger Kunsthalle, Schaffhausen, 1999

Andy Warhol's Exposures. New York, 1979

Mapplethorpe, Robert

Coleman, A.D.: *Critical Focus,* Munich, 1995

Dunne, Dominick: "Robert Mapplethorpe's proud finale". In: *Vanity Fair,* february 1989, pp. 124–132, 183–187

Gaines, Charles/Butler, George: *Pumping Iron II: The unprecedented Woman.* New York, 1984

Lyon, Lisa: *Lisa Lyon's Body Magic.* New York, 1981

Mapplethorpe, Robert: 1970–1983. Cat. Institute of Contemporary Arts, London, 1983

Mapplethorpe, Robert: *The Black Book.* Munich, 1986

Mapplethorpe, Robert: *Ten by ten.* New York, 1988

Mapplethorpe, Robert. New York, 1992

Morrisroe, Patricia: *Robert Mapplethorpe. A Biography.* New York, 1995

Weiermair, Peter: "Homosexuelle Sehweisen in der Fotografie des 19. und 20. Jahrhunderts. Einige Anmerkungen unter besonderer Berücksichtigung des Werks von Robert Mapplethorpe". In: *Fotogeschichte,* no. 19, 1986, pp. 23–28

Newton, Helmut

Haenlein, Carl (ed.): *Anton Josef Trčka, Edward Weston, Helmut Newton. Die Künstlichkeit des Wirklichen.* Cat. Kestner Gesellschaft Hannover, Zurich, 1998

Honnef, Klaus: "Die Lust zu sehen. Mehr als ein Fotograf – Ein Meister der Bilder: Helmut Newton". In: **Honnef, Klaus:** *Nichts als Kunst* Cologne, 1997, pp. 447–457

Newton, Helmut: *Big Nudes.* New York, 1982

Newton, Helmut: *Pages from the Glossies. Facsimiles 1956–1998.* Zurich, 1998.

Helmut Newton. Aus dem Photographischen Werk. Cat. Deichtorhallen Hamburg, Munich, 1993

Newton, Helmut: *Sleepless Nights.* Munich, 1991

Newton, Helmut: *Welt ohne Männer.* Munich, 1984

Newton, Helmut: *White Women.* Munich, 1976

Vogue (Paris), no. 621 (November) 1981

Vogue (German), no. 11 (November) 1979

Peter sen., Richard

Domröse, Ulrich (ed.): *Nichts ist so einfach wie es scheint. Ostdeutsche Photographie 1945–1989.* Cat. Berlinische Galerie, Berlin, 1992

Frühe Bilder. Eine Ausstellung zur Geschichte der Fotografie in der DDR. Cat. Gesellschaft für Fotografie im Kulturbund der DDR, Leipzig, 1985

Honnef, Klaus/Ursula Breymayer (ed.): *Ende und Anfang. Photographen in Deutschland um 1945.* Cat. Deutsches Historisches Museum Berlin, 1995

Peter, Richard: *Dresden – eine Kamera klagt an.* Dresden 1949. Second edition. Leipzig, 1982

Peter, Richard: *Dresdener Notturno.* Dresden, 1961

Peter, Richard: "Gute Fotos kosten Zeit und Mühe". In: *fotografie,* no. 4, 1960

Pommerin, Rainer/Walter Schmitz: *Die Zerstörung Dresdens am 13./14. Februar 1945. Antworten der Künste.* Dresden, 1995

Wurst, Werner (ed.): *Richard Peter sen. Erinnerungen und Bilder eines Dresdener Fotografen.* Leipzig, 1987

Salgado, Sebastião

Salgado, Sebastião: *Serra pelada.* Paris, 1999

Salgado, Sebastião: *Workers. An Archaeology of the Industrial Age.* New York, 1993

Der Spiegel, nos. 10, 11, 17, 24, 26, 1991

Stern, no. 46, 7. 11. 1991

Wald, Matthew L.: "The Eye of the Photojournalist". In: *The New York Times Magazine,* 9 June 1991

World Press Photo 1992. Düsseldorf, 1992

Skoglund, Sandy

Hülsewig-Johnen, Jutta/Gottfried Jäger/J. A. Schmoll gen. Eisenwerth: *Das Foto als autonomes Bild. Experimentelle Gestaltung 1839–1989.* Cat. Kunsthalle Bielefeld, Stuttgart, 1989

50 Jahre Moderne Farbfotografie. Cat. photokina, Cologne, 1986

Köhler, Michael: *Das konstruierte Bild.* Schaffhausen 1989

Lemagny, Jean-Claude/Alain Sayag: *L'Invention d'un Art. Simulacres et Fictions.* Cat. Centre Georges Pompidou, Paris, 1989

Picazo, Glòria/Patrick Roegiers: *Sandy Skoglund.* Cat. Paris Audiovisuel, Paris, 1992

Piguet, Philippe: *Sandy Skoglund.* Cat. Galerie Guy Bärtschi, Geneva, 2000

Skoglund, Sandy: Reality Under Siege. A Retrospective. Cat. Smith College Museum of Art, New York, 1998

Stern, Bert

Eros, no. 3, Autumn 1962

Greene, Milton H.: *Milton's Marilyn: The photographs of Milton H. Greene.* Munich, 1998

Marilyn Monroe und die Kamera. 152 Photographien aus den Jahren 1945–1962. Munich, 1989

Stern, Bert: *Marily Monroe – The Complete Last Sitting.* Munich, 1992

Stock, Dennis

James Dean. Photographien. Munich, 1989

Roth, Sanford und Beulah: *James Dean.* Corte Madera, 1983

Schatt, Roy: *James Dean. Ein Porträt.* Munich, 1984

Stock, Dennis: *James Dean Revisited*. New York, 1978
Stock, Dennis: *Made in USA. Photographs 1951–1971*.
Ostfildern, 1994

Witkin, Joel-Peter
Celant, Germano: *Witkin*. Zurich, 1995
Enfers, no. 1. Biarritz, 1994
Fels, Ludwig: "Grimassen der Lust". In: *Süddeutsche Zeitung Magazin*, no. 40, 1995
Glanz und Elend des Körpers/Splendeurs et Misères du Corps. Cat. Musée d'art et d'histoire de Fribourg/Musée d'Art Moderne de la Ville de Paris, Fribourg/Paris, 1988
Thijsen, Mirelle: "Die Form Gottes. Interview mit Joel-Peter Witkin". In: *European Photography*, no. 42, 1990
Witkin, Joel-Peter. Cat. Stedelijk Museum, Amsterdam, 1983

Witkin, Joel-Peter: Fourty Photographs. Cat. San Francisco Museum of Modern Art, San Francisco, 1985
Witkin, Joel-Peter (ed.): *Masterpieces of Medical Photography. Selections from the Burns Archive*. Edited by Joel-Peter Witkin. Pasadena, 1987
Witkin, Joel-Peter. Cat. Forum Böttcherstraße. Bremen, 1989
Witkin, Joel-Peter. Cat. Centre National de la Photographie, Paris, 1989
Witkin, Joel-Peter. Paris, 1991
Witkin, Joel-Peter. Cat. Galerie Baudoin Lebon, Paris, 1991
Witkin, Joel-Peter: *Gods of Earth and Heaven*. Altadena, 1991
Witkin, Joel-Peter (ed.): *Harms Way. Lust & Madness. Murder & Mayhem*. Santa Fe, 1994

Atget's Paris
Ed. Hans Christian Adam/ Flexi-
cover, Icons, 192 pp. / € 6.99/
$ 9.99 / £ 4.99 / ¥ 1.500

Photo Icons Vol. 1
Hans-Michael Koetzle / Flexi-
cover, Icons, 192 pp. / € 6.99/
$ 9.99 / £ 4.99 / ¥ 1.500

"An in-depth analysis by an erudite historian. Each image is accompanied by a fascinating commentary."
—*Le Monde,* Paris, on *Photo Icons*

" Buy them all and add some pleasure to your life."

African Style
Ed. Angelika Taschen

Alchemy & Mysticism
Alexander Roob

American Indian
Dr. Sonja Schierle

Angels
Gilles Néret

Architecture Now!
Ed. Philip Jodidio

Art Now
Eds. Burkhard Riemschneider, Uta Grosenick

Atget's Paris
Ed. Hans Christian Adam

Audrey Hepburn
Ed. Paul Duncan

Bamboo Style
Ed. Angelika Taschen

Berlin Style
Ed. Angelika Taschen

Brussels Style
Ed. Angelika Taschen

Cars of the 50s
Ed. Jim Heimann, Tony Thacker

Cars of the 60s
Ed. Jim Heimann, Tony Thacker

Cars of the 70s
Ed. Jim Heimann, Tony Thacker

Chairs
Charlotte & Peter Fiell

Charlie Chaplin
Ed. Paul Duncan

China Style
Ed. Angelika Taschen

Christmas
Ed. Jim Heimann, Steven Heller

Classic Rock Covers
Ed. Michael Ochs

Clint Eastwood
Ed. Paul Duncan

Design Handbook
Charlotte & Peter Fiell

Design of the 20th Century
Charlotte & Peter Fiell

Design for the 21st Century
Charlotte & Peter Fiell

Devils
Gilles Néret

Digital Beauties
Ed. Julius Wiedemann

Robert Doisneau
Ed. Jean-Claude Gautrand

East German Design
Ralf Ulrich / Photos: Ernst Hedler

Egypt Style
Ed. Angelika Taschen

Encyclopaedia Anatomica
Ed. Museo La Specola Florence

M.C. Escher

Fashion
Ed. The Kyoto Costume Institute

Fashion Now!
Ed. Terry Jones, Susie Rushton

Fruit
Ed. George Brookshaw, Uta Pellgrü-Gagel

HR Giger
HR Giger

Grand Tour
Harry Seidler

Graphic Design
Eds. Charlotte & Peter Fiell

Greece Style
Ed. Angelika Taschen

Halloween
Ed. Jim Heimann, Steven Heller

Havana Style
Ed. Angelika Taschen

Homo Art
Gilles Néret

Hot Rods
Ed. Coco Shinomiya, Tony Thacker

Hula
Ed. Jim Heimann

Indian Style
Ed. Angelika Taschen

India Bazaar
Samantha Harrison, Bari Kumar

Industrial Design
Charlotte & Peter Fiell

Japanese Beauties
Ed. Alex Gross

Las Vegas
Ed. Jim Heimann, W. R. Wilkerson III

London Style
Ed. Angelika Taschen

Marilyn Monroe
Ed. Paul Duncan

Marlon Brando
Ed. Paul Duncan

Mexico Style
Ed. Angelika Taschen

Miami Style
Ed. Angelika Taschen

Minimal Style
Ed. Angelika Taschen

Morocco Style
Ed. Angelika Taschen

New York Style
Ed. Angelika Taschen

Orson Welles
Ed. Paul Duncan

Paris Style
Ed. Angelika Taschen

Penguin
Frans Lanting

20th Century Photography
Museum Ludwig Cologne

Photo Icons I
Hans-Michael Koetzle

Photo Icons II
Hans-Michael Koetzle

Pierre et Gilles
Eric Troncy

Provence Style
Ed. Angelika Taschen

Robots & Spaceships
Ed. Teruhisa Kitahara

Safari Style
Ed. Angelika Taschen

Seaside Style
Ed. Angelika Taschen

Signs
Ed. Julius Wiedeman

South African Style
Ed. Angelika Taschen

Starck
Philippe Starck

Surfing
Ed. Jim Heimann

Sweden Style
Ed. Angelika Taschen

Sydney Style
Ed. Angelika Taschen

Tattoos
Ed. Henk Schiffmacher

Tiffany
Jacob Baal-Teshuva

Tiki Style
Sven Kirsten

Tokyo Style
Ed. Angelika Taschen

Tuscany Style
Ed. Angelika Taschen

Valentines
Ed. Jim Heimann, Steven Heller

Web Design: Best Studios
Ed. Julius Wiedemann

Web Design: E-Commerce
Ed. Julius Wiedemann

Web Design: Flash Sites
Ed. Julius Wiedemann

Web Design: Music Sites
Ed. Julius Wiedemann

Web Design: Portfolios
Ed. Julius Wiedemann

Women Artists
in the 20th and 21st Century
Ed. Uta Grosenick

70s Fashion
Ed. Jim Heimann